A NY TO APPEND

The Question-and-Answer Guide to

PHOTO TECHNIQUES

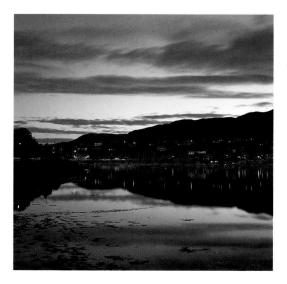

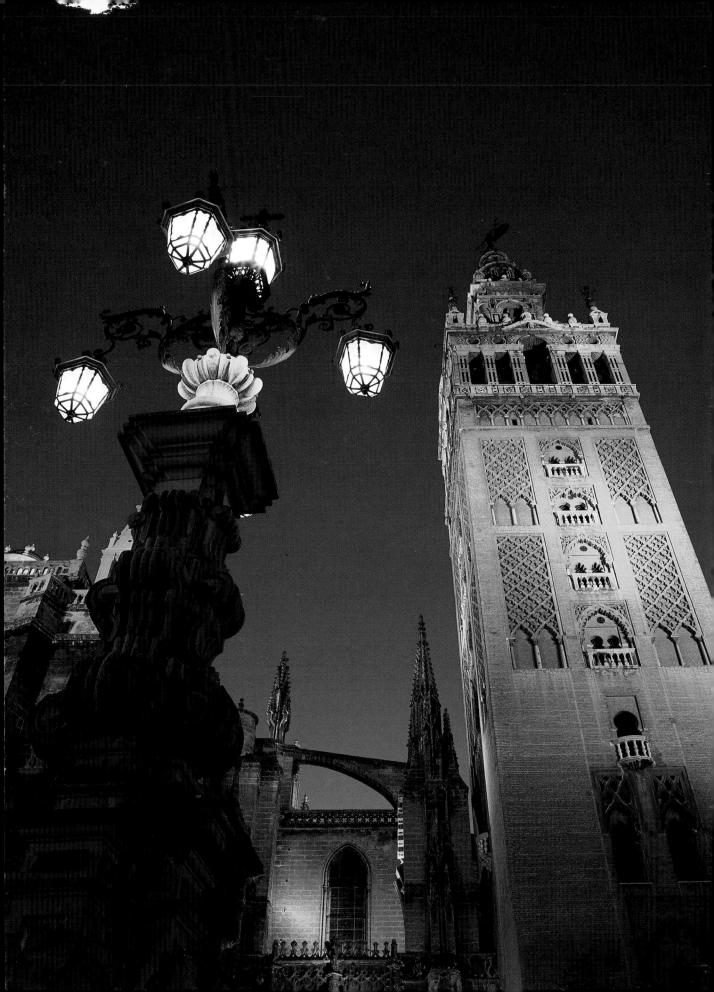

The Question-and-Answer Guide to

PHOTO TECHNIQUES LEE FROST

R David & Charles

Japan 24.95 97164

To Julie, for her patience

A DAVID & CHARLES BOOK

Copyright © Lee Frost 1995

First published 1995

Lee Frost has asserted his right to be identified as author of this work in accordance with the Copyright, Designs and Patents Act 1988.

All rights reserved. No part of this publication may be reproduced, stored in a retrieval system, or transmitted, in any form or by any means, electronic or mechanical, by photocopying, recording or otherwise, without prior permission in writing from the publisher.

A catalogue record for this book is available from the British Library.

ISBN 0 7153 0198 5

Designed by Cooper Wilson Ltd Colour illustrations by Steven Handley Line drawings by Greg Volichenko Printed in England by Butler & Tanner Ltd, Frome for David & Charles Brunel House, Newton Abbot, Devon

CONTENTS

Introduction 6 **EQUIPMENT ANSWERS** 7 Camera Answers 8 Lens Answers 14 Filter Answers 20 Film Answers 26 Flash Answers 30 Accessory Answers 36 **TECHNIQUE ANSWERS** 39 Depth-of-field Answers 40 **Exposure Answers** 42 Lighting Answers 50 **Composition Answers** 54 Colour Answers 60 **Processing Answers** 62 Printing Answers 66 Problem-solving Answers 74

3

77

SUBJECT ANSWERS

Portrait Answers 78 **Kids Answers** 84 Holiday and Travel Answers 88 Candid Answers 92 Landscape Answers 94 Sport and Action Answers 100 Night and Low-light Answers 104 Nature and Close-up Answers 108 Architecture Answers 114 Still-life Answers 118 Special Effects Answers 122 Jargon Buster 126 Index 128

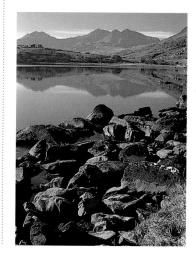

INTRODUCTION

In recent years photography has become more accessible, more affordable, and easier than ever before. Equipment manufacturers have gone to incredible lengths to develop cameras that make the whole picture-taking process as simple as possible, there are films available to deliver high-quality results in every conceivable situation, and high street processing labs make it possible to see your efforts within the hour. Never have we had it so good.

Despite these great advances in technology, however, photography is still a creative process that depends more upon the skill and judgement of the photographer than the contents of a gadget bag. You can own the most expensive, up-to-date equipment available, but without knowledge, guidance and inspiration, your efforts will more than likely be in vain.

Which is where this book comes in. Using a handy question-andanswer format, this fact-packed guide has been carefully compiled to provide all the information you're likely to require as your interest in photography develops. No need to spend hours reading through huge chapters to find those small nuggets of information you seek. Just locate the relevant section, and the solutions to your problems will be staring you in the face – quite literally. Each chapter has also been carefully illustrated to show you the kind of results that are possible if you follow the advice provided.

Section 1 deals logically with the subject of equipment and looks at everything from choosing and using cameras and lenses, to making the most of filters and film, mastering the intricacies of electronic flash and deciding which accessories you need to complete your system.

Section 2 then takes a look at the techniques that are essential to successful picture-taking. Depth-of-field, exposure, composition, understanding colour and mastering light are explored in detail to give you a thorough grounding in the fundamentals of photography, along with how to process and print your first pictures.

Finally, Section 3 takes all this information and applies it to a wide range of the very subjects you're likely to photograph: portraits, kids, holiday and travel, candids, landscapes, sport and action, night and low-light shots, nature, close-ups, and buildings. For those of you in need of more creative gratification, a whole chapter has also been devoted to special-effects photography.

I hope you enjoy reading it, and in doing so gain as much enjoyment as I have from the fascinating art of photography.

6

EQUIPMENT ANSWERS

CAMERA ANSWERS

With such a vast range of models available, choosing a camera can be a difficult job for novice photographers. You don't know what kind of features you are going to need, or what subjects you are likely to photograph in the future, and the hype offered by manufacturers only compounds the problem. Fortunately, camera design has reached such heights of perfection that any model from any of the major manufacturers will produce top-quality results, whether it's a point-and-shoot compact or a feature-packed SLR. The model you choose will therefore be governed mainly by cost, personal preference, and how serious your interest is.

The thing to remember while making

cameras, no matter how sophisticated, are designed to

perform the same task.

They're essentially just a light-tight box containing a shutter that will allow a controlled amount of light to fall on a piece of film placed behind it.

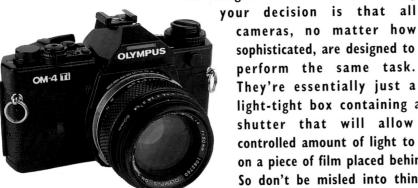

35mm SLRs can be split into two basic categories: the simple, traditional design of manual focus models like the Olympus OM4Ti (above), or more curvaceous autofocus cameras such as the Minolta Dynax 7Xi (right).

Which type of camera would you recommend for a budding amateur photographer?

The answer is simple – a 35mm SLR (Single Lens Reflex). This is by far the most widely used type of. camera, for several reasons.

First, it offers the ideal compromise between ease of use, control, and image quality. If you're new to photography, you can rely on the camera to produce successful results, but once your experience grows it will allow you to take control."

Second, 35mm SLRs can be fitted with a vast range of lenses, flashguns, close-up equipment and filters that allow you to photograph every subject imaginable.

Third, when you peer through the viewfinder of an SLR you see almost exactly what's going to appear on the final picture, as shown on the right.

THE SLR VIEWING SYSTEM pentaprism viewfinder focusing screen film

light path reflex mirror shutter

The heart of the SLR lies in the viewing system, which uses a reflex mirror to reflect the image passing through the lens up to the viewfinder pentaprism.

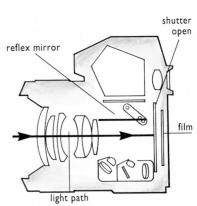

MINELTA

MINCIT

So don't be misled into thinking the latest all-singing, all-dancing model will automatically turn you into a brilliant photographer. All they do is free you from some of the decisions that have to be made

so you can dedicate more thought and time to the creative aspects of

photography. But at the end of the day, any camera is only as good

as the person using it, just like any other machine.

When you trip the camera's shutter, the mirror flips up so light entering the lens can reach the film. When the exposure ends the mirror drops back to its original position.

What features should I look for when buying an SLR?

That really depends on how much you can afford to spend and what kind of camera you're looking for. Most of the SLRs being made today

are autofocus models that use the latest in micro-chip technology and are packed with electronic functions. But it's still possible to buy traditional manual cameras that contain just the very basic features if you like to keep things simple. To give you an idea of the features you should expect to find, let's take a journey around a typical AF SLR. are a joy to work with, but a dark viewfinder will impede accurate focusing.

LCD display Used instead of conventional dials, and allows you to access the camera's many electronic functions via input dials or mode buttons. Information such as frame number, aperture and shutter speed, exposure mode, flash mode and battery condition are displayed.

Metering The metering system is the most important part of an SLR, because it determines how much control you have over the exposure set. The simplest models use just manual metering and rely on you to

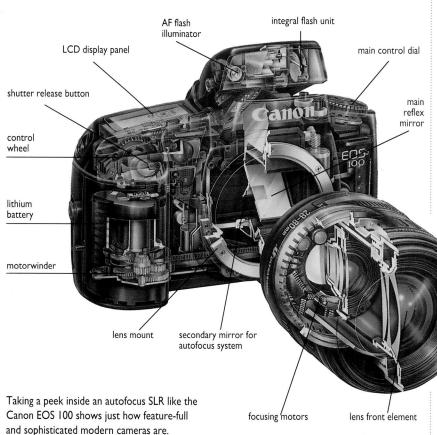

The viewfinder As well as allowing you to see what's going to appear on your pictures, the viewfinder on many models provides information such as the aperture and shutter speed set, under- or overexposure warnings, and a 'flash ready' lamp. The viewfinder on manual focus SLRs also incorporates a focusing screen to aid accurate focusing, while AF SLRs use one or more focusing targets. Bright, crisp viewfinders

set the aperture and shutter speed required, but modern SLRs use a whole host of automatic exposure modes and metering patterns. A camera with aperture priority and manual modes, plus a spot or partial metering option, is more than adequate (see Exposure Answers, page 42).

Exposure compensation Camera meters don't always give accurate results, so some

kind of facility which allows you to override the exposure set is essential. Ideally, you should be able to under- or overexpose by up to 3 stops, in third, half or full stop increments (see Exposure Answers, page 48).

Shutter speed range Most pictures are taken using shutter speeds from 1 to 1/1,000sec, but a typical range on a modern SLR is 30 to 1/2,000sec. Some models offer faster speeds, but longer shutter speeds are far more useful because they allow you to take pictures at night with your camera on automatic. Make sure the shutter also has a 'Bulb' setting, so you can hold the shutter open indefinitely (see Night and Low-light Answers, page 104).

Depth-of-field preview This feature stops the lens iris down to the aperture it is set to, so you can assess depth-of-field. Although by no means essential, it will prove very useful and is well worth having.

Film speed range Modern SLRs set the film speed automatically using DX-coding. A film speed range of ISO25 to 3200 should cater for all your needs, but ideally a manual film speed option should also be provided (see Film Answers, page 26).

Integral flash Many autofocus SLRs have a small flash unit built into the pentaprism. It's handy for taking snapshots, or for fill-in flash outdoors, but the power output is quite low so the working range is limited.

Built-in motorwinder Not essential, but handy as it ensures the camera is always ready for use and you never miss a shot. An advance rate of 2 frames per second is the average speed.

Lens mount Each brand of camera, bar few exceptions, has its own unique bayonet mount to accept interchangeable lenses. This means that if you buy a Canon SLR, for example, only Canon lenses or independent lenses with the Canon mount can be fitted.

Other features to consider include: a cable release socket in the shutter release, a flash sync socket so you can use offcamera or studio flash, a self-timer, and a multiple-exposure facility.

Which type of camera would you recommend for a complete beginner?

A

If your main interest is taking snapshots at parties, get-togethers and holidays, then a 35mm compact camera will suit you perfectly.

The main advantage of compact cameras is they're so easy to use. Everything is there for you in one neau package, so all you have to do is switch on, point, and shoot. Being small and light they can also be carried in a pocket or handbag, so you never miss a chance to grab a great picture.

The simplest models have a fixed lens - usually a slightly wide 35mm, fixed focusing, automatic exposure and a simple integral flashgun that has to be switched on in low light. They're handy for general snapshots, but image quality isn't that high and they don't offer any control.

If you like the idea of a truly compact compact, but want a camera that has more features, then you could go for a more expensive fixed-lens model. All the major camera manufacturers produce pocketable compacts that incorporate a more advanced design to give perfectly exposed results in all lighting conditions, a better flash, and improved image quality.

Moving up the size and price scale we arrive at dual-lens, or twin-lens, compacts. As the name suggests, these cameras offer the choice of two focal lengths – usually

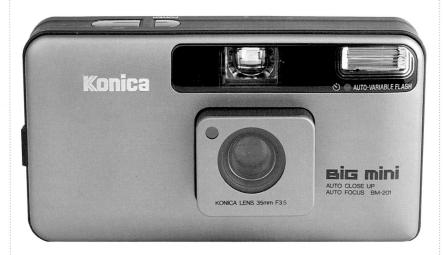

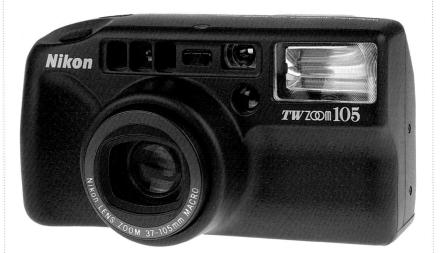

The Konica Big Mini (top) is one of the most popular fixed-lens compacts, and perfect for slipping into a pocket or handbag, while a zoom model such as the Nikon TW Zoom 105 (bottom) offers all the features you need to photograph a wide range of subjects.

35mm and 50mm – so your options are increased. Again, the amount you pay will determine how sophisticated the model is, so it's worth inspecting a variety before making a decision.

Finally, if you want optimum versatility and don't mind paying the extra, nothing beats a zoom compact. The optical freedom offered by a continuous zoom lens means you can tackle a much broader range of subjects, and compose your pictures with greater precision. The focal length varies from model to model, with the smallest covering a range from 35 to 60mm or 35 to 70mm and the largest covering 38 to 115mm. As this range increases, so does the size of the camera and the price tag.

Zoom compacts also tend to be packed with other features, such as a sophisticated flash offering fill-in, slow sync and night modes, a wider shutter speed range, exposure compensation, and sometimes even a multiple exposure mode, so you can produce top-quality results with ease.

The main drawback with compacts is that you're limited to a fixed lens, and even the best models offer little control over the exposure set, so once your interest in photography grows you may find them rather restricting.

•••••

Why are some SLRs tagged 'professional' models?

Certain SLRs, such as the Nikon F4, Canon EOS 1, Olympus OM4Ti and Pentax LX, earn this distinction because they're built to endure

rigorous daily use by professional photographers, who tend to treat their equipment more like tools of the trade than expensive jewellery.

Pro-spec SLRs are built from tougher materials so they can withstand regular knocks and, heaven forbid, drops. Their bodies also tend to be better sealed, so they'll continue to function in wet weather, there's usually some provision for manual operation should the batteries fail, and they boast a wider range of features than 'amateur' SLRs.

You have to pay more for this, but for professionals it's money well spent because their reputation and livelihood are dependent on their ability to come up with the goods no matter what.

TYPES OF SHUTTER

There are two very different types of shutter being used in cameras today. The most popular is the focal plane shutter, which you'll find in all SLRs and some medium-format models, while compacts, most medium-format and all large-format cameras use a leaf shutter. Both types use the same system of shutter speeds, but they work in totally different ways.

Focal plane shutters (below) are fitted inside the camera body and comprise

two curtains or blades which move horizontally or vertically in front of the film to allow light to reach it. When you trip the camera's shutter release, the first curtain moves across the shutter gate so light can pass through, then soon after the second curtain follows to close the shutter gate. At slow shutter speeds these two actions are distinct, but when using fast shutter speeds they both move almost instantaneously to create a narrow slit passing very quickly in front of the film.

Q

My camera has so many functions I never know which to use. What do you suggest?

This can be a problem for novice photographers. The modern SLR camera is packed with so many different functions that you're literpoilt for choice, and until you know

ally spoilt for choice, and until you know what each one is capable of, deciding which to use when can cause great confusion.

In the beginning you'll find working in program or full auto mode the easiest option. The camera will sort out the exposure for you, if there's an integral flash it will cut in automatically, and all you have to do is look for interesting subjects.

As your experience grows you can then move away from program mode and make use of features which give you more control. You'll begin to experiment with the other exposure modes and alternative metering patterns, make use of the exposure compensation facility and depth-offield preview, exploit the full range of shutter speeds, and so on. But just because the features are there, don't feel under pressure to use them, and if you find a system of working which suits you perfectly then stick to it. By sticking to one method whenever possible, you not only get to know how your camera will perform in different situations, but you'll be able to work quickly and instinctively so you never miss a chance to take a great picture.

What are the pros and cons of autofocusing, and how do different AF modes operate?

The first SLR to appear using a successful autofocus system was the Minolta 7000, back in 1985.

Since then, manufacturers have invested many millions of pounds refining the methods used to produce a system that's fast, accurate, and completely foolproof. They're not quite there yet, but the latest autofocus SLRs from Canon, Nikon and Minolta aren't far off. The advantage of the focal plane shutter is it makes faster shutter speeds possible – the fastest currently available is 1/12,000sec on the Minolta 9xi. The disadvantage is electronic flash has to be used at a relatively slow shutter speed for synchronization to occur (see Flash Answers, page 31).

Leaf shutters (above) are found in the lens rather than the camera body, and close down centrally, like the blades in the lens iris which control the aperture size.

This design prevents such fast shutter speeds being used – the highest is usually 1/500sec. However, electronic flash can be synchronized at any shutter speed, so it's ideal for fill-in flash in bright sunlight, for example.

The main advantage of autofocusing is it gives you one less factor to think about, so you can respond to photo opportunities far more quickly. This isn't so important for static subjects such as landscapes and architecture, but for sport, action and candid photography, where pictures are often spoiled by inaccurate focusing, it can be a real boon when used correctly.

Autofocusing works using sensors in the camera body which detect subject contrast (see page 12). Motors in the body or lens then adjust the focusing distance accordingly. To achieve sharp focus the focusing 'envelope' in your camera's viewfinder must be centred on your main subject.

Most AF SLRs use two different focusing modes. For general use with static subjects there's 'one-shot' AF, which prevents the shutter from firing until the lens has focused. Usually the focus can also be locked by half-depressing the shutter release and holding it. This allows you to place your main subject away from the centre of the frame.

For moving subjects; 'servo' AF is used.

EQUIPMENT CAMERA ANSWERS

This works by continually adjusting focus so your subject remains sharp as it moves closer to or further away from the camera, which will allow you to capture exciting sequences of pictures.

A variation of this found in some SLRs is 'predictive' AF, which estimates where the subject will be at the exact moment of exposure, and adjusts the focus even as you trip the shutter to ensure a sharp result.

Autofocusing isn't totally foolproof, of course. If something crosses your path the lens is likely to hunt around. Many systems also have difficulty focusing on areas of low contrast or continuous tone, such as blue sky, green grass, misty scenes, white objects or plain walls, or in really low light. But in tricky situations you can always switch back to manual focusing to prevent problems – most AF lenses have a manual focusing ring of some description.

Another good reason for buying an autofocus SLR is they tend to include many other useful features that are lacking on traditional cameras, such as a wider shutter speed range, more exposure modes, and better metering systems.

Is there a correct way to hold a camera?

The way you hold your camera should be given careful consideration because it can make all the difference between pin-sharp pictures and pictures ruined by camera

shake. If you adopt a strong, stable stance you'll be able to use relatively slow shutter speeds and still produce perfect results, but a sloppy, unstable stance will cause no end of problems.

Here are a few suggestions to make sure that doesn't happen.

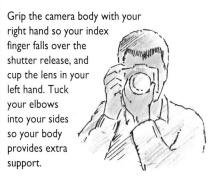

HOW AUTOFOCUSING WORKS

Modern AF SLRs use a system known as 'phase detection' to ensure accurate focusing. Here's how it works:

Twin separator lenses inside the camera body project dual images of the scene you're photographing on to two rows of Charged Couple Devices (CCDs) which emit an electrical signal based on the amount of light hitting them. A microprocessor in the camera then compares these signals to a reference signal built into its memory, and when the signals match, sharp focus has been achieved.

If the lens has focused in front of your subject, the signals emitted by the

CCD are closer together than the reference signal, while if the lens focuses behind your subject the signals are further apart. In either case the space between the signals is analysed and focusing motors in the lens adjust the focusing accordingly until those signals are 'in phase'. Clever stuff!

When using long lenses a kneeling stance tends

to provide better stability. Place your right knee

on the ground, and use your left leg to support

Alternatively, sit on the ground cross-legged

and rest both elbows on your legs so both the

your left arm which is holding the lens.

camera and lens are well supported.

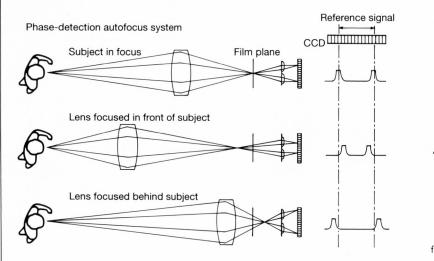

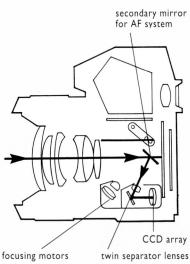

legs slightly apart and your back straight so your body is in effect acting like a tripod. Leaning forwards or backwards reduces stability and should be avoided.

Stand with your

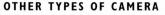

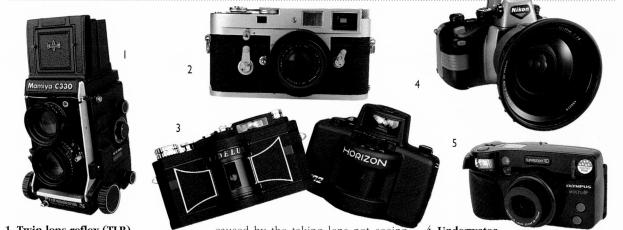

1 Twin-lens reflex (TLR)

The TLR is an old-fashioned type of medium-format camera which uses two lenses – one for viewing the subject and the other for taking the picture. Most models are fitted with a fixed 80mm standard lens and produce 6x6cm images on rollfilm.

Parallax error can again be a problem at close-focusing distances, and using graduated or polarizing filters is tricky because you can't see the effect obtained. Despite this, some fashion and portrait photographers still use them. Secondhand models can also be picked up cheaply, so they offer a budget introduction to medium-format photography.

2 Rangefinder

Rangefinder, or non-reflex, cameras use separate viewing and taking systems like compacts. This can lead to parallax error caused by the taking lens not seeing exactly the same thing as the viewfinder, but most models are corrected for parallax.

Rangefinder cameras are smaller and lighter than SLRs. With no reflex mirror to flip up when you trip the shutter they're also much quieter, and the viewfinder doesn't black out during the exposure. These factors make them a favourite among photojournalists.

3 Panoramic

Many compacts now offer the option of the elongated panoramic, while for professionals there are more expensive models such as the 35mm Widelux and Horizon shown, or cameras from Linhof and Fuji which produce originals on rollfilm measuring 6x17cm!

The panoramic format is ideal for scenic photography, fun snapshots or unusual portraits.

4 Underwater

The most popular underwater camera for many years was the Nikonos, but Nikon have recently launched the world's first underwater autofocus SLR – the RS AF (shown) – which uses a range of interchangeable lenses. There are also many underwater compacts available for both fun or serious use, at quite reasonable prices, plus a number of waterproof housings for conventional 35mm SLRs and compacts.

5 Weatherproof

If you don't require full waterproofing, but would like to take your camera on the ski slopes, on the beach, or out in foul weather, there are many weatherproof compacts to choose from. Essentially they're just like normal 35mm compacts, with a sealed body to give protection against the elements.

What's the advantage of using a medium- or large-format camera?

The main reason for using medium- or large-format cameras instead of 35mm is they give far

superior image quality due to the longer film size. A medium-format camera such as the Pentax 67 or Mamiya RZ67, for example, produces negatives or transparencies which measure 6x7cm – that's almost five times the size of a 35mm original. As a result, they can be enlarged to much larger sizes before sharpness becomes unacceptable, and when reproduced in books, magazines, calendars and posters they look superb. There are other reasons too. Most medium- and large-format cameras use leaf shutters in the lens, rather than a focal plane shutter like a 35mm SLR, so electronic flash can be synchronized at any shutter speed (see panel on page 11).

The majority of medium-format cameras also have interchangeable backs, so you can switch to different film types and formats – including Polaroid instant film – mid-roll. Large-format cameras also allow you to adjust the position of the lens in relation to the film plane to control perspective and depth-of-field and prevent converging verticals when photographing buildings (see Architecture Answers, page 114). This ability is known as 'camera movements'.

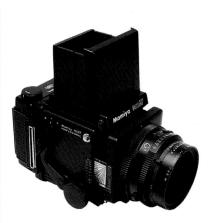

The Mamiya RZ67 is a popular medium-format camera among professionals.

LENS ANSWERS

Lenses hold the key to a whole world of photographic creativity. Your camera may be capable of amazing things, but it's the lenses you fit to it that determine, more than anything, what appears on the final picture.

You can use wide-angle lenses to capture sweeping views, and telephotos to isolate eye-catching details or fill the frame with distant subjects. Zooms give you the option to capture near and far subjects at the flick of your wrist, while macro lenses allow you to create stunning close-up images.

Whatever your needs, you can guarantee there's a lens of some description that will satisfy them. The characteristics of different lens types can also be put to good use, helping you turn an ordinary picture into a true work of art.

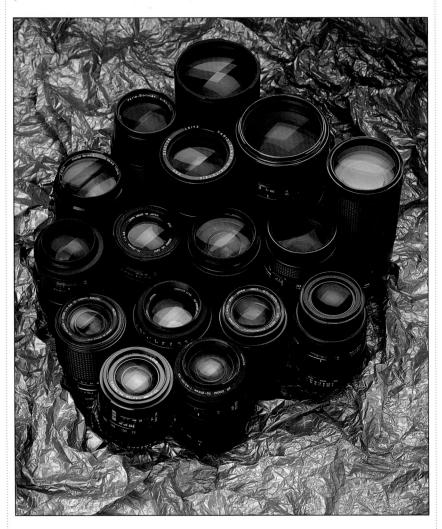

Lenses are the most powerful tool in your photographic armoury, making it possible to photograph any subject imaginable.

Could you explain how lenses are made and how they work?

Lens technology has come a long way in recent years, and modern optics are now painstakingly designed by computers to give optimum image quality for minimum cost.

If you take a slice through a typical lens you'll see that it comprises a series of glass elements arranged in groups of two or more. This optical configuration varies from lens to lens, but its basic purpose is to correct the optical aberrations that are caused when light rays are passed from one lens to the next, so sharp pictures with accurate colours and acceptable contrast are produced. It also determines the focal length of the lens.

Lens quality still varies considerably, but even the most inexpensive lenses are capable of producing excellent results due to improvements in design and higher standards of materials.

This cross-section shows the main components found in a typical lens.

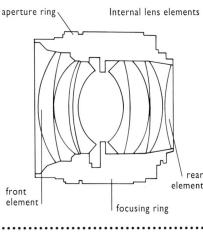

I'm a little confused about the terms 'focal length' and 'angleof-view'. What do they mean exactly?

Both terms are commonly used when discussing lenses, so it's important you understand them.

Technically, focal length is the distance between the centre of the lens

APERTURES

As we'll discuss in more detail in Exposure Answers (page 42), all lenses have a variable aperture so you can control the amount of light reaching the film to ensure correct exposure.

The aperture scale is represented by a series of standard f/numbers, as shown below.

The largest aperture is f/1, and as you move up the scale each subsequent f/number is half the size of its neighbour and admits exactly half as much light.

If you look at the f/number scale on your lenses you'll see that the range offered varies. Most standard 50mm lenses have a maximum aperture of f/1.4 or f/2 and go down to f/16, for

example, whereas on a 70–210mm telezoom the maximum aperture may be f/5.6, and the minimum aperture f/22.

The maximum aperture is particularly important because it determines the lens 'speed'. Lenses with a wide maximum aperture such as f/2.8 or wider are said to be 'fast' because they allow faster shutter speeds to be used.

Finally, all f/numbers are identical from lens to lens. An aperture of f/8 on a 28mm lens is exactly the same as f/8 on 50mm lens, 600mm lens or 80–200mm zoom, for example, and therefore allows the same amount of light to the film. Most lenses give the sharpest results when set to an aperture of f/8 or f/11.

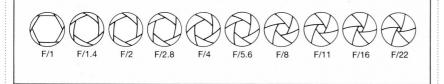

and the point at which the light rays passing through it focus; but more normally it's used simply as a means of expressing the magnification of a lens.

There are basically three focal length groups: standard, wide-angle, and telephoto. The standard focal length for any given film format is equal to the diagonal measurement across one frame of that film: 50mm for 35mm film, 80mm for 6x6cm, 150mm for 5x4inch and so on. Any lens with a focal length smaller than the standard is known as 'wide-angle', and any lens with a focal length bigger than the standard is known as 'telephoto'.

Angle-of-view is a measurement of how much a lens 'sees', and can be directly related to focal length. A wideangle lens has a greater angle-of-view than a standard lens, for example, while a telephoto lens has a smaller angle-of-view than a standard.

This illustration shows the angle-of-view of lenses with focal lengths from ultra wide-angle through to long telephoto. As you can see, the bigger the focal length, the narrower the angleof-view. This allows you to be selective about what is included in your pictures.

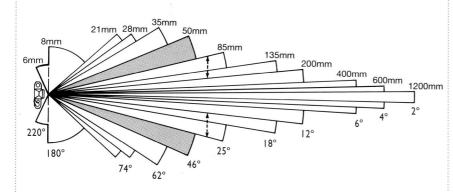

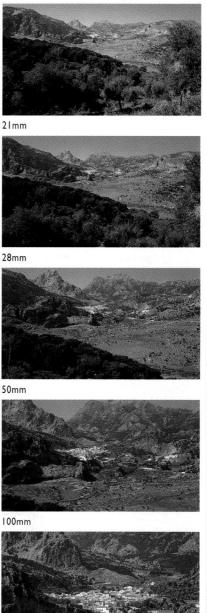

200mm

400mm

Here you can see how lenses with different focal lengths affect how much you can include in a shot. All the pictures were captured from exactly the same position.

EQUIPMENT: LENS ANSWERS

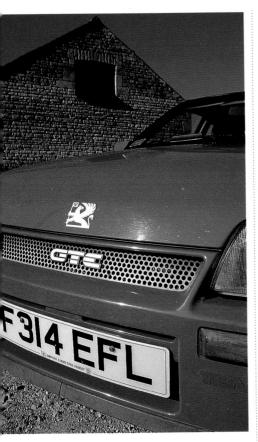

Here the photographer used a 21mm ultra wide-angle lens to create this dramatic composition. Notice how the shape of the car has been stretched and distorted due to its close proximity to the camera.

How can I get the best results from my wide-angle lens?

The most obvious thing you'll notice when you fit a wide-angle lens to your camera is it gives you the opportunity to capture much more than can be seen with the naked eye. As a result, they're ideal for landscape, architecture and general scenic photography, where large areas have to be crammed into the frame, or if you're working in confined space.

Wide-angle lenses also offer other benefits. Firstly, they stretch perspective so the elements in a scene appear further apart, and tend to distort objects that are near to the edges of the picture area. This allows you to emphasize features by moving in close so they dominate the frame, or exaggerate lines and foreground

interest to produce powerful compositions when shooting landscapes.

Secondly, wide-angle lenses give extensive depth-of-field (the area of acceptable focus) at small apertures such as f/11 or f/16, so you can keep everything in sharp focus, from the immediate foreground to the distant background.

Most photographers prefer a 28mm or 24mm wide for general use as either lens offers all the benefits mentioned without being tricky to use. You still need to take care though, as it's easy to end up with windy, boring compositions. Once your experience grows you'll also find the extra distortion and exaggeration of ultra wides, from 17–21mm, ideal for producing strong images when used creatively.

Standard lenses don't seem very popular these days. Are they still worth using?

Since zoom lenses have become so common the poor old standard 50mm lens has fallen out of fashion. However, it's a very useful lens and shouldn't be ignored.

The optical quality is first rate, so you can produce pin-sharp results, and its angle-of-view is similar to the human eye so it's ideal for still life, landscapes and a whole host of other subjects.

Standard lenses also have a generously wide maximum aperture – usually f/1.8 or f/2, although f/1.4 and even f/1.2 models are available. Combine this with its small

size and light weight and you have the perfect lens for taking handheld pictures in low light.

telephoto lenses?

Telephoto lenses basically do the

How can I make the most of my

opposite of wide-angles. Instead of including more in a shot they magnify your subject and include

less. Instead of stretching perspective they compress it, so everything appears much closer together. And instead of giving extensive depth-of-field, they reduce it considerably even at small apertures so backgrounds are thrown well out of focus and your main subject stands out. These characteristics become more evident as the focal length increases.

The most useful telephotos fall in the 85–300mm range. Lenses with a focal length from 85–105mm are often referred to as 'portrait' lenses due to the way they flatter our facial features. Slightly longer telephotos of 135–300mm are better suited to candid photography, or isolating small landscape and architectural details. The 300mm lens is also a favourite among sport, action, press and nature photographers.

Telephoto lenses allow you to magnify interesting details in a scene and make them the main feature of your picture. Here a 200mm midtelephoto lens was used.

Once you go beyond 300mm, the lenses begin to get much bigger, heavier and more expensive. This not only makes a tripod or monopod necessary to prevent camera shake, but the rather small maximum aperture tends to limit your use of fast shutter speeds in all but the brightest conditions, unless you load up with faster film or buy expensive faster lenses.

Long telephotos also need to be used with more care. Depth-of-field is severely restricted, especially at wide apertures, so accurate focusing is critical if your main subject is to be sharply recorded.

Saying that, if you're seriously interested in sport or nature photography, you'll soon discover that a 400mm, 500mm or even 600mm lens is necessary to take frame-filling pictures of distant subjects.

Most independent lens manufacturers produce long telephoto at a reasonable price.

What's a mirror lens?

It's a specially designed compact telephoto which uses mirrors to fold the light back on itself. This allows a focal length of 500mm or

600mm to be achieved in a body that's only a fraction of the length and weight of a traditional telephoto lens.

Mirror lenses are handy if you need to travel light, and they're small enough to handhold. The main drawback is they have a fixed aperture – usually f/8 – which limits your use of fast shutter speeds.

This picture was taken with a 500mm mirror lens. The doughnut-shaped rings in the background are characteristic of such lenses, and often can't be avoided.

LENSES AND PERSPECTIVE

The angle-of-view of a lens not only determines how much it sees, but the way in which perspective can be recorded as well.

If you capture the same scene from exactly the same position with a 28mm wide-angle lens, and then a 300mm telephoto, perspective will be exactly the same. This can be proven by enlarging a small section from the wide-angle shot that covers the same area as the telephoto shot. However, by changing camera position, perspective can be altered completely to give different results.

If you photograph a queue of people with a 28mm wide-angle lens, for example, the apparent distance between each person will be exaggerated. This is because wide-angle lenses stretch perspective. Now do the same with a 300mm lens, keeping the person at the front of the queue the same size in the frame, and the people appear much closer together than they are in reality. This is due to the way telephoto lenses compress perspective to give a 'stacking up' effect.

When used creatively, these characteristics can produce stunning results.

This set of pictures shows how different lenses are able to alter perspective when one element in a scene is kept the same size in the frame.

28mm lens

50mm lens

200mm lens

Are zoom lenses better than fixed focal length lenses?

To decide that, you need to weigh up their relative pros and cons. For most photographers, zooms are a firm favourite because as well as

reducing the number of lenses that need to be carried – a couple of zooms can replace a whole bagful of fixed (prime) lenses – they allow you to adjust focal length precisely so your pictures are perfectly composed. You can shoot at 140mm, 185mm, and other obscure focal lengths that just aren't available on fixed lenses.

There are drawbacks to zooms though. For starters, the maximum aperture is usually a stop or two slower than on prime lenses in the same focal length range. This means in identical conditions you'd be forced to use slower shutter speeds or faster film with a zoom. The smaller aperture also gives a darker viewfinder image, which can make focusing trickier in low light. Fast zooms are available, but they're very expensive.

Secondly, zooms tend to be heavier than their prime counterparts. Usually this isn't a problem, but it does mean that you need to use faster shutter speeds when handholding, to avoid camera shake.

Finally, the optical quality of zooms still isn't quite as high as that of prime lenses, so if you need to produce the sharpest possible pictures you may find prime lenses a better option.

......

I'd like to take some 'zoomed' pictures. What's the easiest way to do this?

Any type of zoom covering any focal length range can be used for this popular technique, and the effect is created simply by zooming

the lens through its focal length range during a longish exposure, so your subject records as an explosion of colourful streaks.

For the best results choose a simple, bold subject so it will stand out in the final image. People, buildings, trees, flowers and statues are all ideal. You should also use a shutter speed of 1/8sec or slower, so you've got enough time to zoom through the full range before the shutter closes at

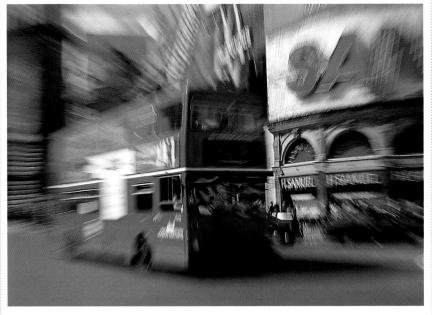

For this shot, taken in London's Piccadilly Circus, the photographer used a 35–70mm zoom and an exposure of 1/8sec at f/16.

the end of the exposure.

All you have to do then is focus on your subject with the zoom set at one extreme of its focal length range, and just as you're about to trip the shutter release, start zooming quickly and evenly through the focal length range. Continue zooming after the shutter has closed, to ensure a smooth effect (see above).

What does a shift lens do?

Shift lenses, also known as 'perspective control' lenses, are designed to correct the converging verticals caused when you have to

tilt the camera back to photograph a tall building or other structure. This is made possible by adjustable elements that can be moved up and down, so you can include the top of the building in the frame while keeping the camera perfectly square.

Shift lenses usually have a focal length of 28mm or 35mm, although there are one or two 24mm versions. Unfortunately, their high price tag tends to restrict use to professionals only (see Architecture Answers, page 114).

Q

Is it possible to buy lenses that are specially made for close-up photography?

Yes. Both independent and marque manufacturers produce a range of lenses that are designed to give optimum image quality when used

at close focusing distances. Most offer half lifesize reproduction (1:2), while some allow you to take lifesize (1:1) pictures either with or without further attachments.

The focal lengths of macro lenses can be divided into two main groups: 50/55mm and 90/100/105mm lenses. The shorter models are smaller and lighter, but the longer lenses allow you to work at greater focusing distances, so the risk of scaring timid subjects is reduced. The focal length is also ideal for portraiture.

• See Nature and Close-up Answers (page 108) for more details.

.....

What are teleconverters used for?

The teleconverter is an optical accessory which fits between your camera body and lens and increases the focal length of that lens.

The most common type is a 2x converter which doubles focal length, turning a 200mm lens into a 400mm, or a 70–210mm zoom into a 140–420mm. You can also buy 1.4x converters, which

increase focal length by 40 per cent, and 3x converters which triple focal length.

The main advantage of teleconverters is that they increase the optical scope of your existing lens collection and reduce the number of lenses you need to carry. Instead of buying a 400mm telephoto lens, for example, you could buy a 2x converter for a fraction of the cost and use it on your 200mm lens.

Unfortunately, teleconverters do have drawbacks. For a start you lose two stops of light with a 2x model, which restricts your use of fast shutter speeds, and makes the camera's viewfinder rather dark. They also reduce the optical quality of the lens they're used on, particularly zooms, so your pictures may not appear quite as sharp – particularly at the edges. To minimize this, buy a seven-element converter.

Teleconverters are ideal for subjects such as sport, action and nature photography, which require powerful telephoto lenses.

BUILDING A SYSTEM

With so many different types of lens to choose from, deciding which you'll need for your own brand of picturetaking will be a subject of much personal debate.

Until a decade or so ago it was fairly traditional to start out with a 50mm lens, then once funds allowed it, add a 28mm wide-angle and a 135mm telephoto. Today, zoom lenses have changed things considerably and it's now common practice to buy an SLR body with a 28–80mm or 35–70mm zoom then invest in a 70–210mm or 80–200mm telezoom later.

Whichever route you take, these initial investments will provide a good system for all-round use, and you'll find that lenses from 28–200mm will cover perhaps 90 per cent of your picturetaking needs. Any further additions can then be made once you begin to specialize in certain subjects.

If you're interested in sport or wildlife photography, for example, a 300mm, 400mm or 500mm lens will be invaluable for capturing distant subjects. Many photographers cover this range by purchasing a 300mm lens and a good quality 1.4x or 2x teleconverter to provide extra power when required.

For landscape, architecture and general scenic photography, wide-angle lenses from 20–35mm are more useful. So you may decide to cover that whole range with a 21–35mm zoom, or buy a couple of prime lenses such as a 21mm and 28mm, or 24mm and 35mm. The main thing to bear in mind is that the lenses you use have a major influence on the quality of your pictures, so always buy the best you can afford.

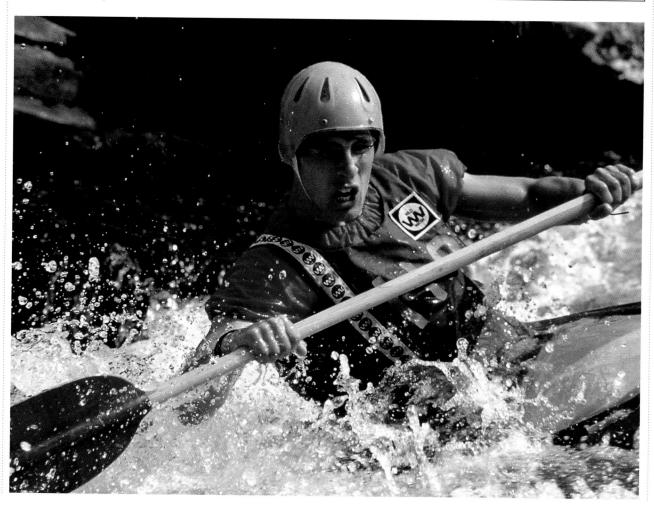

FILTER ANSWERS

Professional photographers have been using filters almost since the birth of photography itself, but it's only in the last decade or so that their popularity has really taken off among enthusiasts. Today you can choose from literally hundreds of different types, all of which allow you to manipulate the image seen through your camera's viewfinder.

From a purely technical point of view, filters are invaluable for controlling colour balance and contrast, so your pictures are as close to reality as possible. This is often necessary because what the eye sees isn't always the same as what the film in your camera records. You can also use filters intentionally to distort reality by changing the way film responds, or adding an endless range of special effects.

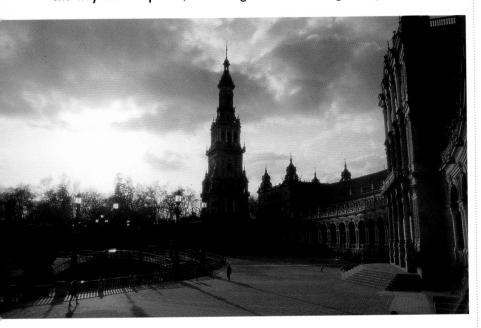

For this shot of the Plaza de España in Seville, Spain, an orange 85B colour conversion and soft-focus filters were used together to add colour and atmosphere to what would otherwise have been a rather dull, lifeless scene.

I'm about to start building up a filter collection, but can't decide which system to invest in. What do you recommend?

There are two basic types of filter available: either the round type that screws directly to the front of your lens, or the square variety that

slots into a special holder.

In terms of flexibility, the square systems are a far better choice. All you need is one holder and a selection

of adaptor rings to use the filters on lenses with different screw thread sizes. You can also use three or four filters in the holder at once to combine effects. Round filters are designed to fit lenses with a specific filter thread, and come in all standard sizes. They're fine if all your lenses have the same thread, but most don't, especially if your system contains both wide-angles and telephotos.

smaller lenses you'll need step-up or step- you to use the same filters on all your lenses.

down rings, which are fiddly and slow to use. The depth of the filter mount itself also means if you use two or more together there's a risk of vignetting (see Problem-solving Answers, page 74).

Square filters come in different sizes. Does it matter which type I buy?

Yes. The smaller square filters, measuring 64mm, are fine for use with 35mm SLR lenses as wide as 28mm. However, for wider lenses

you'll need to use a larger system of 84mm or 100mm filters, otherwise the lens will 'see' the edges of the filter holder and cause vignetting. A larger filter system will also be required if you use long telephoto lenses or medium-format lenses, simply because they have huge filter threads.

I've just bought a polarizing filter but don't really know how to use it. Could you explain what it does, and when it should be used?

When light rays strike a surface, some of them are scattered in all directions and become polarized. This creates glare and specular

reflections which weaken the colours in a scene.

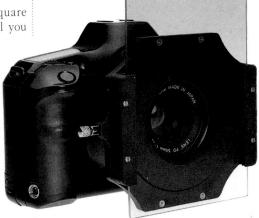

To use round filters on larger or Square systems offer total flexibility by allowing

FILTERS AND EXPOSURE

Many filters reduce the amount of light entering your lens, so you may need to compensate the exposure when using them to prevent your pictures coming out too dark. Each filter is given a 'filter factor' which indicates by how many times the initial exposure needs to be multiplied to make up for this loss. A factor of x2 indicates an exposure increase of one stop, x4 two stops, x8 three stops and so on. The filter factor is usually printed on the filter mount or box.

If your camera has TTL (through-thelens) metering and you meter with the filter in place, any light loss will be taken into account automatically, so you needn't worry about it. However, if you meter without the filter in place, or

Polarizing filters work by preventing that polarized light from entering your lens, and in doing so they provide several benefits. Blue sky contains a lot of polarized light, so if you photograph it through a polarizer its blue colour will be deepened considerably. Polarizers also reduce glare on non-metallic surfaces such as foliage and paintwork, so colours look far richer, and they eliminate surface reflections in water and glass, so you can see into rivers and through windows.

For the best results, use your polarizer in bright, sunny weather. The effect can be gauged simply by rotating it in the mount or holder while peering through your camera's viewfinder. When you're happy with what you see, stop rotating and fire away.

use a handheld meter, you must increase the exposure accordingly based on the filter factor. The table shows the filter factors for some common filters.

Filter	Filter factor	Exposure increase
Polarizer	x2 to x4	I to 2 stops
81A warm-up	x1%	⅓ stop
Blue 80A	x4	2 stops
Orange 85B	x3	1 ³ / ₃ stops
Yellow	x2	l stop
Orange	x4	2 stops
Red	×8	3 stops
Skylight	xl	none
Diffuser	хI	none

When shooting blue sky, keep the sun at right-angles to the camera so you're aiming at the area of sky where polarization is maximized. Take care when using wide-angle lenses though - polarization is uneven across the sky, so you can easily end up with a darker band on one side of your picture.

Similarly, when eliminating reflections, you'll get the best results if your lens is at an angle of about 30° to the surface being photographed. You can find this by adjusting your camera position slightly and checking the effect.

A polarizer can also be used to enhance attractive reflections in water. If you rotate it slowly the annoying surface reflections and glare will be removed to reveal the true reflections.

Which type of polarizer should I buy: circular or linear?

If your camera has a beam splitter or semi-silvered mirror you'll need a circular polarizer, otherwise exposure error will result due to

polarized light being created inside the camera. This group includes all autofocus SLRs, plus the Olympus OM2SP, OM3 and OM4Ti, the Canon T90 and all Leica Rseries SLRs.

Polarizing filters come into their own for deepening blue sky and saturating colours to produce vibrant images.

These pictures show how, when used correctly, a polarizing filter can noticeably reduce glare and reflections on glass and other shiny surfaces.

With polarizer

Without filter

Grey graduated filters are invaluable for toning down the sky when shooting landscapes. For this shot a one-stop grad was used carefully so that its effect is impossible to detect.

> I've heard that graduated filters are used by many landscape photographers. What exactly do they do?

If you take a meter reading from the ground and the sky when shooting landscapes, you'll find there's a big difference between

the two - often three or four stops if you're shooting into the sun. This means that if you set an exposure that's correct for the sky, the landscape itself will come out too dark, but if you correctly expose the landscape the sky will come out too light and lose most of its colour.

The easiest way to avoid this is by using graduated filters, which are clear on the bottom half and coloured across the top half. By positioning the filter in its holder you can darken down the sky so its brightness is similar to the landscape and both areas come out correctly exposed when you meter for the landscape.

There are two types of graduated filter available: coloured and neutral density (grey). Coloured grads such as pink, tobacco, blue and mauve can add life to a dull, grey sky, and the warmer colours are ideal for enhancing the sky at sunrise and sunset. The effect they give can easily look false though, so they must be used carefully. Grey grads are designed to darken down the sky without changing its colour, so they're preferred by photographers who want to create natural results.

When using a graduated filter be sure to align it carefully so you don't darken part of the foreground as well. Pressing your camera's depth-of-field preview while adjusting the filter will help you to determine its position.

As the filter is only affecting part of the picture you don't need to adjust the exposure, so take a meter reading without the grad in place and use the settings obtained for the final shot with the filter. If you take a meter reading with the filter on the lens, overexposure will result due to the dark band fooling your camera.

Finally, whenever possible you should use a mid-range aperture, such as f/8, so the line where the graduation ends isn't obvious in your pictures.

I've been told it's a good idea to keep a clear filter fitted to my lenses so the front element is protected. Which type should I use?

You can use either a skylight or ultraviolet filter to protect your lenses. The UV filter is designed mainly to cut through atmospheric

haze and to reduce the slight blue cast in the light at high altitudes. The skylight filter does the same, but also warms up the light a little as well.

How can I remove a screw-on filter that's jammed onto my lens?

This is a common problem with round screw-in filters, and can cause great frustration. The key is to apply even pressure around the filter mount, so it doesn't buckle.

Your local camera dealer may stock a purpose-made filter wrench. Failing that, wrap a length of electrical flex around the filter mount, twist the ends together, then jerk the flex to loosen the filter's grip.

FILTERS FOR SPECIAL EFFECTS

Filters are mainly used to control contrast and lighting balance, but there's also a range available that allow you to create eye-catching special effects.

The starburst, or cross-screen, is probably the most common. This is simply a clear filter with fine lines etched into the surface which turns bright points of light into twinkling stars – you can choose from two-, four-, six-, eight- and sixteen-point stars.

Starbursts are ideal for transforming night-time scenes, or making the highlights on water shimmer. They can also be combined with coloured filters for more eye-catching results.

Taking the starburst idea one step further are diffraction filters, which break up bright points of light into the colours of the spectrum to create brilliant-coloured highlights. A variety of effects are possible, and they can look stunning on silhouettes or night pictures. Multiple-image filters work by surrounding your subject with anything from three to twenty-five repeated images of itself, depending upon the number of facets on the filter.

For the best results keep just one distinct subject in the frame, such as a person, building or statue. If there are too many details in the shot you'll end up with a confusing mess. You should also use lenses from about 50–135mm, and stick to an aperture of f/5.6 or f/8 so the division between each image isn't too well defined and they merge together.

Multiple-image filters work well on a wide range of subjects, from portraits to buildings.

Here a filter with five facets was used.

Starburst filters are perfect for use on nighttime scenes, turning every point of light into a twinkling star.

EQUIPMENT: FILTER ANSWERS

The natural light in this autumnal scene was enhanced using an 81B warm-up – one filter that no photographer should be without.

> My pictures sometimes come out with a very warm or cold colour cast, and some shots I took in tungsten lighting looked

very yellow. Which filters do I need to use to produce natural results in these situations?

There are two main groups of filters that are designed to balance colour deficiencies in the light, be it natural or artificial. They're

known as 'colour-correction' and 'colourconversion' filters, and the type you need depends upon the strength of colour cast produced.

Colour-correction filters comprise the 81-series of straw-coloured 'warm-ups' (81A, B, C, D and EF) and the 82-series of pale blue 'cool' filters (82A, B and C). With warm-ups the 81A is the weakest and 81EF the strongest. The 82-series work the opposite way, with the 82A being the strongest and 82C the weakest.

Warm-up filters are ideal for balancing the blue bias found in the light in dull, cloudy weather, in the shade or in really bright sunlight. They can also be used to enhance warm sunlight early or late in the day, and to make skin tones more attractive. An 81A or 81B is best for general use, while the others are reserved for stronger colour casts.

The 82-series of pale blue filters cool down the light. At sunset, for example, your pictures will come out noticeably warmer than the original scene. Usually this looks beautiful, but if you want more natural results an 82B or 82C filter will remove some of the excess warmth.

Colour-conversion filters again come in two colours – the blue 80-series and orange 85-series – but their colour density is much deeper so they're able to balance stronger colour casts.

The blue 80-series is mainly used to neutralize the yellow/orange cast created if you take pictures in tungsten light on daylight-balanced film. A blue 80A filter (the strongest) should be used with household tungsten lights or video lights, a blue 80B for tungsten photoflood studio lights and a blue 80C for tungsten photopearl studio lights. You can also use these filters

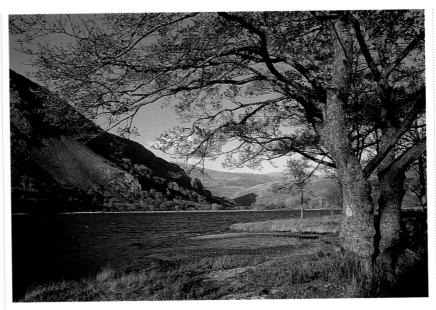

Stronger colour-conversion filters can be used to give your pictures a deep colour cast. Here a blue 80A adds an air of mystery to this Scottish loch scene.

to give pictures shot in daylight an overall blue cast.

An orange 85B filter allows you to obtain natural results if you use tungstenbalanced film in daylight, or to lose the strong blue cast if you're taking pictures in really dull weather. However, they're more commonly used creatively to add a warm glow to portraits, landscapes and sunsets. See also Lighting Answers (page 53).

Q

What are colour-compensation filters?

These are another group of colourbalancing filters that tend to be used by professionals to control any minor colour deficiencies in a

batch of slide film or a particular type of light source.

Kodak makes the most extensive series, known as Wratten filters. They're available in a variety of colours such as magenta, cyan, yellow, green, blue and red, and different strengths measured in colour correction (CC) values.

EQUIPMENT: FILTER ANSWERS

Usually a special colour-temperature meter is used to measure the colour temperature of the light and indicate which filters are required to balance the casts. A combination of the required filters are then fitted to the lens.

0

How can I get the best results from soft-focus filters?

A

Soft-focus filters are perfect for injecting a touch of atmosphere into portraits, landscapes and still

lifes. They work by bleeding the highlights (the lightest parts of the scene) into the shadows, so fine details are suppressed, colour saturation is reduced and your subject is surrounded by a delicate glow.

The effect obtained depends upon the make of the filter. Some add a lot of diffusion, while others are more subtle. There are also several variations on the diffuser theme available. Pastel filters, for example, add an overall haze which softens colours.

Whichever type you use, for the best results photograph subjects that are either backlit or against a dark background. Any lens can be used successfully, and you can control the level of diffusion by adjusting the lens aperture. Wide apertures give a strong effect, while small apertures reduce the level of diffusion.

Soft-focus filters are ideal for adding a touch of mood to portraits.

FILTERS FOR BLACK & WHITE

It may seem strange using colour filters for black & white photography, but they serve a very important purpose. The problem is that while all colours appear different to the naked eye, some record as very similar grey tones. Red and green are common examples.

To overcome this, photographers use strong-coloured filters to alter the tonal balance in a scene and to control contrast. These filters mainly work by lightening their own colour and darkening their complementary colour, but other effects are also produced.

Yellow Slightly darkens blue sky so white clouds stand out. Lightens skin tones and helps to hide skin blemishes. Ideal for general use.

Orange Noticeable darkening of blue sky in sunny weather so white clouds stand out strongly. Also helps to

reduce haze, hide freckles and increases contrast. Green Good separation of green tones makes this filter ideal for landscape and garden photography or shots of trees. It also darkens red. Red Blue sky goes almost black, clouds stand out starkly and a dramatic increase in contrast allows you to create powerful pictures. Darkens greens considerably and can be used with mono infrared film. Blue Increases the effects of haze but lightens blue sky. Also brings out details in the face and strengthens skin tones, so it's often used for portraits of men.

An orange filter produces a marked effect in sunny weather by deepening blue sky and making white clouds stand out.

.

FILM ANSWERS

Film is the very material that makes the whole photographic process possible. In the early days, photographers used glass plates crudely coated with light-sensitive materials, but in the last 150 years things have come a long way. Today the amount of technology that goes into film production is quite staggering, and the quality of results possible just doesn't compare with the materials used only two or three decades ago.

With well over 150 different types of film available today, all capable of producing excellent results, photographers are also spoilt for choice. Walk into a well-stocked photographic shop and you'll be confronted by thousands of yellow, green, blue and orange boxes, all seeming to shout out buy me, buy me!

So which one do you buy? Is Kodak film better than Fuji, Konica, Ilford or Agfa? Should you use print or slide film? Do you need slow film, or will something faster be better? Throughout this chapter you'll find answers to these questions, and many more besides...

Photographers have never had it so good, with film types to suit every conceivable subject and situation.

Which film format is best for general photography?

general photography?

That really depends upon your needs. The smaller films such as 110 and disc allow cameras to be kept very compact, but the nega-

tives or transparencies (slides) produced require great magnification to give decentsized prints. This means image quality is unacceptable for anything but snapshots.

The most popular format is 35mm, mainly because it offers a good compromise between size, cost and quality. The film is still small enough to keep the camera size down to a manageable level, but image quality is of a high enough standard to make enlargements of 16x12 or 16x20in if slow film and good-quality lenses are used. You also get up to 36 shots on a roll, and the cost per shot is very reasonable.

Where greater image quality is required, medium-format cameras are

favoured, for the simple reason that the bigger the original image is, the less it needs to be enlarged. The rollfilm used in medium-format cameras comes in two lengths – 120 or 220 – and gives a number of image sizes depending upon the camera type. The most popular are 6x4.5cm, 6x6cm and 6x7cm, while some models offer 6x8cm or 6x9cm and are

often used for scenic photography.

Finally, when nothing but the best will do, 5x4in and 10x8in sheet film is used in large-format cameras. These formats are often used by professional advertising and architectural photographers, but the material and equipment costs are generally far too high for amateur budgets to accommodate.

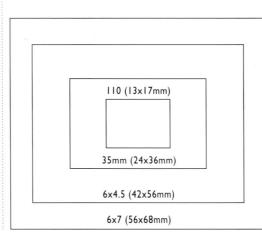

This illustration shows the actual image sizes obtained using film formats from 110 to 6x7cm.

26

EQUIPMENT: FILM ANSWERS

What does the 'speed' of a film relate to?

Film speed is a means of quantifying a film's sensitivity to light, or how much exposure it requires to produce a correctly exposed

image. The ISO (International Standards Organization) scale is used to measure film speed.

Film with a low ISO number, such as 25, 50 or 100, is said to be 'slow' because it isn't very sensitive to light. Film with a high ISO such as 400, 1000 or 1600 is considered 'fast' because it's more sensitive to light, and needs much less exposure than slow film. Every time you halve the speed of a film it needs to be exposed for twice as long, and vice versa.

.....

How do I know which speed of film to use for different subjects?

The light levels you'll be working in will partly determine which speed of film you use. Slow film is ideal in bright conditions, for

example, because there's plenty of light around to allow decent exposures, but faster film is more convenient if you want to take handheld pictures in lower light, especially when fast shutter speeds are required to freeze movement.

However, film speed is also directly related to image quality, so you need to consider this factor as well. Slow films offer fine grain, rich colour saturation and superb sharpness, but as the film speed increases quality begins to drop. Grain becomes coarser, which leads to a reduction in sharpness and resolving power, and colours become weaker.

The ideal compromise is to use the slowest film you can, so you gain maximum benefits on both counts.

Ultraslow film (ISO 25–50) is the ideal choice when you require optimum image quality for subjects like landscapes, architecture and still life.

The lack of speed means you'll need to use a tripod in all but the brightest conditions, but the superb sharpness, perfect colours and almost invisible grain allow you to make big enlargements without sacrificing too much detail.

Slow film (ISO 50–100) A good speed for all subjects, and the standard choice for most photographers. Image quality is still superb, with excellent colour saturation, sharpness and fine grain, but the extra speed means you can set decent exposures in normal conditions. You'll still need to use a tripod in low light.

Fast film (ISO 200–400) ISO 200 film is ideal for compact-camera users who have no control over exposure set, or anyone who likes to take pictures in a wide variety of lighting situations. Image quality is compromised slightly, but the convenience makes this worthwhile.

Grain is coarser and colours noticeably

weaker with ISO 400 film, but it's invaluable if you need to use fast shutter speeds in dull light, or you want to take handheld pictures indoors without flash.

Ultrafast film (ISO 1000–3200) These films are designed for taking handheld pictures outdoors in low light, or photographing indoor subjects such as sport and stage plays. Grain is unashamedly coarse, colours are rather weak, and contrast is poor, but considering the speed, image quality isn't that bad. You can also use the characteristics to add atmosphere to landscapes, portraits and still-life shots.

Which type of film is best for amateur photographers: colour print or colour slide?

If convenience is important, print film wins every time. To show family and friends your latest pictures all you have to do is pass

around a photo album, or a pile of enprints. There are also thousands of high-street labs where you can drop off your print films and pick up the results an hour or two later.

Another great benefit of print film is its tolerance to exposure error - known as exposure latitude. You can accidentally under- or overexpose a picture by at least three stops, and still obtain an acceptable result because any error can be corrected at the printing stage. Unfortunately, slide film has no more than half a stop of latitude, so you need to get the exposures spot-on. Of course, there are benefits to using slide film. For a start, image quality is superior because there's no intermediate printing stage, where problems can occur with colour balance and contrast. If you intend selling your work you will also need to shoot slide film, as few publishers and picture buyers will accept colour prints.

CARING FOR YOUR FILM

I Always try to use your film before the expiry date.

2 Keep unused film in its plastic tub. If grit gathers on the felt light trap it could scratch the whole roll of film when you use it.

3 If your film is going to remain unused for several weeks or more, store it in an airtight container inside your refrigerator. When you need to use some, allow it to warm up to room temperature for a few hours before removing it from the tub.

4 Never leave film in direct sunlight or warm places like the glove compartment of a car. High temperatures cause colour shifts that spoil your pictures.

5 Never buy film that has been stored on a shelf in direct sunlight for long periods. Professional film should always be stored in a refrigerator in the shop, not on the shelves.

6 Process exposed film as soon as possible after use.

This picture was taken on ISO 400 black & white film which had been uprated to ISO 1600 then push-processed by two stops.

My camera has something called DX-coding. What exactly does this do?

DX-coding is a relatively new innovation which allows film speed to be set by your camera automatically. This is possible because film is

now manufactured with a chequered pattern of black and silver squares on the side of the cassette - a DX-coding pattern - which indicates its ISO rating. Most modern SLRs and compacts have DXcoding pins inside the film chamber, so when you load a roll of DX-coded film the pins read the pattern and the correct film speed is set.

The advantage of DX-coding is that it prevents you from accidentally setting the wrong film speed, which would lead to incorrectly exposed pictures. Unfortunately, it can also cause problems if you want to rate the film at a different speed.

Some SLRs give you the option of setting film speed manually throughout the ISO range, as well as using DX-coding. The alternative is to buy DX-coding labels, which you can stick on non-DX-coded films so the correct film speed is set or you can alter film speed. These labels are available from large photo shops.

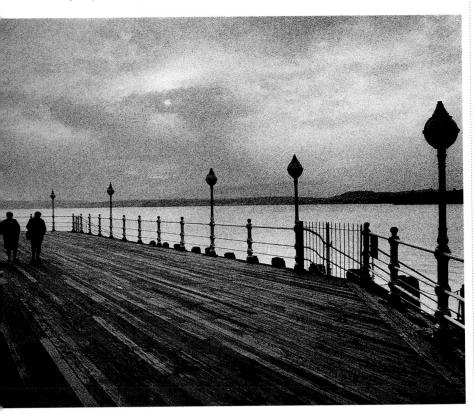

Do films differ in their characteristics from brand to brand?

The differences between colour print films aren't so obvious because much depends upon the quality of the printing. However,

slide films differ considerably in terms of colour saturation, contrast and sharpness, so the brand you choose is important.

Fujichrome Velvia slide film, for example, is known for its vivid colours and punchy contrast, whereas Agfachrome or Kodachrome slide films reproduce colours more faithfully. So Fujichrome is ideal if you want contrasty, well-saturated slides, or if you're shooting in dull weather: but for subjects such as portraiture a film with more natural rendition may be chosen instead.

Experiment with a range of films, then pick and choose specific brands for different subjects or situations.

Can film be used at a different

Yes. Occasionally you may find yourself in a situation where the film you're using isn't fast enough for you to continue taking pictures, for example.

If this happens you can improvise by rating the film you do have at a higher ISO. This is known as 'uprating'. By rating a roll of ISO 100 film at ISO 400, for example, you can use faster shutter speeds or smaller apertures.

By uprating film in this way you're effectively underexposing it, so to compensate it's then developed for longer, or 'push-processed'. If you uprate ISO 100 film to ISO 200 you need to push it by one stop; if you rate it at ISO 400 you need to push it by two stops, and so on.

The main drawback with uprating and push-processing film is that it causes an increase in image contrast and grain size. However, when used creatively this can look highly effective, as you can see from the shot left.

Colour slide film and black & white film are the easiest to uprate as most labs offer a push-processing service free of charge. However, colour negative film doesn't push very well.

EQUIPMENT: FILM ANSWERS

Do I need to use a special film when taking pictures in tungsten lighting?

You can use normal daylightbalanced film in tungsten lighting, but a blue 80A or 80B filter must be fitted to your lens to counteract

the yellow/orange cast (see Filter Answers, page 24).

The alternative is to load tungstenbalanced film instead, which is designed to record colours naturally in tungsten light without the need for filters. There are several types of tungsten slide film available, including Fujichrome 64T and Kodak Ektachrome 64T for high-quality work, and Kodak Ektachrome 160T, 320T or Scotch Chrome 640T for use in lower light.

Could you give me some advice on how to use infrared film – both colour and mono?

The main attraction of infrared film is that it records the world differently to the way our eyes see it, so all sorts of surreal effects are poss-

ible. Mono infrared film turns blue sky black and foliage white, while colour infrared turns grass and foliage a variety of strange shades.

There are two types of mono infrared film available: Kodak High Speed 2481 (35mm only) and Konica 750 (35mm and rollfilm). The Kodak version must be loaded and unloaded in complete darkness to prevent fogging, but Konica 750 can be handled in subdued light. Both films work best in bright, sunny weather and on scenes that contain a lot of foliage. They should be exposed through a deep red filter or a visually opaque infrared filter (Kodak Wratten 87 or 88A).

If you use a red filter, rate the film at ISO 50 and take a meter reading without the filter in place, or rate it at ISO 400 and meter through the filter. With infrared filters, rate the film at ISO 25 and meter without the filter in place. Bracketing a stop over and under is recommended.

Finally, infrared film focuses on a different point to visible light, so to obtain sharp results you must focus as normal, then adjust the distance on the lens so it falls opposite the IR focusing index – usually a small red mark.

Scenes containing plenty of foliage make perfect

subjects for mono infrared pictures.

Pictures taken under tungsten lighting on daylightbalanced film exhibit a strong orange cast.

Colour infrared film is normally exposed through a deep yellow filter, but I prefer the results obtained using a sepia filter as it gives stronger colours. In terms of exposure, rate the film at ISO 200, meter through the filter, and bracket at least a stop under and over the metered exposure. No focusing adjustment is required, though it's wise to use small apertures, and the film must be processed using the old E4 system, which is only offered by a few labs in the UK.

FLASH ANSWERS

Flash photography is a subject that causes great confusion and frustration among amateur photographers. Just about everyone buys a flashgun at an early stage in their hobby, but few ever get to grips with it. As a result, for most of the year it lies in the bottom of a gadget bag gathering dust, only to make the odd fleeting appearance at parties or family get-togethers.

However, the humble flashgun is an invaluable piece of equipment that can create stunning results. As well as being a handy source of extra illumination in low-light situations, it's also ideal for a range of creative techniques and offers endless scope for experimentation.

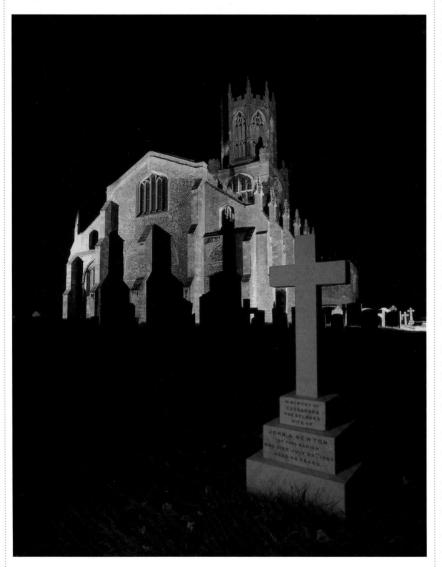

Once you've mastered the basic techniques, all sorts of stunning effects can be created with your electronic flashgun. Here a red filter was placed over the flashgun to light the cross in the foreground, while a long exposure recorded the floodlit church.

Q

What features should I look out for when buying a flashgun?

Flashguns vary enormously in size, shape and price, but most offer a range of similar features. Here's a rundown of what they are and what they do, using a typical automatic flashgun as an example (see page 32).

Auto-aperture switch Set this to the required auto-aperture after checking scale on back of gun so that correctly exposed pictures are obtained automatically. The setting chosen should match the apperture your lens is set to.

Hotshoe Connects the gun both physically and electronically to your camera so that synchronization occurs when you trip your camera's shutter to take a picture.

Autosensor The photo-electric cell which measures light bouncing back off your subject, and quenches the flash when sufficient light has been delivered to give a correctly exposed picture.

Bounce head Tilt it upwards to bounce the flash off a ceiling, or swivel it if possible to bounce the light off a side wall. This not only reduces red-eye, but also gives more attractive illumination with softer shadows.

Zoom head The average flash beam covers an angle suitable for a 35mm lens, but with a zoom head you can adjust it for other focal lengths – usually from about 28 to 80mm.

Ready light Tells you when the flash is charged and ready for use. Let it glow for a few seconds to ensure full power is available. Some SLRs have a 'flash ready' light in the viewfinder as well, so you needn't take your eye off the subject.

Test button Allows the flash to be fired without tripping the camera's shutter. This is handy for checking your subject is within range to give correct exposure, and for multiple flash or painting with light techniques.

EQUIPMENT: FLASH ANSWERS

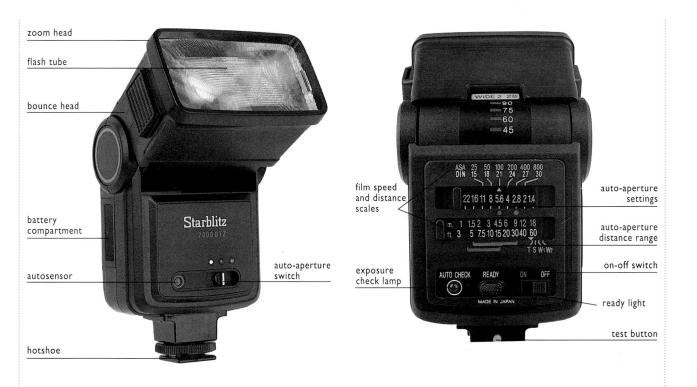

Exposure check lamp Lights if the subject is within range to give correct exposure after the flash has fired. If it doesn't, set a wider lens aperture or move closer to your subject so it receives more light and is correctly exposed.

Film speed and distance scales With automatic flashguns you need to set the film speed on the gun so you know what the working range is on an automatic gun for the different auto-aperture settings.

Auto-aperture settings Give correct exposure over a certain distance range using the same lens aperture – the extremes will be indicated. The more settings a flashgun has, the more control you have over close-range and distant subjects and the more flexible the gun is.

Thyristor A circuit found inside automatic and dedicated flashguns which stores unused energy after a picture has been taken. This reduces the flash recycling time and saves battery power.

Variable power Sometimes known as 'ratio control'. Allows you to fire the flash using a fraction of its power – usually ½, ¼, ½ and ½ full power. This is ideal for closeup flash and fill-in or slow sync flash when only partial power is needed.

I understand that all flashguns have a guide number. What exactly is this?

The Guide Number (GN) of a flashgun gives an indication of its maximum power output, and the distance it will be effective over – the bigger the number the greater the output, and vice versa. All GNs are stated in metres, for ISO 100 film.

The integral flashgun found on compacts and many SLRs has a relatively small GN – usually 10 to 14 – so they're only effective over a shorter distance. Press photographers, on the other hand, tend to favour large hammerhead flashguns with a GN as big as 60, as they can be used to capture long-range subjects.

For general use a flashgun with a Guide Number around 30 is powerful enough, allowing you to photograph subjects that are a reasonable distance from the camera or use small lens apertures for close-range subjects.

By dividing the GN of your flashgun into the flash-to-subject distance (in metres), you can calculate the aperture required to give correct exposure (for ISO 100 film). If the GN is 30, for example, and your subject is 2m away, the aperture you need to use is 30/2=15 or, when rounded up, f/16.

FLASH SYNCHRONIZATION

Back in Camera Answers (page 8) we looked at how the focal plane shutter in an SLR works. When you trip the shutter release, the first curtain in the shutter moves away so light can reach the film, then soon after, the second curtain follows to cover the film again. At fast shutter speeds this action is like a narrow slit moving across the film. So if you used flash with fast shutter speeds, part of your subject would be obscured by the shutter curtain when the flash fired, resulting in a section of the picture being blacked out.

To prevent this, cameras have a 'flash sync speed' – usually 1/60 or 1/125sec, although a few SLRs allow 1/250sec. This is the fastest shutter speed you should use when working with flash to ensure a successful result. Slower shutter speeds can be used, but nothing faster. The only exceptions to this are certain SLR and flashgun combinations, such as the Olympus OM4Ti and F280 flashgun, which allow flash synchronization at all shutter speeds – even 1/1,000 or 1/2,000sec!

FILL-IN FLASH

No flash

Flash under at a ratio of 1:4

Fill-in flash is a technique used to soften harsh shadows and lower contrast when you're shooting portraits against the light or in bright sunlight. An added benefit is the flash also puts attractive catchlights in your subject's eyes.

The basic idea is to combine a controlled burst of flash with the daylight exposure, so the flash has the desired effect without dominating the shot. This is done by setting your flash-gun to fire at half or quarter power, rather than full power.

If your flashgun has a variable power output you can do this simply by pressing a button. If not you have to fool it into delivering less light. This is easiest to achieve with automatic guns.

- First take a meter reading for the background and set it on your camera, remembering that the shutter speed used must be no faster than your camera's flash sync speed. Let's say this is 1/125sec at f/11.
- Using the flash on quarter power to give a flash-to-daylight ratio of 1:4 tends to give the most attractive results. This is achieved by setting your flashgun to an auto-aperture setting that's two stops wider than the aperture you're going to use on the lens in this case the flash should be set to f/5.6.
- If the light is really harsh and you need more flash, a stronger effect can be produced by setting the flash to an aperture one stop wider than the one you're using, so a ratio of 1:2 is obtained. With lens set to f/11, for example, you should set the auto aperture on the flash to f/8.
- If you only need a weak burst of light, set the auto aperture on the flash to a setting three stops wider in this case f/4.

Here you can see how a controlled burst of fill-in flash can improve portraits shot in contrasty sunlight. A flash to daylight ratio of 1:4 usually gives the best results.

What's the difference between manual, automatic and dedicated flashguns, and which type would you recommend?

The main difference between these types of flashgun is the amount of control they give you. Price is also a factor – the more features and

automation a gun has, the more it tends to cost.

Manual flashguns are the simplest type, with the power output usually fixed at maximum so the amount of light delivered is always the same. A table on the back of the gun tells you which aperture to set to give correct exposure for different flash-to-subject distances and film speeds.

If you need to use a different aperture you must change the flash-to-subject distance or use faster/slower film.

Automatic flashguns use a series of automatic aperture settings which allow correctly exposed pictures to be taken over a flash-to-subject distance range – the extremes of which are indicated by a scale on the back of the gun.

You set the flashgun and lens to the same aperture, then when the flash fires, a sensor on the front of the gun measures the light reflecting back from your subject, and once sufficient light has been delivered it cuts out the flash to ensure a correctly exposed picture is obtained.

The number of auto-apertures settings varies from one to five, but a flashgun with three or four is ideal for general use.

Dedicated flashguns offer even greater sophistication. They work in conjunction with the metering system of a specific SLR model and guarantee perfect exposures time after time. All you have to do with dedicated flashguns is to switch the gun on, fire away and everything else is set automatically, including the correct sync speed and lens aperture.

Levels of dedication vary from gun to gun. Some models are totally automated, so you can't override them at all, while others have automatic and manual modes too, plus a range of other features that may include variable power output, strobe flash, multiple flash and much more. Obviously, the more features on offer, the more expensive the gun.

EQUIPMENT: FLASH ANSWERS

What's the advantage of bouncing flash, and how exactly is it done?

The main reason photographers use bounced flash is that it gives much more flattering results than direct flash. If you point a flashgun

straight at your subject, the light produced is very harsh and casts dense shadows on the background; but by bouncing the light off a wall or ceiling first, it's softened considerably and shadows are weakened.

If your flashgun has a bounce/swivel head you can simply tilt it in the right direction while it's still attached to your camera's hotshoe. If not, take the gun off the camera and point the whole thing towards the bouncing surface. To do this you'll need a flash sync cable, so the gun can be connected to your camera.

For the best results, bounce the flash off a white wall, ceiling or reflector. High ceilings are no use as they spread the light over too wide an area, and coloured surfaces should be avoided because they give the flash a colour cast which will spoil your pictures.

Some flashguns have a secondary flash unit, fitted below the main tube, that can be used to soften the shadows created by bouncing. Alternatively, place a white reflector beneath your subject's chin if you're bouncing from a ceiling, or on one side of their face if you're bouncing from a wall to punch light into the shadows.

Finally, bouncing causes a light loss. Automatic and dedicated guns make up for this loss by increasing the light output, but if you're using a manual gun the lens aperture must be opened up by 11/2 to 2 stops to ensure correct exposure.

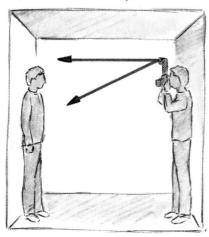

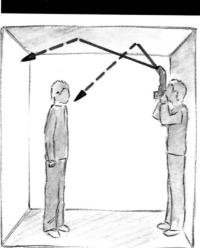

Flash bounced off white ceiling

As you can see, bounced flash (top) gives far more flattering results than flash fired direct at your subject (above).

Whenever I take portraits with flash my subjects always suffer from red-eye. How can this be avoided?

Red-eye is caused by light reflecting back off the retinas in your subject's eyes, and usually occurs when a flashgun is positioned too

close to the lens axis and fired directly at your subject.

Cameras using an integral flash are the biggest culprits because the position of the flash can't be altered. To combat this, many models use a red-eye reducing flash which fires one or more weak preflashes to reduce the size of your subject's pupils before the main flash fires.

If your camera doesn't have a red-eye reduction facility, or you're using a hotshoe-mounted flashgun, here are a few tips on how to banish red-eye:

• Ask your subject to look to one side of the camera instead of straight at it.

• Ask your subject to look towards a room light or stand near a window for a couple

of minutes, so their pupils reduce in size.Fire the test button on your flashgun before taking the final picture.

• Bounce the light off a wall or ceiling so it isn't hitting your subject directly.

• Take the flashgun off your camera's hotshoe and either hold it to one side or place it on a flash bracket.

Red-eye makes people look like beings from another planet!

Is it possible to use my flashgun off the camera?

SLOW SYNC FLASH

Using a flashgun off your camera is indeed possible, and opens up a whole new avenue of creativity because you can vary the position

of the gun around your subject to control the lighting effect obtained, instead of being limited to just frontal light.

Place the gun at 90° to your subject, for example, and you'll create strong sidelighting, with half their face lit and the other half in shadow. Alternatively, by holding it at an angle of 45° you can mimic traditional three-quarter lighting.

To use off-camera flash you'll need to buy a flash sync cable, which allows you to connect the gun to the camera. Ideally go for a cable that's several metres long, so you can vary the flash-to-subject distance. If your camera doesn't have a flash sync socket you'll also need a coaxial adaptor which slots onto the camera's hotshoe and provides a socket to plug one end of the sync cable into.

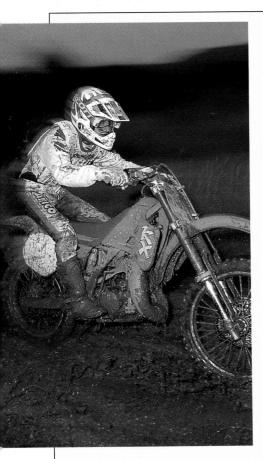

This technique is often used by sports photographers, but it can be used on any moving subject that's close to the camera. All you do is combine a burst of flash with a slow shutter speed, so your subject is frozen by the flash but blurred by the ambient exposure. When used properly the effect can look stunning. Many compact cameras have a 'flash-on' or 'slow-sync' mode which automatically combines flash and a slow shutter speed in low light, but an SLR with a flashgun

For this shot of a motocross rider the photographer used an exposure of 1/8sec at f/11, and panned the camera while tripping the shutter, so the background blurred as well.

mounted on the hotshoe gives better results.

• Start by taking a meter reading for the ambient (available) light and setting this on your camera. Use your camera in aperture-priority mode so you can set the aperture, which is important for control of the flash exposure, while the shutter speed is set automatically.

• Use a shutter speed of 1/15sec or slower to get sufficient blur in the picture. Using slow film and stopping your lens down to f/11 or f/16 will help.

• To make your flashlit subject stand out, underexpose the background by a stop. This is achieved by setting the exposure compensation facility on your camera to -1. The shutter speed will be altered, not the aperture.

• To balance the flash with the ambient light you also need to underexpose the flash by one stop. To do this, set your flashgun to an auto-aperture setting that's one stop wider than the aperture you're using on the lens – f/8 instead of f/11, say.

EQUIPMENT: FLASH ANSWERS

Firing your flashgun into a reflective brolly is one way of improving the quality of light.

Are there any other ways of improving the light from a portable flashgun?

There are various accessories available from manufacturers such as Lastolite, Photax and Jessop that

are specially designed for use with portable flashguns. A special attachment allows you to fit a portable flashgun to a lighting stand so it can be positioned anywhere in relation to your subject, while softboxes or flash brollies are used to soften and spread the light.

The only drawback with using these attachments is they lose up to three stops of light, so you need fairly powerful flash-guns to make up for this and allow you to work at an aperture of f/8 or f/11 with slow- or medium-speed film.

It's also a good idea to use dedicated flashguns and a dedicated sync cable, so all exposure calculations will be dealt with automatically.

What about if I want to use more than one flashgun at the same time?

Using two, three, four or more flashguns for the same shot, along with some of the accessories described above, is a great way to

produce professional-quality lighting. All you need is some means of ensur-

ing the flashguns fire at the same time. You could do this by purchasing a multisocket attachment which allows several guns to be connected to your camera at once via flash synch cables. However, a much better way is to connect just one gun to the camera then fit the others with a slave unit – a small electronic eye which triggers the gun it's attached to when the main flash fires. That way, you won't have cables trailing everywhere.

As for the position of each gun, that's entirely up to you. Shown here is just one example, but there's an endless number of lighting set-ups possible – all you need is a little imagination.

Try placing one light behind your subject, aimed back at the camera, with two others directed on your subject's face. Here the photographer used two separate flashguns, as shown by the illustration. The main gun (1) was placed inside a 1m softbox and positioned at 45° to the subject. A white reflector (2) was also used to fill in any shadows cast by this flash. The second flashgun was placed behind the subject and aimed at the background.

ACCESSORY ANSWERS

As well as cameras and lenses there are several other items worth considering as you build a system of photographic equipment. Some, such as tripods and gadget bags, are essential, while others are designed to make your life easier.

The key when buying accessories is to decide

which you really need for your own brand of picture-taking. As with all hobbies, photography is inundated with gizmos that promise miracles but rarely deliver, and if you get bitten by the gadget bug you could find yourself spending large amounts of money on things that just aren't necessary.

Q

I'm thinking of buying a tripod. What features should I look out for when choosing a model?

The main aim of a tripod is to provide a stable support for your camera, so you can use slow shutter speeds without having to worry about camera shake spoiling your pictures. This allows you to load up with the slowest films for optimum image quality, stop your lenses down to small apertures to maximize depth-of-field, and use exposures of many seconds, even minutes, to capture low-light scenes.

When choosing a tripod the first factor to consider is its weight. A big, heavy model may keep your camera rock-steady in a hurricane, but you'll give yourself a hernia trying to carry it.

Similarly, a small, lightweight tripod may be highly portable, but if it's unstable you might as well not bother using one.

The solution is to find a model that offers the ideal compromise between weight and stability. There are several other features worth looking out for...

Pan-and-tilt head This is the most common type of tripod head and allows you to adjust the camera position forward/backwards, vertically and horizontally. Some models use a ball and socket head instead.

Quick-release platform Allows speedy removal or attachment of your camera. The platform can be left screwed to the baseplate of your camera, then all you have to do is clip it into place on the tripod head.

Centre column A common feature that provides extra height. It tends to be the most unstable part of the tripod though, and should only be used when absolutely necessary.

Leg bracing Increases the stability of the tripod legs and keeps them equally splayed apart. Some models have removable bracing so the legs can be spread wider for low-angle work.

Built-in spirit level Tells you whether or not the tripod head is perfectly horizontal – if the head is, your camera will also be, once you screw it into position.

Leg locks Quick-release clips allow rapid adjustment of the tripod height. The locks are used regularly, so they need to be robust. Ideally go for metal locks rather than plastic, which tends to break.

Legs All tripod legs are broken down into sections so they can be tucked away for carrying. Generally, the fewer leg sections there are, the sturdier the tripod – three is an ideal number. Tubular legs are stronger than open-section legs.

feet

Feet The choice is basically between spikes for soft surfaces and flat rubber feet for harder terrain, with the latter being better for general use.

Height Ideally you need a model that can be extended to eye-level -1.5 to 1.8m (5 to 6 feet) is about right - with only a few inches of the centre column in use.

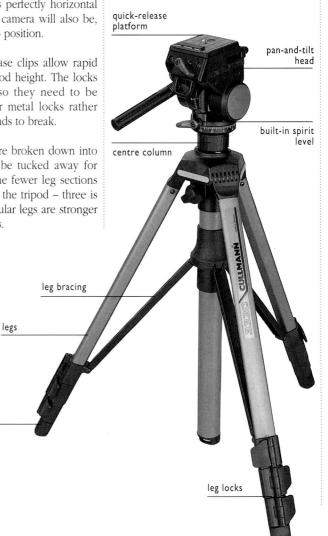

Are there any other types of camera support available that I can use in awkward situations?

A

Yes. If you shop around you'll find all sorts of different supports for use in every conceivable situation.

Monopods are a popular alternative to tripods. They're basically a telescopic tube, just like a tripod leg, and are used in conjunction with your body weight to keep the camera steady.

Sport and action photographers tend to prefer monopods because they provide plenty of support for heavy lenses but still give freedom of movement. They're also ideal when you need to use slowish shutter speeds but can't carry a tripod.

Pocket tripods are ideal when you need to travel light or in situations where a fullsized model isn't permitted. They can be rested on a wall, pillar, car bonnet or other available support to provide the necessary height.

USING LENS HOODS

When shooting towards the light, or taking pictures with a bright light source just out of frame, you may notice strange ghostly patterns in your camera's viewfinder. This is known as flare, and it ruins pictures by lowering contrast and reducing colour saturation to produce very wishy-washy images.

To prevent flare you should fit your lenses with lens hoods when shooting in bright conditions, so the front element is protected from stray light. Many telephoto and zoom lenses have a sliding lens hood built in, but with others you'll need to buy hoods that can be screwed onto the end.

Make sure the hoods you buy are designed to be used with a specific

focal length, otherwise they won't work properly. This is particularly important, with wide-angle lenses, as a hood that's too narrow will cause vignetting (see Problem-solving Answers, page 74).

Flare can ruin a potentially great picture, but fitting a lens hood will usually prevent it.

Chestpods and **pistol grips** can be used to support long lenses or prevent camera shake when using slow shutter speeds, but they don't provide the same level of stability and require a steady hand to work properly.

Where support is required but you don't have room for a tripod you could use a **clamp**, **spike** or **suction pod** to fit your camera to fences, railings, table tops, shelves, windowledges and so on.

Finally, for uneven surfaces, you can rest your camera on a beanbag, which will turn walls, fence posts, car bonnets, rocks, tree stumps and all sorts of things into impromptu supports.

I have a habit of taking pictures with wonky horizons. How can this be avoided?

You need a small spirit level that can be slipped onto your camera's hotshoe to let you know if the camera is perfectly square. Most

levels have bubbles that allow you to check for horizontal and vertical accuracy.

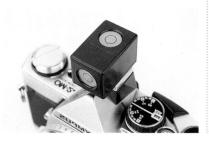

EQUIPMENT: ACCESSORY ANSWERS

BAGS AND CASES

Photographic bags and cases are designed to serve three main functions: to make carrying your equipment as easy and comfortable as possible; to protect that equipment from damage; and to provide easy access to the contents. When choosing one you also need to consider the amount of equipment you normally carry, and the type of conditions you expect to take pictures in.

For general use a traditional gadget bag provides the best solution, and should have the following features:

• A padded main compartment to give protection if the bag is dropped or knocked against a hard surface.

• Adjustable padded dividers inside, so you can arrange the layout to suit your needs and ensure your cameras and lenses are separated.

• The outer shell and lid should be at least showerproof, ideally with a storm flap to provide extra protection. If you intend working in bad weather go for a fully waterproof bag.

• A selection of pockets to store film, filters and other accessories.

• Strong zips, buckles and fastenings that will withstand regular use for many years.

• A wide, padded strap to make carrying heavy loads as comfortable as possible.

In terms of size, go for a bag that's big enough to carry a couple of 35mm SLR bodies, five or six lenses, a flashgun, plenty of film, filters and all the other items you're likely to need. You may not own that much equipment now, but in the future you probably will so it's worth making provision for it.

The alternatives to traditional bags are many and varied. If you need to travel light, for example, you could buy a series of pouches which can be fitted to a belt and carried on your waist. Photographers' vests serve a similar purpose, and are preferred by many photojournalists.

Where equipment needs to be carried for long periods or long distances, a backpack design will be more suitable. Backpacks are slower to use than normal gadget bags, but they distribute the weight evenly across both shoulders, making it far easier to carry heavy loads.

.....

Hard cases made from aluminium or highimpact plastics come into their own when optimum protection is required, but they're unsuitable for carrying around.

Could you recommend a selection of items for cleaning my cameras, lenses and filters?

It makes sense to put together a cleaning kit, so you've always got the necessary items to hand should you need them in an emergency.

The following bits and pieces should cover your needs.

microfibre lens cleaning cloth lens cleaning fluid cotton wool buds stiffer body brush

What's the purpose of a cable release?

Cable releases, allow you to take a picture without touching your camera's shutter release. This is handy when the camera is on a tripod and you're using long exposures or long telephoto lenses, as pressing the shutter release with your finger can cause vibrations which lead to camera shake. There may also be occasions when you need to take pictures at a distance from the camera – when photographing timid animals and birds, or shooting self-portraits.

The most common type of cable release screws into the camera's shutter release and is operated by pressing a plunger on the end. Electronic releases are also available which plug directly into the camera's motorwinder. Finally, pneumatic releases consist of a thin plastic tube – usually around 6m (20ft) long – with a plunger on one end and a rubber bulb on the other. A picture is taken by squeezing the bulb.

If your camera doesn't have a cable release socket – many modern SLRs don't – you can buy an attachment which allows a release to be fitted.

Cable releases are an essential accessory for shake-free or remote photography.

2

TECHNIQUE ANSWERS

DEPTH-OF-FIELD ANSWERS

Whenever you take a picture, an area extending in front of and behind the point on which you focus the lens also comes out acceptably sharp. This area is known as the 'depth-of-field', and being able to control it is a vitally important part of photography. When shooting landscapes, for

example, it is common practice to keep everything in the scene sharply focused, so depth-of-field needs to be as wide as possible. However, when shooting portraits you usually want minimal depth-of-field so your main subject stands out against the background.

What are the factors controlling depth-of-field?

There are three factors you can use to control depth-of-field: the size of the lens aperture used, the focal length of the lens; and the camerato-subject distance.

• For any lens, wide lens apertures, such as f/2.8 or f/4, give limited depth-of-field, whereas small lens apertures, such as f/11

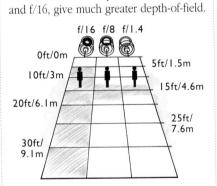

• At any given lens aperture, depth-of-field becomes smaller as focal length increases. A 28mm wide-angle lens set to f/16 will record everything sharply from about 2m from the camera to infinity, for example, but the depth-of-field from a 300mm set to f/16 will only extend a few metres either side of the point you focus on.

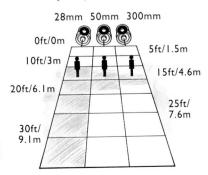

Wide-angle lenses and small apertures are the perfect combination when you want to render everything sharply focused. Here the photographer used a 28mm lens set to f/16.

• The closer you are to your subject, the

less depth-of-field there will be for any

lens or aperture. So if you use a 50mm

lens set to f/16 and focus on 2m there will

be far less depth-of-field than if you focus

the same lens on 10m. This makes accu-

rate focusing essential when working at

close range - especially if you are shoot-

ing close-up or macro images.

How can I check what will be in or out of focus in a picture?

Being able to assess depth-of-field is important, because often you will need to know roughly what is going to be in and out of focus in

the final picture. Looking through your camera's viewfinder offers no clues, because what you see is how the scene would be recorded if you used the lens at its widest aperture.

The easiest way to assess depth-of-field is by using your camera's stopdown or depth-of-field preview button. If you press

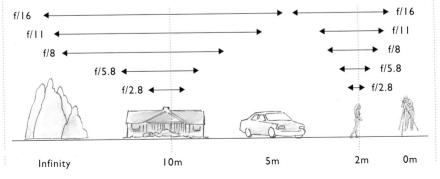

it, the lens iris will close down to the aperture set to give you a rough idea of what will be in and out of focus. The main drawback with this method is that when using small apertures the viewfinder goes very dim, so you cannot see very clearly. Also, many modern cameras are no longer made with such a facility.

The second method is to use the depth-of-field scale on your lens, which appears either side of the main focusing index. All you do is focus on your subject, then read off the distances which fall opposite the aperture you are using on the depth-of-field scale – as shown below. These distances indicate the nearest and furthest points of sharp focus.

If you need greater depth-of-field, set the lens to a smaller aperture, or if you need less just set the lens to a wider aperture.

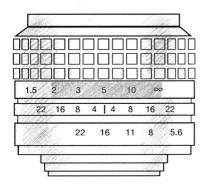

From this illustration you can see that with the lens focused on 5m/16%ft and set to f/16, depth-of-field extends from roughly 2m/6%ft to infinity.

MAXIMIZING DEPTH-OF-FIELD

One of the problems of trying to obtain maximum depth-of-field is knowing exactly what to focus on, especially if you are using a wide-angle lens to capture a sweeping view. As a rule-ofthumb, you could work on the basis that depth-of-field extends twice as far behind the point of focus as it does in front, but this is not very accurate.

The alternative is to employ a tech-

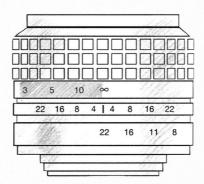

nique known as 'hyperfocal focusing'. To do this, focus your lens on infinity

and check the depth-of-field scale to

see what the nearest point of sharp

focus will be at the aperture you are

going to use. This distance is known as

the 'hyperfocal distance'. Now refocus

your lens on the hyperfocal distance,

and depth-of-field will extend from half

the hyperfocal distance to infinity.

Here you can see that with the lens focused on infinity and set to f/22, the hyperfocal distance is 3m/9ft10in.

BELOW Where minimal depth-of-field is required, use telephoto lenses and wide apertures. For this shot the photographer used a 135mm lens set to f/4 to isolate the subject from the background.

By refocusing the lens on 3m/9ft10in, the hyperfocal distance, depth-of-field now extends from 1.5m/5ft to infinity.

Can depth-of-field be used creatively?

Yes, that is why you should think carefully about the lens and aperture you are using. Pictures taken on a wide-angle lens with every-

thing sharply recorded can look stunning. But that impact will be diluted if the background or foreground comes out blurred because you didn't set an aperture small enough to provide sufficient depth-of-field.

Similarly, a simple subject can be made to look strongly three-dimensional if you restrict depth-of-field so much that it is the only sharp element in the frame. However, the effect will be ruined if you give too much depth-of-field so that other elements in the scene begin to compete for attention, such as a cluttered background that's sharply focused in a portrait shot.

Like all aspects of photography, the more you practice, the better you will become.

41

EXPOSURE ANSWERS

Exposure is without doubt the most crucial aspect of photography, because unless you know how to get the right amount of light to the film in your camera, everything else pales into insignificance. There's little point in practising your portrait skills if half your pictures come out overexposed. And no one's going to admire the fact that you're an expert sports photographer if your shots are too dark to see what's going on.

Actually, things aren't quite as bad as they seem. Modern cameras have taken much of the

guesswork out of getting the exposure right, and can be relied upon to come up with the goods 95 per cent of the time. But that still leaves a crucial 5 per cent of situations where, unless you have a thorough understanding of exposure theory, you'll end up with badly exposed pictures. Ironically, it's those very situations which also tend to generate the most exciting pictures, so knowing how to deal with them is vitally important if you don't want to miss out. Throughout this chapter we will be telling you how to do that.

A thorough understanding of exposure is vitally important if you want to take perfect pictures in tricky lighting situations. To capture this dusk scene overlooking the beautiful Spanish village of Casares, the photographer based his exposure on a spot meter reading taken from the neutral tone of the castle on the hilltop. A twostop grey graduated filter was also used to reduce the brightness in the sky so its natural colour would record on the final image. *Olympus OM4Ti, 50mm lens, 4sec at f/11, Agfachrome 100RS Plus.*

I'm confused about the basics of exposure, and how apertures and shutter speeds relate to each other. Could you explain this for me?

The basic aim of exposure is to get exactly the right amount of light onto the film in your camera so an acceptable image is created on its light-sensitive emulsion. To do this, the correct film speed is first set on the camera, so the meter is calibrated to give the right exposure values. Next, a meter reading is taken to measure the light levels and to establish how much exposure the film needs.

To get that light to the film you have two controls: the lens aperture, which regulates how much light passes through the lens; and the shutter speed, which determines how long that light is allowed to strike the film.

To understand how this works,

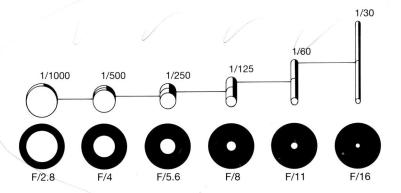

imagine you're filling a kettle. The amount of water required is the exposure, the size of the tap is the lens aperture, and the length of time the tap is left running is the shutter speed.

If you use a large tap (wide lens aperture), you only need to turn it on for a short time (use a fast shutter speed). But if the tap is narrow (small lens aperture), it must be left running for much longer (slow shutter speed) to get exactly the same amount of water into the kettle.

Now apply this theory to exposure. Each time you set your lens to the next biggest f/number, the size of the aperture is halved, so the shutter speed must be doubled to ensure the same amount of light reaches the film. If your camera suggests an exposure of 1/250sec at f/5.6, for example, any of the combinations shown above could be used.

The combination you choose will depend on what your subject is. For sports photography a fast shutter speed is required, so 1/1,000sec at f/2.8 would be an ideal combination, but for landscapes a small aperture is more important as you need maximum depth-of-field, so 1/30sec at f/16 would be better. The mid-range settings tend to be used for general picture taking.

Q

How does my camera measure the light and calculate the correct exposure?

Just about all cameras with an integral light meter use a system known as TTL (through-the-lens) metering to measure the light

passing through the lens. This means that if you place a filter or any other attachment on the front of the lens, any light reduction it causes will automatically be taken into account.

The light measured is that being reflected back from your subject, so the reflectance of the subject, and light or dark area in the scene, can influence the reading obtained. We'll cover this in more detail later.

.....

How do I know which aperture and shutter speed combination my compact camera has set?

Unfortunately, you don't. Your compact may have a range of apertures and shutter speeds, but the combination set is chosen at

random, and there's no way of telling what it is.

In normal, sunny weather or when using flash this needn't be a problem, but in lower light a slow shutter speed may be set without you knowing and cause camera shake.

That's why it's a good idea to use a slightly faster film, such as ISO 200, if you intend taking pictures in a variety of lighting situations. The extra speed could be your saving grace.

My camera has a backlight. How does it work?

This handy feature is designed to help prevent underexposure when your subject is backlit by the sun. If

you press it just before taking the picture it will increase the exposure set by about 1½ stops. It's fine in most situations, but in really bright conditions the increase may not be enough.

Here the backlight button on an SLR was used to prevent sunlight streaming down from behind the subject causing underexposure.

My camera has a variety of exposure modes. What does each mode do, and when should I use them?

I use them? The job of any camera is to ensure that the correct amount of light

reaches the film inside it to produce a well-exposed picture. However, different cameras do this in different ways using a variety of modes, which vary the degree of control you have over the exposure set. Most compact cameras use just one fully automatic exposure mode, but SLRs tend to give you the choice of one, two, three or more so you can pick and choose the mode to suit different subjects.

Program mode This is a fully automatic mode which sets both the aperture and shutter speed, usually displaying them in an LCD panel on the top plate. The choice made is based on data programmed into the camera's memory, so you have no control over it. Fortunately, most SLRs now have a Program Shift facility, so you can alter the aperture and shutter speed combination if the one selected isn't suitable.

Program is a quick mode to use so it's ideal when you need to respond instantly to a photo opportunity. Without Program Shift, however, it offers the photographer no creative control.

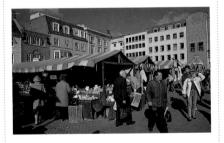

Specialist program modes Some SLRs use program modes which are tailored for more specific use.

Program Depth, or Program Low, for example, is designed to set the smallest practicable aperture to give maximum depth-of-field. In doing so it also gives slow shutter speeds.

Program High, or High-Speed Program, sets a fast shutter speed to freeze action. As a result it's handy when using telephoto lenses, as the fast shutter speed helps to prevent camera shake. A wide aperture is also set, so it can be used if

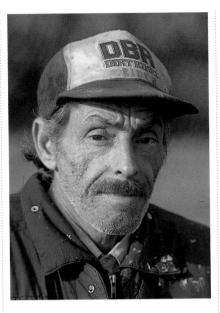

you need to throw the background out of focus to make your subject stand out.

Pictograms Taking the specialist program mode idea one step further, some SLRs now use a series of subject-based modes which set not only the exposure controls, but the autofocusing, flash, film advance and various other camera functions to suit specific subjects, such as portraits, landscapes, action and close-up.The idea of this is to give novice photographers the opportunity to capture a range of different subjects without any prior knowledge. The modes offer no control, but as your experience grows you can switch to other modes that only handle the exposure.

Aperture Priority AE In this mode you set the lens aperture and the camera automatically selects a shutter speed to ensure correct exposure. It's one of the most common and popular modes, and is ideal for subjects such as landscape photography, where control over depth-of-field is important. It also enables you to use the camera's long exposure capability when taking pictures at night.

Shutter priority This time you set the shutter speed and the camera sets an aperture to give correct exposure. Again, it's a relatively quick mode to use, and ideal for subjects such as sport and action, where control over the shutter speed set is more important than the aperture.

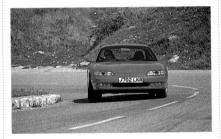

Metered manual The simplest and most basic exposure mode available. After taking an exposure reading, you set both the aperture and shutter speed required. It's relatively slow to use, but offers total control and allows you to work in conjunction with a handheld light meter.

METERING PATTERNS

When you use your camera to take an exposure reading, the light entering the lens is measured using a special metering 'pattern'.

Until a decade or so ago, most cameras used the same pattern, but in recent years a number of new designs have been devised which measure the light in different parts of the viewfinder to help recognise tricky lighting situations and help overcome the exposure error they cause. Some SLRs even give you a choice of patterns so you can pick and choose, depending upon the conditions you're working in and the subject you're shooting.

Here are the most common patterns, and how they work.

Centre-weighted average is still the most popular metering pattern found in SLRs and compacts. It works by taking a light reading from the whole of the viewfinder, but pays particular attention to the central 40 to 60 per cent because that's where the main subject tends to be positioned. In normal conditions it gives accurate results.

Partial metering takes a light reading from a smaller central area of the

Do I need to expose differently when using colour slide instead of colour print film?

The basic rule with colour slide film is to expose for the highlights and leave the shadows to their own devices. This is because you

only get one bite at the cherry, and dark shadows are far preferable to washed-out highlights. Exposure accuracy is also far more important with colour slide film, as it can only tolerate half a stop of over- or

viewfinder, which varies in size from 6 to 15 per cent of the total image area. This means you can meter from a more specific part of the scene so surrounding light or dark areas don't influence the reading obtained. Better than centre-weighted in tricky light.

Multi-zone metering Many camera manufacturers now have their own 'intelligent' metering systems, which are designed to reduce exposure error by recognising tricky situations.

They work by dividing the image area into several segments and taking an individual light reading from each to assess the contrast and brightness of the

scene. This information is then compared to 'model' lighting situations built into the computer's memory, and an exposure is selected. They're reliable, but far from foolproof.

Spot metering With this pattern a light reading is taken from a tiny spot in the centre of the viewfinder – usually covering only 1 per cent of the total image area. This allows you to take substitute readings from a very specific part of the scene and obtain perfect exposures in the trickiest conditions. In experienced hands it's the most accurate system available.

Multi-spot metering Works in the same way as spot metering, but allows you to take several individual spot readings from different parts of the scene, store them in the camera's memory, then average them out to obtain the correct exposure. Many cameras with spot metering give you this option.

underexposure before a picture is fit for nothing but the bin. With negative film, the opposite applies. You should expose to record some detail in the shadows and not worry too much about the highlights because they can always be toned down to show detail at the printing stage. Print film also has much wider latitude. You can under- or overexpose by at least three stops and still obtain an acceptable result, as any error can be corrected at the printing stage. This is particularly handy for compact camera users.

Slight underexposure can increase colour saturation when shooting colour slides.

Whenever I take pictures of subjects against a light or dark background, or landscapes including a lot of sky, they always come out either too light or too dark. What causes this, and how can I overcome it?

Ah-ha, you've discovered a problem that many photographers fail to realise even exists - namely that no matter how modern or

sophisticated your camera is, it isn't totally foolproof and can still get the exposure wrong in certain situations.

The main reason for this is because the light meter built into your camera is designed accurately to expose average subjects. These subjects are assumed to comprise an even number of light and dark tones, and reflect 18 per cent of the light falling on them. The benchmark for this is a sheet of mid-grey coloured cardmore commonly referred to as 18 per cent grey.

Most of the things you photograph are 'average' in their tonal balance, so your camera can usually be relied upon to give

Subject against a light background

Subject against a dark background

correctly exposed results. However, when you try to photograph something that isn't average, your camera still tries to record it as if it were, and that's when exposure error results.

This problem is compounded because the light meter in your camera measures light reflecting back from the subject, so the exposure it sets is influenced by high or low reflectance. A sheet of white card reflects far more than 18 per cent of the light falling on it, for example, but your camera still treats it as 'average' and underexposure results.

Below is a list of the most common causes of exposure error, and how to deal with them. In just about all cases you can obtain an accurate exposure reading by using a handheld meter or taking a substitute meter reading from part of the scene. Where this isn't practical or possible, adjust the exposure your camera suggests by the amount shown.

Subject against a light background This is one of the most common tricky lighting situations. Examples include a person against a white wall, sky, water or snow. The high reflectance or brightness of the background fools your camera's meter into underexposing, so your main subject comes out too dark.

Increase the exposure by $1\frac{1}{2}$ to 2 stops.

Subject against a dark background This is the exact opposite of the above problem, and again usually occurs when you photograph someone or something against a dark, shady backdrop. Your camera tries to record the background as grey, so it overexposes and your main subject comes out too light.

Reduce the exposure by 1½ to 2 stops.

Bright subject The most common example here is a snow scene, but a bride in her wedding dress, an animal with

Bright subject

white fur or any other light-coloured subject causes the same problem. Again, your camera meter treats the subject as if it were average, so underexposure occurs and it comes out grey.

Increase the exposure by 2 to 2½ stops.

Dark subject This time it's the proverbial black cat in a coal cellar, or any other dark subject including people dressed in black clothing. Your camera meter again treats the subject as average, so overexposure occurs and everything comes out grev.

Reduce the exposure by 2 to $2\frac{1}{2}$ stops.

Shooting into the light This situation covers any subject where a bright light source like the sun is in the shot, and includes backlit portraits. The bright background influences the exposure set and your main subject will either be grossly underexposed or record as a silhouette. Sometimes that approach can give stunning results, but usually only when it's done intentionally. To make sure your main subject is correctly exposed ...

Increase the exposure by 1 to 3 stops, depending upon how bright the background is.

Bright sky in shot The sky is generally much brighter than the ground, so if you include a large slice of it in your pictures it tends to influence your camera's meter and cause underexposure of the land-

Dark subject

scape. This is easily overcome by tilting your camera down to exclude the sky, so you're metering from the foreground alone. Alternatively...

Increase the exposure by 1 to 3 stops, depending upon the brightness of the sky.

Bright sky in shot

High-contrast scene Colour slide film is able to record a brightness range of about five stops, while colour negative film can record a range up to seven stops. Unfortunately, in really bright, sunny weather, the brightness range of a scene can be as much as nine or ten stops, so something has to give and detail must be sacrificed in either the highlights or the shadows.

If you leave the decision to your camera, underexposure will probably result, so decide what the most important part of the scene is and meter directly for that.

High-contrast scene

Shooting into the light

What does the exposure compensation facility on my camera do, and when should I use it?

This allows you to override the exposure set by your camera, and tends to be used when you're

photographing a non-average subject that may fool the integral light meter into setting the wrong exposure (see pages 46-47).

Most SLRs have some kind of exposure compensation facility which allows you to increase or reduce the exposure set by anything up to three stops, in third, half or full stop increments.

If your camera lacks such a facility, you can still override the meter by switching to manual exposure mode and adjusting the aperture or shutter speed after setting the suggested exposure.

Do handheld meters offer any advantages over the light meter built into my camera?

Yes, they do. The main benefit of using a handheld light meter is it gives you the option to take incident readings of the light falling

ABOVE AND TOP A handheld light meter allows perfect exposures in lighting conditions that would confuse your camera's integral meter.

onto your subject, rather than the light being reflected back. As a result, the reading obtained isn't influenced by the reflectance of your subject, or light and dark areas in the scene, so you can obtain perfect exposures in the trickiest lighting.

To use a handheld meter, hold it in front of your subject so the white diffuser is pointing back towards the camera. If you're unable to get close to your subject, simply hold it up and point the diffuser over your shoulder, so it's in the same light that's falling on your subject.

The meter reading obtained can then be set on your camera, which should be switched to manual exposure mode.

Is there any way of obtaining accurate exposures when photographing non-average subjects if I don't have a handheld meter?

One way is to take a normal meter reading, then increase or reduce the exposure suggested by an amount you think is correct (see

pages 46-47). However, this is rather hit and miss, because no two situations are the same.

A much better method is to take a substitute meter reading from something that's similar in tone to 18 per cent grey and won't confuse your camera's meter. All sorts of things are suitable, such as green grass or foliage, concrete, roof

OPPOSITE Here a spot reading was taken from the sunlit area around the church to prevent the darker surroundings causing it to overexpose.

slates, stone or brickwork, grey clothing and so on. Or you could buy an 18 per cent grey card and meter from that by holding it in front of your subject.

Alternatively, take a reading from your hand or your subject's skin, and then increase the exposure. Caucasian skin is roughly one stop brighter than 18 per cent grey, so you would need to increase the exposure by a stop.

If your camera has a spot or partial metering facility you can use that to take a substitute reading. If not, fit a telephoto lens to your camera and isolate a suitable area, or where possible, move in close to take the reading.

Do I always need to use the exposure my light meter sets, even if I know it's correct?

Not at all. The 'correct' exposure isn't necessarily the exposure that will get sufficient light to the film to produce a technically perfect

image, but the exposure you think will record your subject in the way you want to see it.

That's why it's so important to have a thorough understanding of the factors influencing exposure, and how your camera will respond in different situations. Once you know all the technical tricks you can then commit them to your subconscious and let your imagination take over. Creative photography isn't about doing everything by the book, but following your instincts.

Imagine you're photographing the landscape in very stormy weather. Once you know which exposure will record the scene as you see it, there's nothing to stop you intentionally underexposing your pictures by half or even a full stop, so the tones are darkened down and the drama of the event is increased. Similarly, photographers often overexpose their pictures slightly when shooting portraits or nudes in soft lighting, because doing so lightens the tones to create a dreamy, high-key effect. Exposure is very subjective and open to endless personal interpretation, so never be afraid to experiment.

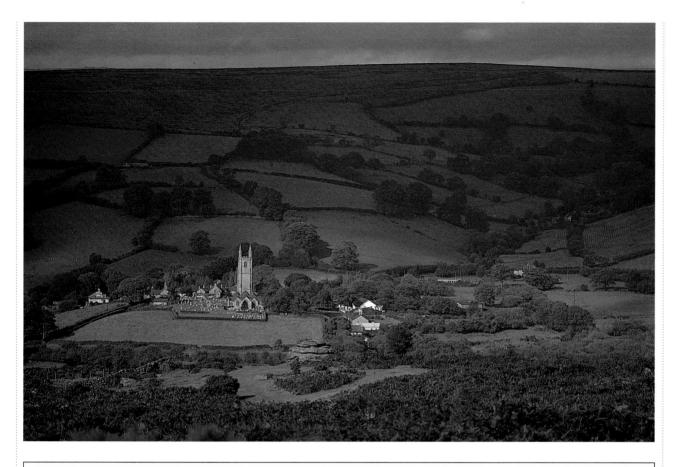

If you're ever unsure which exposure will give the best result when shooting in tricky lighting, then you can resort to a technique known as 'bracketing'.

This basically involves taking a picture at the exposure your light meter suggests, then further pictures at exposures over and under this, to make sure at least one frame is perfectly exposed. The amount you need to bracket by will depend on the type of film you're using and how difficult the conditions are. Slide film demands great exposure accu-

BRACKETING

racy, so bracketing in one-third or halfstop increments is advised. But negative film has far more latitude to exposure error, so bracketing in full stops will be sufficient. In some situations you may only bracket half a stop over and under, while in others a two-stop bracket either way will be required.

If you know that the subject you're photographing is likely to cause underexposure then you may also limit the bracket to just overexposure, rather than wasting film by going both ways. Some

modern SLRs have an autobracketing facility which fires off three or five frames in quick succession using the bracket set. But most photographers bracket by using their camera's exposure compensation facility and taking each picture in turn.

This set of pictures shows the effect bracketing has on colour slide film. Notice how only a small amount of over- or underexposure can totally transform the picture.

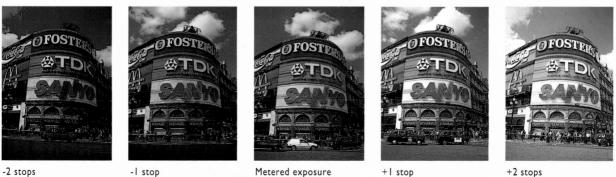

-l stop

Metered exposure

+1 stop

+2 stops

LIGHTING ANSWERS

Light is the single most important ingredient in photography. Without it we couldn't take pictures in the first place, as it's the action of light on film that creates an image. But there's much more to it than that. Light changes considerably in colour, harshness, intensity and direction, and all these factors influence the aesthetic success of our photographs. Understanding what causes these changes, and appreciating how they can be utilized, is therefore essential.

The purest form of light is produced by the sun, perched in the sky some 93 million miles away. As the globe rotates each day, we on the ground experience the light as constantly changing and constantly moving. You can't control the light in any way, but you can exploit it by timing your shoot carefully to capture the best conditions, and by changing camera or subject angle.

In other words, to make the most of daylight you must accept the limitations it imposes and work within them. Once you're able to do that you'll discover God is the best lighting cameraman in the world, and anything is possible with a little patience.

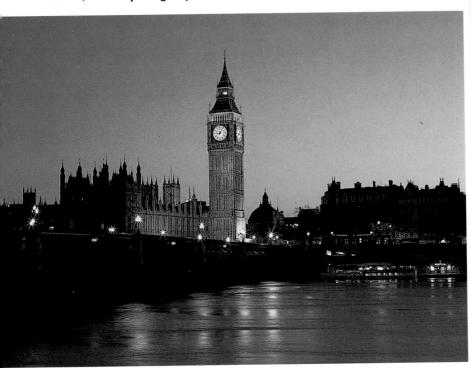

This set of pictures of London's Big Ben shows how the colour and intensity of daylight changes throughout a single day. (TOP RIGHT): During mid-afternoon the light is harsh but reveals every detail in the intricate stonework. (BOTTOM RIGHT): Early evening sunlight makes the buildings glow with a beautiful warmth. (ABOVE): Twilight turns the sky into a backdrop of delicate colour while artificial illumination picks out Big Ben.

All pictures taken with Olympus OM4Ti and Fuji Velvia film.

What's the main factor affecting the quality of daylight?

The time of day. Throughout every 24-hour period the sun travels in an arc across the sky, and as it does so the colour and intensity of the light changes.

The most attractive periods for outdoor photography are early morning and late afternoon, when the sun is low in the sky. During these periods the light has a beautiful warmth which makes everything look photogenic and its intensity is reduced due to the thickness of the atmosphere. Long, raking shadows are also cast, revealing texture and modelling in even the flattest subjects. In the hours between, the sun is relatively high in the sky – reaching its zenith around noon. Many photographers naturally consider this to be the best time to shoot as there's lots of activity going on and high light levels allow fast shutter speeds and small apertures to be used. However, the light is very harsh, creating high contrast, and with the sun almost overhead, shadows are very short and dense. As a result, the landscape tends to look flat and uninspiring, while glare reduces colour saturation.

If you're forced to take pictures in these conditions, choose your subject and camera angle carefully.

A polarizing filter can be used to maximize colour saturation, while an 81A or 81B warm-up filter will help to balance the slight blue cast in the light. Portraits are best taken in the shade, where contrast is lower and the light's much softer.

Shooting in stormy weather is always a risky

business, but sudden changes in the light can create magical conditions for scenic photography. *Olympus OM1n, 50mm lens, 1/30sec at f/11, Fuji RF50.*

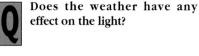

Most definitely – in some cases more so than the time of day. If a fluffy white cloud obscures the

sun, for example, the intensity of the light is immediately reduced and shadows are weakened. You can see this clearly in windy weather, when the sun is forever dipping in and out, but you need to take care with the exposure as the light levels can fluctuate by several stops.

Replace that cloud with a grey, overcast blanket and the effect is even stronger. Light levels fall dramatically, shadows almost disappear, and the sky acts like an enormous diffuser. The soft light of an overcast day is ideal for portraiture, fashion, outdoor glamour, and to a certain extent architectural and landscape photography. Colours take on a delicate, pastelly appearance, fine detail is obscured and visibility is reduced to create very moody conditions.

These effects are increased by mist and fog. Early morning mist gives scenes a flat, monochromatic feel that makes for very moody pictures. Fog is less photogenic because it reduces visibility, weakens colours and makes everything appear very flat. The all-encompassing greyness can also be rather depressing to look at.

To make the most of fog, try to include one or two dominant shapes such as buildings or trees rising out of the gloom, and ideally a splash of bright colour to provide a focal point. The effect of both mist and fog can be emphasized using a telephoto lens.

Dull, rainy weather is less inviting, but you can produce successful pictures in heavy downpours. Try using a slow shutter speed to blur the rain so it records like mist, or shoot against a dark background so the raindrops are clearly visible.

Stormy weather can also be very rewarding. If the sun breaks through against a dark, stormy sky the contrast creates incredibly dramatic conditions for landscape and architectural photography. If you're lucky you may even have the chance to capture a rainbow, or bolts of lightning. Predicting such phenomena is almost impossible though, so you simply have to brave the elements and hope for the best.

Does it matter where the sun is in relation to my main subject when I'm taking a picture?

Lighting direction is just as important as the intensity and colour of light, because it has a great effect on the appearance of your subject.

Most photographers still follow the old adage of keeping the sun over their shoulder when taking a picture. This is fine if the light has an attractive warm cast that makes everything glow. The downside is that shadows are cast behind your subject, so the results have a tendency to look rather flat. When the sun is low in the sky you may also have problems excluding your own shadow, especially when using a wide-angle lens.

A much better approach is to keep the sun on one side of the camera, or at least at an angle. That way, shadows are cast across your subject and help to reveal texture and form to give a strong threedimensional effect. This works particularly well during early morning or late afternoon, when shadows are long and the warm light glances across surfaces.

Dramatic images can also be created by shooting into the light. If you leave the exposure to your camera, any solid foreground features will record as strong silhouettes. Alternatively, meter carefully for your main subject, and either let the background burn out or tone it down with a graduated filter. BELOW LEFT Shooting with the sun to the left of the camera has made the most of raking light in this rustic autumnal scene.

Pentax 67, 55mm lens, ½sec at f/16, Fuji Velvia.

BELOW Frontal lighting reveals colour but lacks texture. Foreground interest adds depth. Olympus OM2n, 17mm lens, 1/60sec at f/11, Fuji RFP50.

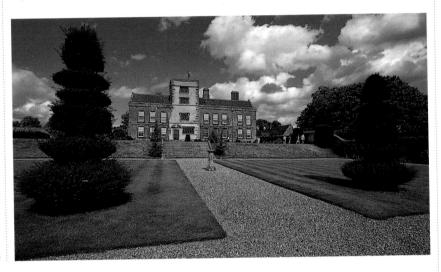

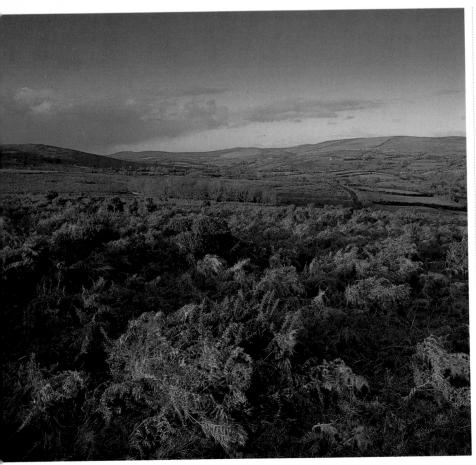

The direction from which light strikes your subject can have a powerful influence on its appearance. In the illustration above you can see how frontal, side and back lighting alter the way shadows are cast.

52

COLOUR TEMPERATURE

Yet another factor you need to consider is the colour of light. At sunrise and sunset daylight is much warmer than around midday, or in dull weather. Artificial light sources such as tungsten also have their own colour. These variations are measured using a colour temperature scale, and expressed using a unit that is known as 'Kelvin'. Warm light has a low colour temperature, cool (blue) light has a high colour temperature.

Our eyes can adapt to changes in colour temperature automatically, so any type of light looks more or less white. Unfortunately, film can't. It records colour temperature as it really is, so if you take pictures in light that's too warm or too cold your pictures will come out with a colour cast.

Normal daylight-balanced film is balanced for light with a colour temperature of 5,500k. This is usually found around midday in sunny weather, and is known as 'mean noon daylight'. At sunset, however, the colour temperature can be as low as 3,000k, so your pictures will come out much warmer than the original scene. Similarly, in intense sunlight under a clear blue sky the colour temperature can be as high as 10,000k, so your pictures will take on an obvious blue cast.

When accurate colour balance is required these casts can be corrected using filters. The table below shows the recommended filtration for a range of common situations captured on daylight-balanced film.

Source	Colour temp (k)	Filter required
Blue sky	10,000	orange 85B
Open shade in summer sun	7,500	81B+81C warm-ups
Overcast weather	6,500	8IC warm-up
Slightly overcast weather	6,000	81A warm-up
Average noon daylight	5,500	none
Electronic flash	5,500	none
Early morn/eve sunlight	4,000	blue 82C
Hour before sunset	3,500	blue 80C
Tungsten photopearl bulbs	3,400	blue 80B
Tungsten photoflood bulbs	3,200	blue 80A
Sunset	3,000	blue 80A
Domestic tungsten	2,800	blue 80A + 82C
Candle flame	2,000	blue 80A+80C

I'd like to take some pictures of a sunrise or sunset. Is there anything important I need to bear in mind?

Photographers often consider sunrise and sunset as more or less the same thing, but although both create beautiful conditions for

photography, they're completely different. When the sun comes up at the start of

the day it's rising over a cold earth and into an atmosphere that has been cleansed during the night, so while the first rays of sunlight may be very warm, shadows are blue and the landscape has a very cool, eerie aspect. The weather also plays a key role. On a clear, summer's morning the sun's intensity tends to be very high as soon as it peeps over the horizon - often too intense to include in a shot without causing flare. But in autumn and winter the sun is usually obscured by light mist or haze, so you can photograph its beautiful orange orb without any problems.

At sunset, conditions are rather different. The earth is much warmer, the atmosphere is thicker due to dust and pollution, and the light rays from the sun are scattered. This increases the warmth of the light considerably, and during the last hour before sunset it appears almost golden. The sun's orb also tends to look bigger because the light has to cut through the thicker atmosphere.

To exaggerate the size of the sun's orb

Scenes containing water always make good locations for sunrise and sunset pictures, as it mirrors the fiery hues in the sky. Olympus OM I n, 50mm lens, 1/125sec at f/11, Fuji RF50.

use a telephoto lens of 200mm or longer, but never look directly at the sun through your camera's viewfinder if it's bright, as you could cause permanent damage to your eyesight.

At sunrise, contrast tends to be quite low, unless you're shooting in clear, summer weather, so you can usually obtain a well-exposed foreground without burning out the sun itself. When this seems unlikely, use a grey graduated filter to darken the sun and sky so its brightness is toned down to match that of the landscape.

At sunset, the light is often stronger and contrast is higher, so the usual approach is to create silhouettes of key foreground details such as buildings, trees and people. This can usually be done by firing away with your camera on auto, but in very bright conditions you should take a meter reading from a patch of sky on one side of the sun, to prevent the sun's intensity underexposing the whole scene.

COMPOSITION ANSWERS

Painters have a distinct advantage over photographers when it comes to composing a picture. Their canvas is empty, and they can arrange the elements in a scene more or less as they wish – even excluding features if they feel it's necessary.

Unfortunately, you don't have the same freedom. Your canvas is already full, so in order to create a successful composition you first have to decide which part of the scene you want to capture, then arrange the elements contained in it so they form a visually pleasing whole.

To help you do this effectively there are many different tools at your disposal. Lenses allow you to control how much or how little is included in a shot. Choice of viewpoint and use of perspective affect how your subject appears. The quality of light can also be used creatively because it influences how well texture, shape, tone, colour and form are defined in a scene. There are even rules and formulas available to improve your compositional skills.

In the beginning you'll find yourself using all these things at different times. However, as your skills, confidence and experience grow, the whole act of composition will become an intuitive response to the things you see. Composition is a very diverse subject that's influenced by our individual style and way of seeing the world. This simple but highly effective image relies on the careful use of colour and symmetry for its appeal, for example, but it's doubtful any two photographers would capture it in the same way.

Q

What's a focal point, and how does it work in a photograph?

The focal point is the main point of interest in a picture, and the element to which the eye is naturally drawn. Often that will be your

main subject, as in the case of portraits. However, with scenic subjects, particularly landscapes, a focal point is usually included to add visual balance and give the viewer's eye something to settle upon – like a hiker on a hillside, or a barn in a field. Brightly coloured and easily identifiable objects make ideal focal points because they stand out, even when only very small in the frame. Where more than one focal point is included, the way you arrange them in the viewfinder can alter the compositional balance. A group portrait of three people will work better if the sitters are arranged in such a way that their heads form a triangle, for example, rather than a straight line, as the triangle is a very strong shape.

> Does the viewpoint I shoot from make a difference to the composition of a picture?

Many photographers have the habit of taking pictures from the first viewpoint they come across, but by exploring your subject from differ-

ent angles and positions you'll often come up with a far better shot.

First of all, always make sure you're close enough to your main subject. Nine times out of ten a picture can be improved simply by taking a few paces forward so the overall composition is tightened up and unwanted detail is omitted from the frame – as the late photojournalist Robert Capa used to say, 'If a picture's not good enough, you weren't close enough.'

Secondly, notice how changing camera-to-subject distance alters the relationship between foreground and background. The closer to your subject you are the more it will dominate the shot, whereas if you move further away it becomes smaller in the frame and has less emphasis.

With static subjects like landscapes and architecture it's always a good idea to have a stroll around for a few minutes before taking any pictures. That way you can find the best angle, locate suitable foreground interest, and observe the way your subject's appearance changes with the light falling from different directions.

Finally, never be afraid to shoot from unusual viewpoints. We're all used to seeing the world from eye-level, so by intentionally raising or lowering the camera you'll immediately produce an unusual image.

High viewpoints offer a much clearer view and allow you to see further into the distance. You can discover this by standing on a wall or chair. Scale is also changed, and the higher you go the more

THE RULE OF THIRDS

This is by far the most common compositional 'rule' used by photographers, and it's intended as a means of achieving visual balance in a picture.

All you do is divide up your camera's viewfinder into sections using horizontal and vertical lines a third of the way in from each corner. Your main subject or focal point should then be positioned on one of the four intersection points created.

The Rule of Thirds won't work for every picture you take. However, for pictures that include a small focal point it can make all the difference. In this scene, the isolated farm, which serves as the main focal point, has been carefully positioned in accordance with the Rule of Thirds to produce a balanced, harmonious composition.

dramatic it becomes. If you look down from a tall building or bridge, for example, people appear like small dots, dwarfed against much bigger structures. This in itself is enough to produce superb images if you home in on part of the scene with a telephoto lens, and can make the ordinary appear extraordinary.

Shooting from a low position to capture a worm's eye view of the world has the opposite effect. Smaller objects appear much larger in relation to their surroundings, so you can make people seem as tall as office blocks and create dramatic results in the most everyday locations. Subjects that are close to the camera also dominate the whole composition. When shooting landscapes, for example, you can make a relatively small object fill the whole foreground by crouching down and moving in close to it.

Shooting from a high viewpoint produces images that offer a surprising and unusual view of the world. This scene, captured from the Alhambra in Granada, Spain, appears almost like Toytown due to the strange angle and scale. *Olympus OM4Ti, 180mm lens, 1/500sec at f/5.6, Fuji Velvia.*

How can lines be used to improve the composition of a picture?

Lines serve three important purposes in a composition. Firstly, they help to carry the viewer's eye through the picture to the horizon

or focal point. Secondly, they can create a strong feeling of depth and make that picture appear three-dimensional. Thirdly, they can effectively divide a picture into well-defined areas, and help concentrate attention on the most important subject matter.

All sorts of man-made and natural elements form powerful lines, such as roads, walls, hedges, rivers, paths and fences. The furrows created by a plough or the shadows cast by lamp posts and

Converging lines carry the eye through a scene as they taper away into the distance, and in doing so produce a powerful visual effect. For the best results capture them with a wide-angle lens. *Pentax 67, 55mm lens, 1/4sec at f/16, Fuji Velvia.* trees also work well.

Wide-angle lenses are ideal for emphasizing lines because the way they stretch perspective exaggerates the effect. If you stand in the middle of a road and look down it through a 28mm lens, for example, the lines created will converge dramatically into the distance.

At the other extreme, a telephoto lens will allow you to make a feature of lines that would be lost in a wider view, such as the strong vertical lines created by tree trunks or other upright structures.

Different types of lines also create a different feel. Horizontal lines are restful and easy to look at, and carry the eye from left to right. Vertical lines, on the other hand, are more powerful because they suggest vertical movements.

Diagonal lines cover more ground, so they're ideal for carrying the eye up through a picture from the foreground, while converging lines are the most powerful of all because they add a strong impression of depth.

Finally, assumed lines can work as well as real lines. The line of a person's gaze will attract just as much attention as a road cutting across a scene, for example.

Does a picture look better if it's framed by something, like the overhanging branches of a tree?

Using natural or man-made frames in a picture can work wonders, because as well as tightening up the overall composition it also

directs attention on the main subject and gets rid of unwanted space. The overhanging branches of a tree make an excellent frame that hides dull, empty sky. Doorways, gateways and windows work well too. In fact anything that frames your main subject is suitable.

Again, wide-angle lenses are ideal for exploiting frames because their great angle-of-view allows you to juggle with the relationship between the elements in a scene. To make sure both the frame and your subject are in sharp focus, set a small aperture of f/11 or f/16 so there's plenty depth-of-field.

USING PERSPECTIVE

One of the biggest problems with photography is that you're recording three-dimensional subjects in two dimensions only. The third dimension – depth – is missing. To give your pictures a feeling of depth you must therefore include visual clues which suggest it, and by far the easiest way to do this is by using perspective creatively.

If you capture a scene that contains rows of similar-sized features, such as lamp posts, trees or buildings, for example, they appear to get smaller as their distance from the camera increases. This is known as 'diminishing perspective', and it's a common way of showing depth. In the same way, parallel lines created by roads, railway tracks and ploughed furrows suggest depth because they converge into the distance. This is 'linear perspective'. For the strongest effect, include the vanishing point where the lines appear to meet, and use a wide-angle lens from close range to emphasize the convergence.

Other forms of perspective include 'aerial' and 'tonal'. Aerial perspective occurs when contrast, colour and tone are reduced with distance due to atmospheric haze. You can show this by taking telephoto shots of mountains or hills – each layer of the scene will appear lighter than the one in front. Tonal perspective is based on the fact that light or warm colours are said to 'advance' while darker or cooler colours 'recede'. If you photograph an orange subject against a blue background, for example, tonal perspective will create a feeling of depth and distance.

Finally, lenses allow you to control perspective. If you take a picture through a telephoto lens the elements in a scene appear crowded together, while wide-angle lenses space everything further apart.

TOP Linear, diminishing, tonal and aerial perspective are all evident in this scene, and combine to produce a powerful sense of depth.

RIGHT Telephoto lenses – in this case a 135mm – appear to 'compress' perspective so distant elements appear closer together.

TECHNIQUE: COMPOSITION ANSWERS

USING PATTERNS

This jumble of harbourside cottages would be lost in a wide view, but by homing in with a telephoto lens a strong pattern has emerged that looks effective in its own right. *Olympus OM4Ti, 135mm lens, Fuji Velvia.*

We've already seen how the repetition formed by trees, lamp posts and other features have a role to play in emphasizing depth through perspective.. However, when approached in a different way they can create eye-catching, abstract compositions for no other reason than a pattern or rhythm is formed.

If you stand in line with a row of electricity pylons and peer through them, for instance, the repetition of bold lines and shapes produced looks stunning. Looking down a row of trees or architectural columns gives a similar result, which can be emphasized by using a telephoto lens to exclude all other elements from the shot.

If you keep your eyes peeled when you're out and about you'll also see patterns emerge in many other ways. Crowds at a soccer match, cars in a congested car park, apples in a grocer's window, goods on a market stall and piles of bricks or timber on a building site are just a few common examples.

TECHNIQUE: COMPOSITION ANSWERS

OPPOSITE By placing the horizon a third from the top of the frame, foreground interest such as these lakeside rocks can be emphasized to give a picture depth.

Olympus OM2n, 28mm lens, 1/30sec at f/16, Fuji RFP50.

RIGHT The strong vertical elements in this scene naturally suggest an upright composition. Olympus OM2n, 28mm lens, 1/60sec at f/11, Fuji RFP50.

> Will using a tripod help improve the composition of my pictures?

One advantage of using a tripod is that it slows down the picturetaking process and forces you to think more about what you're

doing. You can spend as much time as you like fine-tuning a composition until it's perfect, then leave it in position until you're ready to shoot.

From a purely technical point of view, a tripod also allows you to work at slow shutter speeds and small apertures, so you can exercise control over depth-of-field or take pictures in low light without worrying about camera shake. This in turn maximizes your options and makes composition much easier.

Q

Where's the ideal place to position the horizon in a picture?

Amateur photographers have a habit of sticking the horizon across the centre of the frame. But more often than not this is the worst

place for it because you end up with a static, lifeless image. Generally you should position the horizon a third up from the bottom or a third down from the top of a shot, so the other two-thirds of the picture area can be used to emphasize the foreground or sky. By positioning the horizon in this way you'll create a much more dynamic and visually pleasing composition. The only exception is if you want to produce a symmetrical picture of reflections; in a lake, for example. In those situations, a central horizon can work well. You should also make sure the horizon is perfectly level.

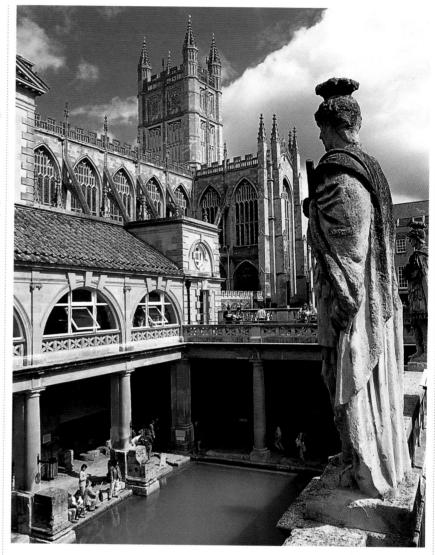

That really depends upon what you're photographing, and what kind of 'feel' you're trying to create. The horizontal format creates a

restful, soothing composition because it suggests repose, and echoes the horizon. That's why it tends to be used for landscape photography. Upright pictures are more energetic and powerful, suggesting motion and vertical direction, so this format is preferred for strongly vertical subjects such as tall buildings and trees.

There are no hard-and-fast rules about when to use each format, but both should be considered because the one you choose can make a big difference to the visual impact of the shot.

Is it okay to break the 'rules' of composition?

Rules are made to be broken, and often doing so can lead to far more impressive results. There's nothing to stop you placing your main

subject in the centre of the frame or cutting a picture in half with the horizon. Equally, no one says you have to produce logical, cohesive compositions.

Basically, the world's your oyster when it comes to composition, but your action must be intentional and considered if they're to produce successful work. And you must know the 'rules' of composition intimately before even thinking about abandoning them, because there's a big difference between bad composition and unusual composition.

COLOUR ANSWERS

Few photographers ever think about the colour content of a scene before committing it to film, but the way different colours relate can make a big difference to the success or failure of a picture. Certain colours harmonize beautifully, for instance, while others clash horribly. But unless you're aware of this you'll never be able to avoid or exploit it. Colour can also be controlled through the use of light, filters and film, giving you the opportunity to create an endless range of powerful effects.

Q

What are primary, complementary and secondary colours?

These three types of colour can be shown on a colour wheel which

contains all the colours of the spectrum – like a rainbow. Primary colours in photography are red, green and blue. If you have a light source in each of these colours it's possible to create any other colour. If you combine all three the result is white light. Complementary

The relationship between different colours can be seen by comparing them on a colour wheel representing the colours of the spectrum.

colours lie opposite each other on the colour wheel – cyan and red, magenta and green and yellow and blue. If you mix a primary colour with its opposing complementary colour you get grey. Secondary colours are formed by mixing two other colours together to form purple, orange and violet.

When you take a picture these colours are formed by the colour layers in the emulsion. Those layers comprise the colours of cyan, magenta and yellow, which record the brightest because they require only one dye layer. Primary colours are formed by the combination of two layers - yellow and magenta form red, yellow and cyan form green, and magenta and cvan form blue - so a wide variety of shades is possible. The secondary colours are formed by a combination of all three layers, so their brightness is never as strong. They're also the most difficult to record - violet often comes out pink, for example, due to the film's spectral sensitivity.

Use of contrasting colours in a picture is a powerful creative tool because it produces images that jar

Although red and blue don't form the strongest colour contrast, they nonetheless produce a very striking result when combined.

the senses and attract attention. Young people often choose to wear clothes that clash so that they stand out from the crowd as you'll know only too well, if you're old enough to remember the 'punk rock' generation. Well it's exactly the same in photography.

The strongest colour contrasts are formed if you combine a primary colour with its opposing complementary colour in equal strengths – see the colour wheel bottom left. Yellow and blue are good examples. They clash violently when included in the same picture. The effect is weakened if one colour occupies more of the shot than the other, or one colour is stronger than the other.

Another factor to consider is the way different colours work on their own. Warm colours such as red, yellow and orange are said to 'advance' because they stand out, while cool blues and greens 'recede' because they remind us of open space – the sea, sky and countryside. So if you combine a warm colour with a cool colour, the warmer colour will always dominate the shot, even in small amounts, but the cooler colour will form an attractive background.

TECHNIQUE: COLOUR ANSWERS

THE SYMBOLISM OF COLOUR

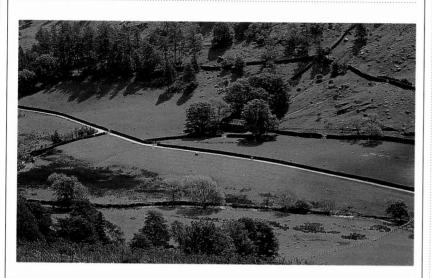

Colour also has the power to evoke different reactions in the viewer due to the way we associate different colours with our moods and emotions.

Red is associated with blood, romance, evil, love, hate, danger and anger, and is often used as a warning due to its brightness and ability to attract attention. Orange and yellow are soothing, relaxing colours that remind us of warmth and the sun.

Of the colder colours, blue can suggest freedom and wide open spaces (the sky and sea), as well as being cold, lonely and sad. Finally, green is nature's own colour so it reminds us of the great Green is a very lively colour that's refreshing and soothing to look at in a picture.

outdoors, freshness, new birth and beauty.

You're not going to create these feelings in the viewer simply by including a certain colour in your pictures, of course, but it's worth bearing in mind this subliminal power when you take a picture. A fiery sunset enhanced by an orange filter will radiate warmth, for instance, while a picture taken on a cold, misty day with an overall blue cast will send a chill down the hardiest spine.

Which colours harmonize the best?

Colours that are close to each other in the colour wheel produce a harmonious result – such as yellow

and red, yellow and green, green and blue and so on. However, any colours will harmonize if they're weak enough.

Colour harmony is useful because it allows you to produce images that have a soothing effect on the viewer. Think of the beautiful colours of woodland in autumn, or the soft hues in a misty landscape.

You can also take superb pictures of scenes comprising just one colour, or the same colour in different shades. Again, soft, hazy light tends to create this effect in nature by bringing the colours closer together, but you'll also find man-made evidence of it too. The effect is known as 'monochromatic colour'.

How can I make sure the colours in a scene look as deeply saturated as possible?

brand. Fujichrome Velvia is renowned for its supersaturated colours, for example, while Kodachrome 64 has a more neutral rendition.

Secondly, the quality of light can affect colour saturation considerably. Colours tend to be revealed at their strongest by

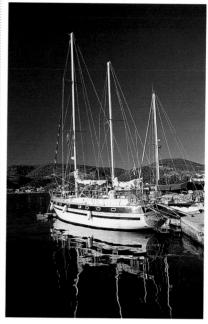

For this shot, bright sunlight, slow film and a polarizing filter were combined to maximize colour saturation.

Late afternoon haze often reduces the landscape to series of delicate warm shades which harmonize beautifully.

bright sunlight during mid morning and mid afternoon, with the light striking your subject frontally.

Thirdly, you can maximize colour saturation by using a polarizing filter to reduce glare on non-metallic surfaces and deepen blue sky. See Filter Answers, page 20, for more details. If you're using slide film, colour saturation can also be increased if you underexpose your pictures by a third or half a stop.

PROCESSING ANSWERS

With processing labs in just about every high street around the country, processing your own films may seem like a waste of time. However, the advantage is it puts you in control of yet another vital part of the photographic process. You can use materials that are intended for a specific brand of film, and vary processing times for film that has been up- or downrated so the possible best results are produced.

Processing black and white film involves just three chemicals – developer, fixer and stop bath, all of which can be purchased from your local camera shop. Developer reacts with the silver halides in the film emulsion to reveal the image. Step bath – a weak solution of acetic acid – is then is used to arrest development by neutralizing the developer. Finally, fixer is used to clear the film and make the image permanent.

Below is a list of the basic items you'll need, all of which should be easily obtainable from your local photo shop.

Could you offer me any tips for loading a roll of film on to a spiral? I always seem to end up in a muddle.

Having to work in complete darkness makes loading film tricky in the beginning, simply because you cannot see what you are doing.

However, if you have a few practice runs with a blank roll of film, first in daylight, then in the dark, you will soon be able to find your way around by touch alone.

To avoid problems, make sure the spiral is completely dry as any moisture in the grooves will cause the film to jam. Blowing the spiral with a hair drier for a few minutes should do the trick.

TECHNIQUE: PROCESSING ANSWERS

I. Cut off the film leader to create a straight line with curved corners.

2. Feed the end of the film on to the spiral using your fingers to guide it into the grooves.

3. Pull out a length of film from the cassette, then carefully rack the sides of the spiral back and forth to feed it onto the grooves.

4. Once the film is fully loaded, cut off the spool with a pair of scissors.

5. Pop the spiral into the tank and secure the lid. You can now switch the lights on and begin processing.

How can I load film on to a spiral if I do not have access to a room that can be blacked out?

Buy a lightproof changing bag, which will allow you to load film onto the spiral in daylight. The film, spiral and tank are placed inside

the bag, and you put your hands through two elasticated holes to do the loading.

What is the best way to store processing chemicals?

Once you open a bottle of developer or fixer it starts to oxidize due to exposure to the air, and eventually becomes exhausted. To prevent wastage, buy small quantities of liquid concentrate in the beginning – 250ml are ideal. Larger amounts are only worth buying if you process a lot of film.

Most film developers are known as 'one-shot'. This means you dilute the concentrate to produce the required amount, then discard it immediately after use. Stop bath and fixer can be re-used until they are exhausted.

Chemicals for re-use should be stored in full, tightly-capped bottles. Plastic or glass drinks bottles are fine, although special concertina storage bottles are better because they can be squashed down to remove excess air. To remove air from partly-used bottles of concentrate, either squeeze the sides of the bottle or drop glass marbles into them until the liquid reaches the top of the neck.

.....

Is liquid developer better than powder?

Both work equally well. Liquid concentrates are convenient because you just dilute the amount required. Powder developers have

to be mixed first, then you can either use the stock to develop several baths of film, or dilute a small amount of it to produce a one-shot working solution.

There are lots of black & white film developers available. What is the difference between them?

Most of the time a general purpose developer is the best choice because it offers the ideal compromise between image contrast,

sharpness and grain size. However, there are other types available that have certain characteristics you may find useful. If you uprate a film to a higher ISO, for example, you'll need a 'compensating' developer. You can also buy developers that give extra-fine grain, increase contrast to give sharper results, and developers that can be used in different dilutions to vary image contrast.

Once your experience grows you can choose developers to suit specific brands of film, different subjects and varying lighting conditions depending on the type of results you want to produce.

TECHNIQUE: PROCESSING ANSWERS

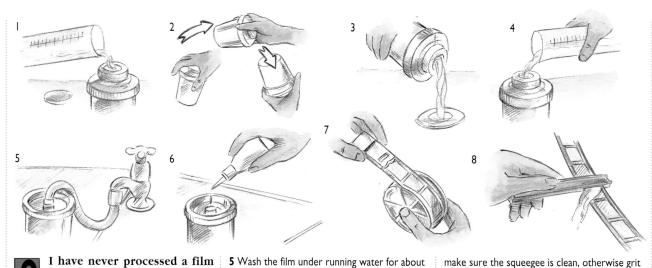

I have never processed a film before. Could you run through the procedure stage by stage?

Once you have loaded the film into the processing tank, clear a suitable working area and get all your chemicals and equipment ready.

The chemicals should be mixed according to the manufacturer's instructions, using measuring graduates to get the quantities right, and clean water. Mark each graduate 'Dev', 'Stop' and 'Fix' so they don't get muddled up in the future.

The correct temperature for processing black & white film is 20°C (68°F). If the chemicals are too warm, place the graduates in a basin of cold water; if they're too cold, use warm water. Check the temperature with a thermometer, and remove them when they reach 20°C.

I Pour the developer briskly into the tank and start the timer. Once all the developer has settled in the tank, place the lid on the tank then tap the tank base on a solid surface to dislodge any air bubbles on the film surface. 2 Agitate the film for 10 seconds by inverting a couple of times. This helps to ensure even development and should be repeated for 10 seconds every minute, or according to the manufacturer's instructions.

3 Keep an eye on your clock or timer, and 10 seconds before the development period ends, start pouring the solution out of the tank into a jug. Pour in the stop bath, agitate the tank continuously for about a minute, then return the stop bath to its storage bottle.

4 Pour in the fixer, agitate continuously for the first 15 seconds, then for 10 seconds every minute. Fixing usually takes a couple of minutes, after which the solution can be returned to its storage bottle for future use.

5 Wash the film under running water for about 30 minutes to remove excess fixer. For the best results feed a hose from the tap into the tank to ensure thorough cleaning, and use a water filter if your local water supply is dirty.

6 Before removing the film, place a couple of drops of wetting agent in the final rinse. This is a weak detergent which breaks down surface tension so excess water slides off the film and it dries quickly and evenly.

7 Pull a few inches of film from the spiral and attach a film clip to it, then draw out the rest. 8 Remove excess water with a squeegee -

Exposure error A correctly exposed negative shows a good balance of detail in both the highlights and shadows.

Development error A well exposed and developed negative shows a good range of tones, with shadow detail.

(see opposite)

may scratch your film. Fit a weighted clip to the

9 Hang the film up to dry in a clean, dust-free

room for at least 12 hours. Once dry, cut the

film into strips of five or six frames with a pair

are correctly developed?

How do I know if my negatives

of scissors and place them in filing sheets.

other end.

An underexposed negative has an overall light appearance, with low contrast and no visible shadow detail.

A correctly exposed but underdeveloped negative will exhibit low contrast and weak highlights.

An overexposed negative appears dark and dense, with loss of subtle highlight detail and weak shadows.

A correctly exposed but overdeveloped negative looks very dense and contrasty.

NEGATIVE FAULTS

Occasionally you may examine a newly processed roll of film and find some or all of the negative ruined by various faults. To help you identify them, here is a rundown of the most common.

Clear film If the lettering on the film edge is visible the film was grossly underexposed – probably due to taking a picture with the lens cap on – or you processed a roll of unexposed film. If the lettering is missing, fixer was poured into the tank before the developer.

Black film If the lettering on the frame edge is visible the frame was grossly overexposed. If it is missing the film was badly fogged either before or during development. To avoid this take care when loading/unloading film. **Grey veil or streaks** indicate the film was fogged before development – check your camera back or darkroom for a light leak. Grey fog and sprocket edge line indicate fogging during development.

Undeveloped patch on film This problem is caused by loops of film on the spiral touching, resulting in areas of the film not receiving developer and fixer. Usually due to poor loading of the film.

Crescent-shaped black marks are caused by the film being creased, usually during loading into the processing tank so the emulsion is damaged. Avoid by careful loading, and start again if the film jams rather than forcing it. Milky veil over film or colour differences on film base indicates underfixing, so the film didn't clear completely. Can be rescued by refixing. Test fixer before use with a spare film leader – it should completely clear in the recommended fixing time.

Powdery stains are caused by chemicals left on film due to insufficient washing. Rewash film to try and remove them. Water droplets left on film as it dries also cause drying marks which appear as circular patches.

Dense negs with yellow stains or grey streaks usually indicate the developer was exhausted. To prevent this, never use stock solution for more films than recommended, and store in full, tightly capped bottles.

Grey veil or streaks

Crescent-shaped black marks

Milky veil over film

Black film

Powdery stains

Dense negs with yellow stains

If you expose the film correctly in the first place, then follow the manufacturer's recommended development time and keep the

developer at 20°C, there is no reason why you should not get perfect results.

The problem is that badly exposed negatives look similar to badly developed negatives, so if there is a fault you may not be able to identify the cause when you first start processing your own films. Following a set processing routine will make life easier, because if you develop the film correctly, any error can be attributed to exposure, but if you use sloppy working practices you won't have a clue what went wrong.

Once a roll of processed film has dried, examine the negatives on a lightbox and use the examples given here as a guide to check that yours are successful, or if not, where the error was created. Your aim should be to produce a correctly exposed and correctly developed negative that will print easily on normal grade 2 paper and produce a full range of tones from pure white to deep black.

Agitation ensures that the whole film receives even development and fixing, and that fresh chemicals

regularly wash over the film. The easiest way to agitate is by inverting the processing tank a couple of times.

Most manufacturers recommend that you agitate for 10 seconds every half minute or minute. Failure to adhere to this may cause uneven development.

PRINTING ANSWERS

So you've processed your first film, produced a successful set of negatives, and now the time has arrived to make your first prints. Excited? Good, you should be, because printing your very own pictures is an incredibly rewarding experience that will amaze and delight you for many years to come.

The procedure involved in making black & white prints is relatively simple providing you follow a few guidelines, so there's no reason why you shouldn't get perfect results on your very first attempt. All you need to do then is practise, practise and practise some more.

The thing to remember with black & white photography is that half the work and most of the fun comes in the darkroom, after the initial picture has been taken. Once you've amassed a little experience, endless manipulations are possible and you can take complete control over the whole process to establish your very own style of working.

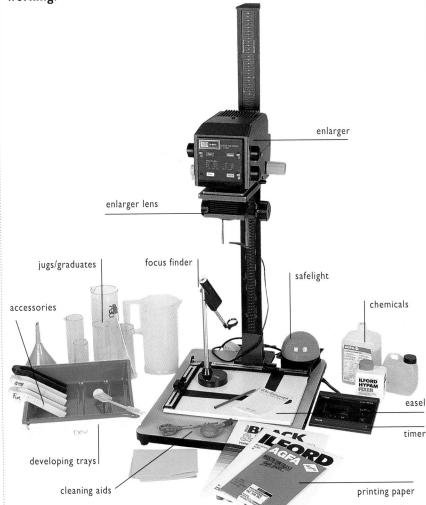

What equipment do I need to make black & white prints?

The basic equipment required to make enlargements from black & white negatives is relatively inexpensive. Most of the items

you'll need can be picked up secondhand if you're working to a tight budget, and in some cases you can improvise by using things you already own.

1 The enlarger forms the heart of any darkroom. It's also likely to be the most expensive item, so you should think long and hard before choosing a model. Most of the prints you make will probably be no bigger than 10x8in, but it's worth buying a model that will allow enlargements up to 16x12in or even 16x20in.

If you can afford the extra it's also a good idea to buy an enlarger with a colour filter head. This means you can make colour prints and use the filters for variable-contrast black & white papers.

Finally, go for an enlarger with a diffuser light source rather than one that uses condensers, as the latter produces much contrastier results and tends to show every speck of dust on the negative.

2 Enlarger lens The quality of your enlarger lens is of great importance because it determines the sharpness of your prints – especially once you start making big enlargements. Six-element lenses cost more than four-element models, but they're sharper and worth paying the extra for. An illuminated aperture scale will also come in handy, plus a wide maximum aperture – f/2.8 is ideal – to aid focusing when you're printing from dense negatives.

For prints from 35mm negs use a 50mm lens, and for 6x4.5cm, 6x6cm and 6x7cm use an 80mm lens.

3 The easel, also known as a masking frame, holds your printing paper flat on the enlarger's baseboard during exposure. It can be adjusted to accept different sizes of printing paper, and allows you to create a white border around the print's edges. 16x12in is a good for general use.

TECHNIQUE: PRINTING ANSWERS

4 A timer is handy for giving precise control over print exposure times and consistency of results. The best timers are wired up to the enlarger, so all you do is set the required time, press a button to switch the enlarger on, then the timer switches it off at the end of the set time.

5 The safelight A low-powered light which provides enough visibility in the darkroom so you can see what you're doing, but won't fog black & white printing paper. For standard bromide paper a red light is used, but for variable-contrast papers a copper light is more suitable.

6 The focus finder This handy accessory allows you to focus on the actual grain of the film to ensure the image you're printing is perfectly focused.

7 Developing trays These are chemicalresistant plastic trays used to process the print. As a minimum you need three: one for the developer, one for the stop bath, and one for the fixer. They should also be slightly bigger than the printing paper.

8 Jugs/graduates Accurate measuring of chemicals is essential for high-quality results, so equip yourself with a selection of measuring jugs and graduates. To prevent cross-contamination, mark each one with either 'Dev', 'Stop' or 'Fix'.

9 Cleaning aids To minimize retouching, each negative should be carefully cleaned before printing using a blast of canned air, a blower brush or an antistatic brush.

10 Chemicals You need three: developer, stop bath and fixer. Different types of developer are available to give optimum results with certain printing papers, but you can produce acceptable results using one brand for all conventional papers. Stop bath and fixer can also be used with any paper type. Always mix according to the manufacturer's instructions, and discard when exhausted.

11 Accessories Tongs to lift prints from trays, a cloth to wipe your hands and mop up spills, scissors to cut paper/film, thermometer to check chemical temperature, and pad and pencil to note exposure details.

12 Printing paper (see page 70)

There isn't enough space in my home for a permanent darkroom. So where's the best place to print?

Most enthusiasts are in the same situation, but they get around it by temporarily converting a room in their home. The bathroom, a spare bedroom, a cupboard under the stairs, even the garden shed will do providing it meets the following criteria:

• It can be blacked out easily to prevent the fogging of printing paper

• You have sufficient space to position an enlarger and processing trays well apart, so there's no danger of liquids coming into contact with live electricity

• It has adequate ventilation

• There's an accessible power point to plug in your enlarger and safelight.

Bathrooms tend to be a favourite choice

because running water is on hand. A sheet of plywood laid across the bath will create a surface for your processing trays, and you can stand the enlarger on a small table or cupboard. The main drawback with bathrooms is they don't have socket outlets, for safety reasons, and you can guarantee that as soon as you start printing the whole family will want to pay a visit.

A spare bedroom is better, because you won't necessarily have to pack everything away after each session. The same applies with a garage, garden shed or cupboard under the stairs. Don't worry about running water – you can always put processed prints in a bucket.

If all else fails, an empty cellar or loft with no windows to black out would do. The only snag is that cellars tend to suffer from damp, which can damage equipment and ruin printing paper, while lofts tend to be boiling hot during summer and freezing cold during winter.

If you don't have the space for a permanent darkroom, your bathroom can be easily converted for temporary use.

- board over bath for print trays
- place processed prints in a tray in the bath
- running water to wash prints
- enlarger placed on cupboard
- board over sink to hold paper and negatives
- window blacked out with black board
- safelight

Got a vacant understairs cupboard? Then with a little planning it can easily be converted into a functional darkroom.

- enlarger
- printing paper

0

- timer
- safelight
- storage shelves
- bench for trayswhite light with
- pull-switch
- socket outlet
- paper storage louvre
- bucket for processed prints
 cloth to dry hands
- doorframe lined to give lightproof seal
 - louvre ventilation in door

TECHNIQUE: PRINTING ANSWERS

you first need to produce a test strip to

determine the exposure required. Because

you're dealing with maybe thirty-six differ-

ent images it's impossible to get the expo-

sure for every one perfect on the same sheet, but by trying various exposures you

can find the best compromise. The step-

by-step guide below gives full details of

- anything from 5 to 15 seconds - you can make the final contact sheet by laying the

negatives out on a full sheet of printing

paper, exposing it for the required time, and repeating the processing stages

mentioned below. After washing and

drying it you can then decide which shots

correctly exposed on the contact sheet.

This is virtually impossible unless the

whole roll of film was shot in very similar

conditions, so a second contact sheet may

be required for some frames if you want

Don't expect every frame of film to be

Once you know which exposure to use

how to make a test strip.

How do I know which negatives will make good prints after processing a roll of film? It's difficult to tell just by looking at them.

You're right, it is difficult to see what a picture is going to turn out like just by looking at the negative. So to make your life easier you can

produce a contact sheet from the set of negatives. This is basically a print containing a small positive image of each shot from which you can choose the best for enlargement.

It's important that you make goodquality contact sheets as they will be filed away with your negatives and used for reference on many occasions when you want to make prints from a particular film. They can also be marked with cropping lines and other information as you decide on the best way in which to print individual frames.

Before making the final contact sheet

I Under safelight conditions place half a sheet of printing paper (10x4 inches) on the enlarger baseboard, emulsion side up. Cover the lens with a red safety filter and turn the enlarger on to check that the pool of light covers the paper.

to enlarge.

to see them all.

2 Carefully lay strips of negatives, emulsion side down, on the printing paper until the sheet is full. Place a clean sheet of glass over the negatives to hold them flat, then cover two-thirds of the area with a piece of black card.

3 Switch on the enlarger and expose the area shown for 5 seconds. Uncover two-thirds of the printing paper and expose for a further 5 seconds, then remove the card completely and expose the final one-third for 5 seconds.

4 Your chemicals should already be mixed up and ready for use. You'll need a tray of developer, a tray of stop bath and a tray of fixer. Mix enough chemistry to half fill each tray, make sure the developer is at roughly 20°C (68°F).

7 Place the print in a tray of fixer, face down, and agitate for about 20 seconds. Turn the print over, continue to agitate the tray gently, then after 1 minute, turn the room lights on and complete fixing. The contact test sheet is now complete.

8 Remove the test sheet from the fixer, drain off excess chemistry then wash for about 5 minutes under running water. Now examine the test strip to determine which exposure is required for the final contact sheet.

5 Place the test strip in a tray of print developer and start your timer or clock. Gently agitate the tray so developer washes over the print, and continue agitating until the end of the recommended development time – usually 1½ minutes.

6 Lift the print from the tray and allow excess developer to drain off for a few seconds. Place it in a tray of stop bath and agitate the tray gently for about 30 seconds. Lift the print from the tray with another pair of tongs and allow to drain again.

I Select the negative you want to enlarge by examining the contact sheet already made. Clean the negative to remove any particles of dust then place it in the negative carrier and slot the carrier into the enlarger.

5 Switch off the enlarger, then under safelight conditions, cut a strip of printing paper about 12cm (3 or 4 in) wide from a sheet of the same type and contrast grade you intend to use for the final print. Return the rest of the paper to its box.

2 Switch off the room light, turn on the enlarger and set the enlarger lens to maximum aperture. Adjust the height of the enlarger head until the image it projects on the masking frame is the correct size for the final print.

3 Place the masking frame on the enlarger baseboard and adjust the blades to hold the size of paper you want to work with. Remember to make provision for a neat white border around the edges of the print.

4 Focus the image on the masking frame by adjusting the focusing control on the enlarger head while looking through a focus finder placed on top of the masking frame. Set the enlarger lens aperture to f/5.6 or f/8.

8 Remove the test strip from the masking frame and process it as you did the contact sheet. When fixing is complete, turn on the room light and check the strip to see which exposure you need to use for the final print.

TECHNIQUE: PRINTING ANSWERS

LEFT A carefully made contact sheet will prove invaluable for assessing your work and deciding which shots to enlarge.

Number each sheet and film so you know which goes with which, then you can start an organized filing system for your work straight away. This will make retrieval of specific shots easier as your collection grows.

BELOW This test strip was exposed for 5, 10, 15, 20 and 25 seconds. As you can see, the area receiving 15 seconds appears to give the best result.

How do I know how much exposure to give a print?

More often than not each negative you enlarge will require a different exposure due to variations in image density, the type of film and

paper you use, plus the actual size of the enlargement made. To discover what this exposure is you need to make another test strip, this time using just the negative you want to print up (see below).

7 Hold a sheet of black card an inch above the masking frame so only one-fifth of the strip is revealed, switch on the enlarger and expose for 5 seconds. Repeat this procedure until the whole of the strip has been exposed a section at a time.

6 Place the strip of printing paper on the masking frame so it covers an area that's either representative of the whole picture area, or concentrates on the most important subject matter – like your subject's face in a portrait.

TECHNIQUE: PRINTING ANSWERS

So how do I make the final enlargement?

With the test strip completed, the required exposure chosen and the enlarger already set up to produce a print of the required size, you're

almost there.

Now all that remains is to give the negative one last clean, make sure the chemicals and everything else you need is ready and waitng, then follow the steps right. If you are still a little unsure, try a dry-run first to get used to the procedure.

I Set the required exposure on your enlarger timer, then turn on the enlarger so it projects the image of the shot onto the masking frame. Check to make sure it's still sharply focused.

CHOOSING THE RIGHT PRINTING PAPER

With so many different brands to choose from, deciding which type of printing paper to use can cause great confusion. To ease that, let's look at the main factors you need to consider.

Firstly, most brands of paper come in two forms: resin-coated and fibrebased. Resin-coated paper is ideal for beginners as it has a plastic base which aids flat drying and it only needs to be washed for 5 minutes. Fibre-based paper gives a wider tonal range, so it's preferred by experienced printers, but it must be washed for at least 45 minutes to remove all traces of chemistry, and it curls while drying.

In terms of size, l0x8in is ideal for general use as it's fairly economical, while 16x12 or 16x20in is better for exhibition and portfolio prints. Glossy is the most popular surface finish because it gives very clean, crisp prints, but a matt or semi-matt finish may suit certain shots. Finally, printing paper is made in different contrast grades, so you can produce the best prints from negatives with different contrast levels. These grades run from 1, which is known as 'soft' because it reduces contrast, to 5 which is known as 'hard' because it increases contrast to give stark prints with few mid-tones. A well-exposed negative with an average contrast range should print easily on grade 2 paper, so this is considered 'normal'.

To make life easier you can buy variable-contrast paper such as Ilford Multigrade III or Agfa Multicontrast which allow you to obtain any contrast grade, from 0 to 5 in half-grade steps, from the same box of paper. This is achieved using filters which are fitted above or below the enlarging lens, or by dialling in the necessary filtration on your enlarger's colour head if it has one.

The table shows the filtration values required to obtain different grades.

	Filtration		
Durst enlargers	De Vere enlargers	Kodak CC filters	
110Y	170Y	80Y	
70Y	115Y	30Y	
none	none	none	
30M	20M	25M	
45M	70M	40M	
95M	120M	100M	
130M	200M	150M	
150M	-	-	
	enlargers I I 0Y 70Y none 30M 45M 95M I 30M	Durst enlargersDe Vere enlargers110Y170Y70Y115Ynonenone30M20M45M70M95M120M130M200M	

2 Switch off the enlarger, then under the safelight remove a full sheet of printing paper from its packet and place it in the masking frame Expose the print for the required time.

3 Develop, stop and fix the print as you did the contact sheet and test strip. After washing for 5 minutes, turn on the room light to assess your handiwork, and then lay the print on a flat surface to dry.

Which type of print developer is best for a beginner?

Any make of developer can be used with any conventional type of paper, so it doesn't really matter which one you go for. Standard

brews such as Ilford PQ Universal or Paterson Acuprint are ideal if you intend using different types of paper, but there are developers specially designed for variable-contrast papers too, such as Ilford Multigrade or Paterson Acugrade.

Buy developer in small quantities as it begins to oxidize once the bottle has been opened and partly used – 250ml bottles of concentrate are a good size. Diluted print developer can be re-used providing it's stored in full, tightly stoppered bottles, but you should discard it once the specified number of prints have been developed, otherwise it won't give top-quality results.

CHOOSING THE RIGHT CONTRAST GRADE

Deciding which grade of paper to use for a particular print can prove confusing to begin with, but as your experience grows you'll know exactly which one will give the best result just by looking at the negative.

As mentioned earlier, a negative with an average contrast range should print easily on grade 2 paper, providing it's well exposed and developed. However, a picture taken in dull, flat light may need to be printed on a harder grade, say 3 or 4, to boost contrast and produce a more punchy result. Similarly, a picture taken in harsh, contrasty light may need a softer grade such as 1 or 1½ to produce the maximum tonal range, otherwise detail will be lost on the print.

Different grades can also be used intentionally to create certain effects. Harder grades are ideal if you want bold, graphic prints, for example, because they produce deep blacks and clear whites with fewer mid-tones.

BELOW Printing the same negative on different grades of paper produces completely different results. Notice how contrast increases considerably as you move from grade 0 to 5 in this comparison, resulting in a loss of highlight and shadow detail. Grade 3 gives the best result.

It's also vital that you leave prints in the developer for the recommended period – usually 1 to 1½ minutes. If a print seems to be going very dark too soon it's tempting to 'snatch' it from the developer prematurely, but this doesn't solve the problem because that print won't exhibit a full range of tones – usually the highlights will be washed out and lacking detail. If this occurs it's because the print has received too much exposure under the enlarger, so reduce the exposure and make another print.

If everything has gone according to plan you should have an acceptable print which shows a full range of tones. Don't worry if you haven't – just try again and eventually you'll get there.

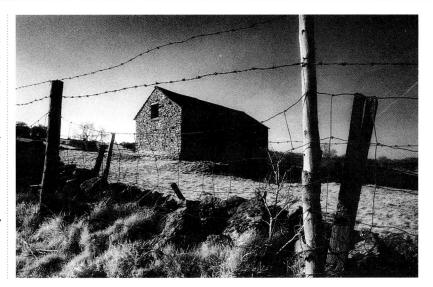

My prints always seem to have something wrong with them. Could you outline the most common print faults, and how to get rid of them?

If you take your time when printing, and work with a well exposed, correctly developed negative, there's no reason why your first

prints shouldn't be close to perfect. However, more often than not, enlargement will reveal a number of flaws you weren't aware of that will need to be remedied either by making another print or treating the one you've already made.

Below I have outlined the most common faults and provided hints on how to overcome them.

Uneven border Caused by not putting the printing paper into the masking frame properly. Next time, make sure it aligns correctly with the guides on the frame so you get an even border.

White spots and lines Dust and hairs on the negative are responsible for this problem. Thorough cleaning of the negative before printing should prevent it, but if the marks are too bad you can spot them out with dyes (see Dodging and Burning opposite).

Black marks These marks indicate scratches on the negative which allow too much light through to the printing paper. Severe scratches can't be corrected, but you can bleach out the marks on the print.

Area too light or too dark The exposure you use may be correct for most of the shot, but with high-contrast negatives you may still end up with areas that are too light or too dark. Either problem can be remedied by giving extra or less exposure to the required areas using dodging and burning-in techniques (see Dodging and Burning opposite).

Part of picture obscured A fault of this nature indicates something was blocking out light from part of the print. It could have been the red swing-in filter on your enlarger, or your hand straying into the light path during exposure.

Untidy edge This happens if you don't crop out the very edge of the negative

using your masking frame. The rebate of the negative appears on the print as an uneven, slightly blurred line. To get rid of it, adjust the masking frame to make a slightly smaller print size.

> uneven border / white spots and lines -black marks -area too light or dark -part of picture obscured -untidy edge ---

By correcting these faults you'll eventually end up with a perfect print that looks very neat and professional and exhibits a full range of tones.

DODGING AND BURNING

If you've done everything right, there's no reason why you shouldn't end up with a near-perfect print. However, because the brightness range that printing paper can record is smaller than the range a negative can record, you may find that some areas of the print are too light or too dark.

If you enlarge a landscape, for example, and print so the foreground is

Burning in

If large areas need burning in, such as the sky in a landscape, you can use a sheet of card or your hand to cover the rest of the image while extra exposure is given. Take care not to cover areas that don't require burning in.

For smaller areas, cut a hole in a piece of black card and 'paint' them with light. Moving the card closer to the print reduces the pool of light produced, and vice versa.

What's the easiest way to get rid of the white marks caused by dust and hairs?

You'll need to buy a special black dye such as Kenro Spot-On and a fine sable brush - 00 and 0 sizes

are ideal. Dilute a tiny amount of dye with water until its shade matches the tone of the area to be retouched, then cover the blemish by applying tiny spots of dye. With bad marks, build up the density of the dye gradually. correctly exposed, more often than not the sky will be far too light. Similarly, if you correctly expose the highlights when making a print, the shadows may go too dark.

To solve this problem, two handy techniques known as 'dodging' and 'burning in' are used. Dodging involves shading areas of the print during exposure so they receive less light and come

Dodging

Small areas can be dodged by taping a small disc of card to a length of fine, stiff wire, then holding it over the area you need to lighten. Vibrate the dodger gently during the exposure so it doesn't leave any tell-tale marks.

To dodge larger areas use your hand or a piece of card cut to roughly the right shape and hold it in the light path. Again, move it gently from side to side to produce a neat effect.

out lighter, while with burning in you expose selected areas of the print for longer so they go darker, while shading the rest of it.

The extent by which the exposure must be increased or reduced can be determined by analysing the initial test strip, and where necessary making further test strips which concentrate on different areas of the image.

Precise control

Where intricate areas require dodging or burning in, make a card mask by holding a sheet of black card about 6cm above the masking frame and tracing the outline of the area onto it.

Next, carefully cut out the mask with a craft knife, then hold it in the light path while you expose the final print, so the required area is lightened or darkened.

Is it possible to make a decent print from a badly exposed or poorly developed negative?

It is possible, but don't expect the same quality you'd get from a wellexposed and correctly developed negative.

Underexposed or overdeveloped negatives appear rather thin and produce very flat, grey prints. You may be able to rescue the shot by printing on a harder grade of paper – try 3 or 4. If that doesn't work, immerse the negative in an intensifier such as Kodak IN-5 to boost contrast, then reprint on grade 3 paper. If the negative has been overexposed or underdeveloped it will appear very dark and dense and produce prints with plenty of shadow detail but burnt-out highlights. This time you may be able to rescue it using an image reducer to lower contrast and bring out what detail there is in the highlights. Alternatively, try printing so that the mid tones are correct, then dodge the shadows and burn in the highlights.

PROBLEM-SOLVING ANSWERS

Making mistakes is an important part of the photographic learning process - if we got everything right on our first attempt, much of the challenge and excitement would be lost. Knowing what caused those mistakes and how they can be rectified is equally important though, otherwise they will continue to be made and could eventually blight your progress as a photographer.

Most photographic problems are easy to identify, and their cause can usually be related to one of three things: user error, equipment error, or processing error. Once you've established that, solving the problem and making sure it doesn't happen again is relatively straightforward.

Here are just a few of the methods you can use to keep your camera steady and ensure pinsharp pictures: (1) lie on the ground and use your elbows to support the camera and telephoto/telezoom lens; (2) press the lens against a wall or post; (3) in windy weather hang your gadget bag from the tripod to increase its stability; (4) use a monopod to support long lenses, or to allow you to work at slower shutter speeds without causing camera shake.

I tend to take a lot of pictures that are ruined by camera shake. What's the easiest way to overcome this?

Camera shake is caused by accidental movement of the camera during the moment of exposure, and produces images with slight or

obvious blur across the whole frame. This is usually a result of using a shutter speed that's too slow for handholding with a certain lens, or adopting an unstable stance.

Camera shake can also occur when the camera is mounted on a tripod, either because the reflex mirror creates vibrations when you trip the shutter, or you create vibrations when you press the shutter release with your finger.

The following steps should help prevent it.

When handholding:

1. Use a shutter speed that at least matches the focal length of the lens -1/250sec with a 200mm lens, 1/60sec with a 50mm lens, 1/500sec with a 300-500mm lens, and so on.

2. If you're using a long telephoto lens or are forced to set slower shutter speeds, rest the lens against a wall or post or crouch down to provide a more stable support.

3. Always adopt a stable stance and hold the camera properly - refer back to Camera Answers (page 12) for details. **4**. Use a tripod whenever possible.

When using a tripod:

1 If your camera has a mirror lock, use it to reduce vibrations.

2 Always trip the shutter with a cable release so you don't have to touch the camera.

3 Make sure your tripod is set up properly, and only use the centre column when necessary as it's the least stable part of the tripod.

4 In strong winds, weight the tripod down with your gadget bag to increase stability, or hang a bag of sand or stones under the tripod.

5 When using long, heavy lenses, mount the lens, rather than the camera, on the tripod so it's more evenly balanced.

I wear spectacles, but have trouble focusing when I'm wearing them. What do you suggest?

Many SLRs and compacts have a dioptre correction lens built into the viewfinder eyepiece which you can adjust to suit your eyesight so

you needn't wear spectacles when taking pictures. Alternatively, most cameras can be fitted with correction lenses that are available from photo dealers in different +/- dioptre strengths.

If both options are out, try fitting a rubber eyecup to your camera's viewfinder, which may help.

Why is it that I still end up with out-of-focus pictures, even though my camera has autofocusing?

Virtually all autofocus cameras have a small focusing 'envelope' marked in the centre of the viewfinder. To make sure your main subject comes out sharply focused you must place this envelope over it while focusing. This is particularly important with compact cameras, as you can't see what the

lens has focused on. With most cameras

you can lock the focus by half-depressing

the shutter release and holding it down. This allows you to focus on your subject then recompose the shot as you wish before taking the final picture.

Inaccurate focusing can also result when you try to focus on an area of low contrast or texture, such as a white wall, or because you're too close to your subject. If this former problem occurs, focus on something else that's a similar distance from the camera, lock the focus, then recompose. With the latter, check the minimum focusing distance of the lens and don't move any closer than that.

I took some pictures recently and the corners were very dark. What do you suppose caused this?

The problem you refer to is known as 'cut-off' or 'vignetting', and it's caused by an attachment that's fitted to the front of your lens

obscuring its angle-of-view. This could be a lens hood that's too narrow, a filter holder that's too small, or because you've fitted too many screw-in filters to the lens at once. Wide-angle lenses are especially prone to cut-off due to their extensive angle-of-view.

Once you've identified the cause, solving it is easy – make sure the lens

hood you use is designed for that particular focal length, switch to a bigger filter holder, or avoid using more than one or two screw-in filters on your lens at once.

No matter how good a picture is, if it suffers from camera shake there's only one place for it – the bin!

With the main subjects off-centre an autofocus camera focuses between them on the distant background, as shown. To prevent this place the AF envelope over one of your subjects, lock focus, then recompose the shot and take your picture.

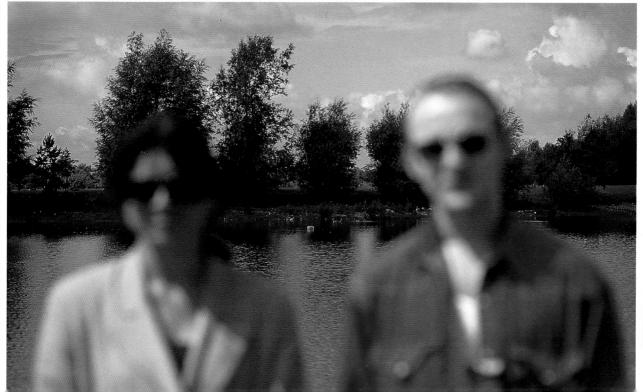

TECHNIQUE: PROBLEM-SOLVING ANSWERS

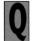

I used some coloured filters with a roll of colour negative film, but the prints looked more or less normal. What did I do wrong?

The automatic printing systems used in most processing labs are designed to give correct colour balance, so they often treat the

effects of coloured filters as a mistake and compensate for them by adding the opposite colour. To prevent this happening, inform the lab that you've used coloured filters on certain shots, so the technicians will know to keep the colour produced.

About half the pictures from a roll I shot recently were ruined by cloudy light patches. Was this a processing fault?

It sounds like some of the shots were fogged due to exposure to light before the film was processed.

Check the negatives as well to see if they suffer from the same problem.

If so, it's probable that you accidentally opened the camera back halfway through the film so part of it was fogged. If the fogging is only on the prints, the printing paper must have been exposed to light by mistake, so inform the lab and ask them to reprint.

Other causes of fogging could be a light leak in your camera or the film cassette, or due to loading a new roll of film in bright sunlight – always do this in the shade.

I got a set of prints back from the lab, and every shot was double exposed with something else. Was this my fault or the lab's?.

This often happens to novice photographers, and they nearly always try to blame the poor processing lab. Unfortunately, double exposure of this type is caused by accidentally running the same roll of film through the camera twice, so it's your fault. To make sure it doesn't happen again, always rewind a used film completely back into the cassette, so you can't forget it has already been used and try to reload it, and have used film processed immediately after you've shot it. If you remove a partly used roll of film with the intention of reloading at a later date, mark the number of shots already used on the leader with a waterproof marker pen. When you reload, wind onto the appropriate frame by firing off the shots already taken with the lens cap on so they aren't double exposed.

Refer to Flash Answers (page 30) for advice on how to prevent common flash faults, and Exposure Answers (page 42) for details on avoiding exposure error.

.

Does this look familiar? If so, the problem is down to you, not the processing lab, as the same film was accidentally loaded into the camera twice.

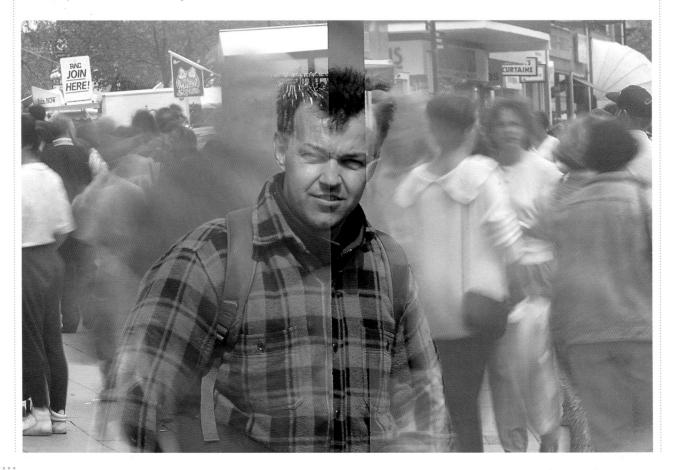

S U B J E C T A N S W E R S

PORTRAIT ANSWERS

If a picture is worth a thousand words, it's probably a portrait. Pictures of people account for more film shot per capita than just about every other subject put together, and are perhaps the biggest single reason why people pick up a camera at all.

Most of the people-pictures we take, however, could never be described as true portraits. Usually they're hastily grabbed snapshots that record family and friends at a party, having fun on holiday or enjoying life, and often the sentimental value of those pictures far outweighs the need for technical perfection – hence it's common to treasure a fuzzy, badly composed shot of a loved one.

Portraiture serves the same purpose, of course, but its aim is to capture the character of a person on film, as well as a physical likeness. A successful portrait should tell us something about the subject, even if we've never met them before.

This may seem like an impossible task, but each and everyone of us give off powerful signals which tell the rest of the world how we're feeling. The job of the portrait photographer is to watch those signals and capture them at the precise moment the personality of the subject is revealed.

Q

Which lenses are best for portraiture?

The ideal lens for general use – particularly head and shoulders portraits – is a short telephoto with a focal length of 85–105mm. This is

chosen mainly because its slight foreshortening of perspective flatters the human face. The depth-of-field provided by a short telephoto is also shallow at wide apertures, so you can throw distracting backgrounds out of focus to concentrate attention on your subject. Most serious portrait photographers use an 85mm, 100mm or 105mm prime lens with a wide aperture of f/1.8 or f/2. However, the same focal length setting on a 70–210mm zoom is equally suitable, even though the maximum aperture is usually smaller. Longer focal lengths can be used effectively, but the increased camera-to-subject distance makes them impractical for general use.

A 50mm standard lens is also handy for half- or full-length shots, while a 28mm or 35mm wide-angle is invaluable for taking environmental portraits which reveal your subject in their surroundings. This revealing portrait of a Scottish fisherman was taken from close range using an 85mm prime lens. Setting the aperture to f/2 reduced depth-of-field considerably to throw the background out of focus.

Olympus OM4Ti, 1/250sec at f/2, Fuji Velvia.

Are there any preliminary steps I can take before commencing a portrait session to ensure the shoot runs smoothly?

The golden rule of portraiture is Be Prepared. Before your subject arrives, make sure you're organized and ready in all respects. Decide

where the pictures will be taken – indoors or out? – think about props, clothing and poses, make sure your cameras are loaded with film and that you have all your equipment at hand, and set up the background and lighting ready for the first shot.

If you get all these tasks out of the way you'll be able to start work the minute your subject' appears and give them your undivided attention so successful pictures result. If not, they will have to hang around waiting, and this will emphasize the nerves they're probably already experiencing.

Being unprepared also means you start the shoot in a panic, rather than being in total control, and this invariably leads to silly mistakes being made, like getting the exposure wrong, or forgetting to set the correct film speed on your camera.

SUBJECT: PORTRAIT ANSWERS

USING WINDOWLIGHT

The daylight flooding in through a window of your home is perfect for portraiture, and with a little care can be used to create a range of effects.

North-facing windows are ideal when you want soft, low-contrast lighting as any light entering them is reflected - for the best results shoot in bright but slightly overcast conditions. South-facing windows admit direct sunlight at certain times of day, so you can obtain totally different results - the warm light of late afternoon is ideal as it casts attractive shadows onto your subject. The traditional approach is to pose your subject with the window on one side, so half their face is lit and the other half is thrown into shadow. In dull weather this creates a very moody effect, but in stronger light contrast will be high so you should position a white reflector

opposite the window so it bounces light back into the shadows. The light can also be softened by taping a sheet of tracing paper to the window.

For more even lighting, shoot with your back to the window so the light floods across your subject's features. Alternatively, use the window as a background and bounce light into your subject's face with a reflector. By exposing carefully the window will then burn out to create an atmospheric high-key effect behind them.

•••••••••••••••

The soft light of a dull day was used for this attractive portrait, with the subject positioned about a metre in front of a large room window.

Olympus OM2n, 135mm lens, soft focus filter, 1/30sec at f/5.6, Kodachrome 64.

Final touches like playing background music, making sure the location is warm, and taking regular breaks to assess your progress, will also help to oil the wheels of success.

Once you establish a rapport with your subject they will feel at ease in front of the camera, allowing you to capture relaxed expressions. *Pentax 67, 165mm lens, 1/30sec at f/16, Fuji RDP100.*

My subjects always seem tense and nervous when posing for portraits. How can I help them to relax?

Few people feel confident in front of a camera, so if the shoot is to be a success you must put a lot of effort into making your subject feel

at ease.

The easiest way to do this is simply by chatting to them. Talk about their hobbies, the news, politics, ancient history, anything to break the ice and help them forget about the camera. It's also a good idea to involve them in the shoot by explaining what kind of effect you're trying to produce, why you're moving the lights around, how you want them to pose and so on. You could even let them look through the viewfinder while you take their position, so they've got an idea what you're seeing.

Feedback is equally important. When things are going well, say so to bolster their confidence, and when you're not completely happy with something, be polite and make suggestions rather than showing your frustration. Communication should be a constant factor throughout the shoot, so you gradually build up a rapport with your subject and eventually they stop worrying about the camera.

SUBJECT: PORTRAIT ANSWERS

Don't always expect your subject to smile and appear jolly – the best portraits invariably capture a more thoughtful, serious expression which helps to reveal a person's more private side.

Olympus OM4Ti, 85mm lens, 1/60sec at f/11, Kodachrome 25.

For this portrait the photographer positioned his subject against the sun to prevent unsightly shadows, then bounced the warm light onto her face with two large reflectors.

Canon T90, 90mm lens, 1/250sec at f/5.6, Fuji RDP100.

How can I encourage my subject to produce interesting facial expressions?

Simply asking your subject to smile rarely works because a true smile can't be produced to order; it has to be natural. Similarly, while

asking your subject to say certain words like 'Russia' or 'whiskey' may animate their face slightly, it's not ideal – unless you choose a funny word which makes them laugh out loud.

The best way to elicit interesting

expressions is by talking to your subject and firing away as they respond. If you want a serious expression, strike up a conversation you know will get them going, or if you want a more light-hearted response, tell a joke. You could even ask them to tell a joke while you capture their expressions and mannerisms.

If you've succeeded in putting your subject at ease during the earlier stages of the shoot you can also ask them to give a certain look – mean, moody, serious. Merely trying this is often enough to generate more spontaneous, natural expressions because they'll find the whole thing highly amusing. Patience and timing are the keys to success.

What conditions are the most favourable for taking portraits outdoors?

Successful outdoor portraits can be taken in virtually any conditions, though some demand a little more care than others. Harsh sunlight is

your worst enemy. It casts deep, black

80

shadows across your subject's face, makes their eye sockets look dark and lifeless, and is very harsh on delicate skin tones. To prevent this, turn your subject away from the sun and bounce light onto their face with a reflector, or use a burst of fillin flash to lower contrast. Alternatively, move into the shade of a building or tree, where the light is much softer and shadows weaker.

Earlier or later in the day when the sun is low in the sky the light has a beautiful warmth which makes skin tones glow. The light can still be harsh though, so your best bet is to keep the sun on one side of your subject if facing it causes them to squint.

Finally, the diffuse, shadowless light of an overcast day can produce very flattering results, though it's a good idea to pop an 81A or 81B warm-up filter on your lens to balance the slight blue cast in the light, otherwise your subject's skin tones may look a little pale and pasty.

Does the background play an important role in portraiture?

Only if you make a bad choice. Ideally the background should be plain and simple, so it doesn't

attract too much attention and your subject stands out against it, but if it competes for attention with your subject, the impact of the portrait will be reduced considerably.

Indoors, a plain wall or sheet of card can be used as a background. White, cream and black are popular colours because they're very neutral, but brighter hues can work well when used carefully. Mottled or spattered backgrounds made from painted canvas also look attractive. Avoid fancy patterned wallpaper at all costs. Outdoors, foliage, stonework and other natural features work a treat, especially if they're in shadow.

If the background you use has an obvious pattern or texture, set your lens to a wide aperture such as f/4 or f/5.6, so it's thrown well out of focus. You can check what it will record like before shooting by pressing the stopdown preview button on your camera or lens. If it's still too obvious, simply set an even wider aperture, or move your subject further away from the background.

POSING YOUR SUBJECT

Few people feel confident standing in front of a camera, so you must give your subject plenty of advice when it comes to posing. If you fail to do this they will end up feeling very tense, and it will make your job of capturing their true personality all the more difficult. Posing is also important because it helps to dictate the overall aesthetic success of a picture.

The good news is there are only so many different poses to work with and they've all been done countless times before, so a quick flick through copies of photographic or fashion magazines will provide lots of useful ideas to be getting on with. You can also dictate the pose to a certain extent by providing a chair for your subject to sit on, or taking the pictures in a specific location.

The main priority is that your subject feels comfortable, because if they look comfortable and relaxed, the odds of success will be stacked firmly in your favour.

Here are a few suggestions.

Hands can look very clumsy floating around doing nothing. Avoid problems by asking your subject to rest one hand on the side of their face or hold something. Interlocked fingers and crossed arms tend not to look very attractive.

Dynamic poses work well if your subject is confident in front of the camera and able to strike interesting poses without your help. Try a range of different poses so you produce a variety of results.

Provide a chair for your subject to sit on. This will not only help to dictate the pose, but people generally feel more comfortable sitting rather than standing.

A tabletop, fence, wall or some other kind of support can be used for your subject to lean against when you're shooting on location.

SUBJECT: PORTRAIT ANSWERS

Taking a few steps back to capture your subject in their surroundings often leads to far more interesting portraits. A 50mm lens was used for this shot of a Norfolk reed cutter.

ISO 1000 colour slide film was used for this attractive portrait. Its speed was necessary to make handholding possible in the poor lighting conditions, but the coarse grain also adds bags of mood and enhances the warm windowlight bathing the subject's face.

How can I overcome cosmetic problems such as a bald head or double chin?

In an ideal world everyone would be perfectly proportioned and infinitely attractive. Unfortunately, it isn't an ideal world, so there will undoubtedly come a time when you have to photograph a less than perfect specimen!

Here are a few hints on how to overcome common problems.

Bald patch Shoot from a slightly lower viewpoint – only a few inches – so the top of your subject's head doesn't appear in the shot. Also ask them to keep their head upright – it's tempting to look down if the camera seems low.

Long noses These can be played down by using a slightly longer lens than normal, such as a 135mm or 200mm, so the extra compression of perspective makes the nose look shorter. Also shoot head-on rather than from the side so the length of your subject's nose isn't revealed.

Double chin A slightly higher shooting angle usually does the trick here, because you'll be looking down on your subject and their neck will be partially obscured by their chin.

Skin blemishes Acne, spots and rashes are emphasized by sidelighting because it reveals texture in the skin, so avoid it at all costs. Instead, use even frontal lighting – a softbox either side of the camera and a reflector below your subject's chin is ideal or if you're taking pictures outdoors in bright sunlight, keep the sun either behind your subject or behind the camera.

A portrait which depicts your subject in their surroundings, whether it's at work, at home or enjoying a hobby or sport. The

advantage of an environmental portrait compared to a traditional headshot is that it tells the viewer a lot about the subject. The extra elements included in the shot, such as where they live or work, or personal possessions, also make for a

more interesting composition and provide you with many different options.

I can never decide which type of film to use for portraiture – got any suggestions?

Accurate rendition of skin tones is usually important in portraiture, so you need to find a film that will give satisfying results. Fine grain

and optimum sharpness should also be considered.

Your best bet is to experiment with a range of different films and see which you prefer. The vivid colours of Fujichrome Velvia look superb with most subjects, for example, but skin tones tend to come out far too warm - especially when shot under studio lighting so this film is usually avoided. Fujichrome RDP 100, on the other hand, gives much more attractive results and is favoured by many portrait photographers. Agfachrome and Kodak Ektachrome slide films are also renowned for lovely colour rendition. If you prefer colour print film try Kodak Gold II 100, Agfa Portrait, Fuji Reala or Konica Impressa.

Fast, grainy films such as Agfachrome 1000 RS or Fujicolor SHG 1600 can also be used to produce very moody, atmospheric portraits – especially if you shoot in soft, warm light.

Are there any filters that will help improve my portraits?

The 81-series warm-up filters are handy for enhancing the light and making your subject's skin look healthy and tanned. Use them in

dull weather or when working in the shade outdoors to counteract any blueness in the light, or to make warm sunlight even richer – an 81B is the best choice for general use while a stronger 81C will be preferable in really dull, cold light.

Soft-focus filters are also ideal for increasing the mood of a portrait by adding a soft overall glow or a soft spot which keeps the face sharp and softens the picture edges. Try combining a warm-up and soft-focus filter with fast, grainy film to produce highly evocative results. This technique works particularly well in warm light.

STUDIO LIGHTING TECHNIQUES

If you're lucky enough to have access to studio lighting equipment, an endless range of moods and effects can be created and you can exercise total control over the direction and strength of light falling on your subject.

In the beginning your best bet is to start off with one light and see how changing its position around your

subject alters the effect obtained. You'd be surprised just how flexible one flash unit or tungsten spot can be, especially if you fit a brolly or softbox to it to soften the light, and use a couple of reflectors to bounce the light around.

Once you've had a little experience, further lights can then be added to give you more control. The thing to remember is that no matter how many lights are used only one will provide the main illumination, so this is the light on which the exposure for the whole shot should be based. The rest are used to balance the shadows or create specific effects.

The set of pictures here shows how you can vary the mood of a portrait using different lighting set-ups.

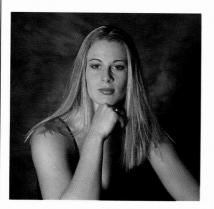

Here just one bare light was positioned at 45° to the left of the subject. Note the harshness of the light and strong shadows, which don't

really make for a flattering result.

This time the same light was fitted with a white flash brolly to spread the light. Shadows are now much weaker, the light is softer, but further improvements can be made.

Here a single light plus brolly were again used on the model's face, but a second light fitted with a snoot attachment was also placed behind her to add a halo effect to her hair.

Many photographers prefer softboxes to brollies because they soften the light even more. Here one light at 45° to the model was fitted with a 1m softbox.

Using two lights fitted with softboxes at 45° to the left and right of the model creates a very soft, shadowless and even form of illumination that's ideal for flattering portraiture.

For this shot four lights were used: one either side of the model with softboxes, a third fitted with a snoot placed above and behind, and a

KIDS ANSWERS

Kids can be a photographer's best friend and worst enemy all rolled into one. Their innocence, boundless enthusiasm and lack of inhibitions make them a joyous subject to photograph. But at the same time, they're are also fiercely independent and have the ability to drive a photographer bonkers within minutes. Ask them to stand and A little planning goes a long way when photographing babies. Choose soft, shadowless lighting, crouch down low so your subject isn't dwarfed by the camera, then simply wait for an attractive expression before firing away. *Canon T90, 90mm lens, 1/60sec at f/8, Fuji Velvia.*

they'll sit. Ask them to smile and they'll stare blankly at the camera. Spend ages setting up a shot, and just as you're about to trip the shutter they up and go!

We've all faced this battle of wits many times before and had our patience stretched to breaking point. But that's what makes photographing kids so challenging and rewarding, and if you accept it rather than trying to fight it you'll produce some of the best pictures of your life.

Got any suggestions about how I might photograph a baby?

Compared to toddlers and older kids, babies are a real doddle to photograph. They can't protest or do a disappearing act as soon as a

camera is produced, so you can spend as long as you like taking perfect pictures. Unfortunately, all they tend to do is sleep or eat, so trying to capture a facial expression other than a yawn is tricky.

If you're the father, why not take a camera along and capture the birth? The light levels are rather low in hospitals, so load fast film to avoid camera shake – ISO 400 may be fast enough, but ISO 1000 is a safer bet. Flash is an option, but its harshness tends to ruin the atmosphere.

Once the baby is home you have all the time in the world to take lots of pictures. A good approach is to place the baby on a blanket or bed or ask an adult to cradle it and sit by a window. Use reflectors to fill in the shadows and create very soft, even illumination.

With a macro lens or the close-up facility

on a zoom you can move in close to take frame-filling pictures of the baby's face, its tiny hands, or delicate toes. For really moody portraits, load the camera with fast, grainy film, and fit a soft focus filter to the lens. If you're using slower film, mount the camera on a tripod and wait until the baby is still before shooting.

A camera should also be kept handy to capture those momentous events like the first smile, the first bath, and some months later the first faltering steps. And don't forget to take pictures of the baby with its proud grandparents, older brothers and sisters.

TIPS FOR SUCCESS

Whole books have been written on the subject, but there are a handful of golden rules that should be obeyed if you want to take successful pictures and make sure your subject is willing to cooperate the next time.

1 Never, ever lose your temper when things aren't going according to plan. If your subject isn't interested, call the shoot off and try again tomorrow rather than forcing the issue. It's impossible to take good pictures if you're frustrated, and any bad vibes will be instantly picked up by your subject.

2 Always get down to your subject's

eye-level. If you tower above them like a giant the results will look odd because the child is forced to look up. It can also make them feel uneasy and intimidated.

3 Kids aren't stupid, so don't treat them as if they are. When giving instructions be firm but polite, just like you would with an adult, and take an active interest in what they have to say or any ideas they have to offer.

4 Don't put your camera down too soon. It's Sod's Law that your kids will start performing the minute you stop shooting, so stay put and don't be afraid to use a lot of film.

SUBJECT: KIDS ANSWERS

My kids always get fidgety and lose interest after a few minutes of being photographed. How can I hold their attention?

Trying to keep a young child in one place for very long is always tricky, especially if they haven't got anything to do. Boredom quickly

sets in, and before you know it they're up and away.

The easiest way to solve this problem is by giving them something to do. Not only will it keep them happy, but they'll also forget about the camera and you'll be able to take more natural pictures.

A favourite cuddly toy or an ice cream should do the trick with toddlers, while a pet rabbit, kitten or puppy dog will keep infants occupied for ages and generate

A garden hose on a hot summer's day is guaranteed to give your kids hours of fun and provide you with the perfect opportunity to grab lots of excellent shots. Here a 1/500sec shutter speed was used to freeze the spray of water.

.....

some lovely expressions. An alternative approach is to offer your subject a small reward for their cooperation, like a bar of chocolate or a trip to McDonald's. Kids will do anything if they've got a good reason.

Older kids like to be taken more seriously, so ask them to show off their favourite possession, like a new bike, or talk to them about their hobbies. Asking a child to dress up like mum or dad for a picture also guarantees success – especially if you give them full access to clothes, make-up and shoes!

> Should I photograph my kids in a formal portrait situation, or just take pictures as and when the opportunity arises?

> The formal approach can work well, providing you get everything set up beforehand so your subject isn't kept waiting. Test the lighting

on an adult model, make sure the camera is ready and loaded, then once your subject arrives begin immediately and keep the shoot brief – ten minutes seems like a lifetime to a kid.

Generally, however, your best bet is to keep a camera handy at all times and just grab pictures when an opportunity arises – kids washing the car, kicking a football around the back garden, paddling in the sea or, playing with their grandparents, are all common events worth documenting.

In other words, make photographing your kids a natural and regular part of daily life rather than a special activity. Not only will this produce lots of great pictures, but your subjects will also grow accustomed to you wielding a camera and it will become perfectly normal for them.

.....

Photographing your kids in a formal studio setting can work well providing you make the shoot fun. For this shot the photographer allowed his subject to wear her favourite clothes, and used two flash heads fitted with large softboxes to create a clear, crisp result. *Canon T90, 90mm lens, 1/60sec at f/1 I, Fuji Velvia.*

85

Q

Which equipment is best for taking pictures of kids?

Given the spontaneous nature of kids you need a camera that can be used quickly and instinctively.

Modern compacts are ideal for keeping handy at all times so you never miss the chance to take a picture, because their automation allows you to just point and shoot in an instant. For general use, however, the extra control offered by an SLR will be a great benefit. Autofocusing can be useful, but is by no means essential if you practise your manual focusing skills.

As for lenses, a short telephoto or zoom setting of 85–105mm is perfect for frame-filling head and shoulder portraits, while longer focal lengths can be useful for candid or action shots of kids taken at a greater distance. Wide-angles are useful too. You can take stunning pictures by using a 24mm or 28mm lens from close range to create distortion, or simply to include your subject's surroundings in the frame.

Other items to consider are a flashgun, so you can take pictures indoors with slow film, reflectors to bounce the light around when taking pictures outdoors or by windowlight, and a tripod to prevent camera shake when using slow shutter speeds. For general use both indoors and out, use a slowish film of ISO 50 or 100, which will give pin-sharp, virtually grainfree results. Faster film of ISO 400 and above is a useful standby if you want to take handheld pictures in low light, or to produce more moody effects.

Do I need to change my approach when photographing kids of different age groups?

All kids must be given the same amount of attention and patience, but the ways in which you photograph them will differ simply

because their needs and demands differ with age. Toddlers, for example, are very mischievous and inquisitive. Suddenly being able to walk gives them endless freedom to explore their home, and they love fiddling around with anything that isn't nailed down – pressing the buttons on the TV, hi-fi and video, emptying the kitchen cupboard, knocking ornaments flying, or covering the room with toys.

By the age of a year or so they're also aware of the camera and able to respond A 200mm telephoto lens was used for this perfectly timed action shot of a young boy sledging over a snow ramp. When shooting moving subjects, prefocus on a point they're heading for to ensure a sharp result. *Minolta XD7, 1/500sec at f/5.6, Fuji RD100.*

to it and your prompts, so you can capture wonderful animated moments as they have fun, or sit watching you with a confused look on their face. Everyday routines provide great opportunities for pictures, like bath time, dressing, potty training, eating and drinking. And don't just concentrate on the happy times – temper tantrums and tears are as much a part of growing up as anything else.

As kids get older, so they become interested in other things and their personality becomes more established. They can also follow your instructions, enabling you to explain exactly what you want them to do, and begin to develop hobbies and interests that can become an integral part of your picture-taking.

Capture your children kicking their first football, riding their first bikes, or baking cakes or making dolls' dresses. Days out, birthday parties, games with friends, holidays and school plays also provide oppor-

LIGHTING FOR KIDS

The key to success with child photography is keeping things as simple as possible at every stage so you have less to worry about – that includes the lighting.

Windowlight is an ideal source as it produces soft, flattering illumination and can be used at a moment's notice. With babies and toddlers all you have to do is place their cot or high chair close to a window, position a large reflector opposite to bounce light into the shadows, and fire away. Older children can be asked to stand or sit by a suitable window.

Bright but slightly overcast weather creates very soft light but keeps the light level high enough for you to shoot at decent shutter speeds on ISO 100 or ISO 200 film. If you need to soften the light further just hang net curtains over the window or tape a sheet of tracing paper to the glass. Warm, late afternoon sunlight flooding through a window also works well.

Electronic flash is another option, but it must be used carefully to give attractive results. Rather than firing the flash direct at your subject, bounce the light off a wall, ceiling or large reflector, so it's softened and shadows are weakened. Alternatively, fit a bounce attachment to the flashgun itself, or take the gun off the camera and hold it to one side so you have more control over the direction of the light in relation to your subject.

Outdoors, successful pictures can be taken in just about any conditions. Just one point: if you're shooting in bright sunlight, make sure your subject isn't looking towards the sun otherwise they'll squint horribly and will quickly feel uncomfortable. Instead, keep the sun behind them, and use a reflector or a burst of fill-in flash to bounce light onto their face.

In the studio all sorts of lighting set-

tunities to capture those formative years on film, so make the most of them while you can.

Once the teenage years are reached, kids aren't kids any longer and tend to be less inclined to pose for mum's or dad's camera. They become very self-conscious

ups can be used to produce exactly the effect you want. Don't be too ambitious though. You can produce superb results with just one light and a couple of reflectors – the less equipment you use, the more you can concentrate on your subject. See Portrait Answers (page 83) for details of specific lighting set-ups.

For this beautiful portrait of a little girl and her baby sister, the photographer used two flash heads fitted with softboxes to generate soft, shadowless illumination. A soft-focus filter was also employed to add an extra touch of atmosphere. *Mamiya RB67, 180mm lens, 1/60sec at f/16, Fuji RDP100.*

about their appearance, and often hate the idea of being photographed in case their spots are captured, or their friends find out.

This can easily be overcome with a little persuasion, but you need to tread carefully and treat your subjects like adults. Let them decide what to wear, how to pose, and where to shoot, and allow them to make decisions about the type of pictures taken. If you involve them at all stages they may actually begin to enjoy it, and you can produce some very poignant portraits.

HOLIDAY AND TRAVEL ANSWERS

Blackpool, Bangkok, Barbados – wherever you go on your annual summer holidays you're going to discover an endless range of things to photograph. All those new sights, sounds and smells have an intoxicating effect on photographers, and more film is consumed in that traditional two-week period than the rest of the year put together.

There's a big difference between taking a few snapshots for the family album and creating a serious photographic record of your stay, though. Travel photography is a subject that requires dedication, hard work and patience, so if you want to return home with a selection of successful pictures you'll need to bear a few essential factors in mind.

Is it worth doing a little research on my chosen destination before I leave home?

Definitely. The more homework you do before leaving home, the better prepared you'll be to make the most of your destination's

photographic potential. Check guidebooks to find out about interesting places or special events worth visiting. Speak to your travel agent about local transport, so you can get around once you're there, and jot any useful information in a notebook. This sweeping view of the Greek island of Hydra was captured at dawn from a rocky hillside above the town. Referring to maps and guides is an ideal way to discover the most interesting views.

Olympus OM4Ti, 50mm lens, 1/30sec at f/11, Fuji Velvia.

Once you arrive it's also a good idea to make a bee-line for the postcard stands. The pictures may not be brilliant, but they'll give you a good idea of what there is to photograph in the area and where the best viewpoints are.

How much equipment should I take on holiday with me?

How long is a piece of string? Most photographers drive themselves to despair deciding which gear to take and which to leave behind,

simply because once you've left home it's too late to wish you'd packed a certain lens or filter.

If your primary concern is taking snapshots, a zoom compact or an SLR fitted with a standard zoom will suffice. But if your intentions are more serious you'll need more than that. Use the following checklist as a guide.

• Two 35mm SLR bodies if you have them, so you can use different film types in each.

• Lenses from 28–200mm for general use. This range can be covered by 28–70mm and 70–210mm zooms if you need to

Put thought and effort into your pictures of local people and you'll be rewarded with excellent portraits. This shot of a presidential guard in India was taken with the subject's permission, even though it appears to be candid.

travel light, or a selection of prime lenses.
A 2x teleconverter will provide a lightweight means of increasing the power of your lenses for the occasional long telephoto shot.

• A portable flashgun for taking pictures indoors or for fill-in in bright sunlight.

• A lightweight tripod for low-light and indoor photography in available light.

• Filters: a polarizer to deepen blue sky and reduce reflections in water, 81A and 81B warm-ups to enhance the natural light, a grey grad to tone down the sky, plus any other favourites such as starbursts and soft focus.

• Accessories: cable release, lens cleaning kit, plenty of spare batteries for cameras and flashguns, notebook for logging location details, lens hoods to prevent flare in bright light.

• A gadget bag that will hold the gear and be comfortable to carry all day.

Q

How should I go about photographing the local people?

Carefully and politely. Imagine you were walking down the high street, minding your own business, when suddenly a foreign tourist jumped

out from behind a tree and started taking your picture. How would you feel? Confused, surprised, annoyed no doubt.

Well, it's exactly the same for the people we photograph every year on our holidays. So if you want total strangers to cooperate with your wishes then treat them with respect and courtesy. Instead of sneaking pictures with a long telephoto lens, approach your subject and ask their permission. Show a genuine interest in them, without being patronizing, and try to strike up a conversation – even if you have to resort to sign language.

In most countries the people are more than happy to be photographed, but some cultures and religions aren't. You may also be asked for money in developing countries. At least by making your intentions clear you'll discover this. Then it's up to you to decide whether to proceed without risking a confrontation.

Approaching your subject also gives you more control over the pictures. You can pose them in attractive light, and encourage interesting expressions. All in all this will lead to better results.

CAPTURING FAMOUS LANDMARKS

We've all photographed famous tourist attractions on our holidays – Big Ben, the Statue of Liberty, the Eiffel Tower, the Taj Mahal. But how many of you could honestly say those pictures were original? Very few, if the truth were known.

The problem is that when we see impressive subjects like this our natural instinct is to start shooting away excitedly. Problems of access and battling through crowds also limit our options somewhat, and many famous sights even have suggested vantage points to take good pictures. So we use them, we follow the crowds, and we end up with pictures that are identical to millions of others already taken.

It doesn't have to be that way though, and with a little effort you'll find ways of taking pictures that are totally original and show your subject in a whole new light.

For starters, you could try shooting from a different angle. Leave the crowds behind and go for a wander to see if you can snatch a glimpse of your subject from somewhere else – up that hill in the distance, or down another street.

Experimenting with different lenses can also make a big difference. While most people fire away with a standard or wide-angle, why not back off and use a telephoto instead, or vice versa? Don't be so keen to include the whole thing either - homing in on smaller details can produce pictures that are far more interesting, providing the subject is still identifiable. Lastly, if you're staving close by, rise at dawn so you can use the beautiful early morning light while the crowds are still tucked up in bed, or return at night when the crowds have dispersed, and take your picture then.

Landmarks like the Eiffel Tower have been photographed literally millions of times, but that needn't stop you coming up with something a little different. *Pentax 645, 75mm lens, 10secs at f/16, Fuji RDP100.*

SUBJECT: HOLIDAY AND TRAVEL ANSWERS

How can I capture the atmosphere of a foreign location, so when people see the pictures they get a real sense of being there?

It seems like a rather tall order, but that's what successful travel photography is all about: capturing the character of a place. The pictures used in brochures and guidebooks do that, and the photographers who take them go to great lengths to make it possible.

There's no magical formula, unfortunately. It's a simple case of being responsive to what's around you and getting under the skin of a place so you react to it with your camera in a positive way, rather than taking dispassionate snapshots. You need to explore your chosen location. Spend time absorbing the atmosphere, let the sights, sounds and smells influence

you, then try to record those feelings in the best way possible - remembering that photography is a visual medium only.

On a more practical level you also need to ask yourself what it is about your location that makes it so interesting and inviting. The beaches? The sea? The architecture? The people? A combination of all these things? The answer to these questions should lead you in the right direction when it comes to taking pictures.

Finally, make an effort to take pictures in the best possible conditions. Rise early and stay out late each day, so you're there when the light is wonderful and things are happening. And pay great attention to detail when taking each picture. Take care with the composition, be patient and wait until everything falls into place, and return to the same spot time after time if necessary. Travel photography is hard work and requires much dedication, but the rewards are immense.

I've heard that X-ray machines in airports can damage photographic film. Is this something I need to worry about?

No, not any more. X-ray machines used to be renowned for fogging film, but modern systems use low dosages that cause no problems.

The only time you should try to get a handsearch is if you'll be passing through several airport terminals, each requiring an X-ray inspection, as X-ray damage is cumulative. Fast film is also more susceptible to damage than slow film, although recent tests have shown that it would take literally hundreds of passes to cause any problems.

Minimize the risk by carrying your film in hand luggage. The chance of a handsearch will also be increased if each film is removed from its box and placed in clear plastic tubs for easier inspection.

Often simple subjects can be highly symbolic and say a great deal about a place. This tiny church on the Greek island of Spetse sums up Greece as well as anything. Olympus OM4Ti, 28mm lens, polarizer, 1/60sec at f/11, Fuji Velvia.

AVOIDING EXPOSURE ERROR

In certain parts of the world, lighting conditions and the type of subjects encountered are totally different from what you'll find in your own country, so you need to take extra care when sorting out the exposure for pictures.

The main areas of concern are subjects which reflect a lot of light, such as whitewashed buildings, sandy beaches and the sea. If you just fire away without a care, chances are your camera's meter will be fooled by the high reflectance and cause underexposure. To prevent this, take a meter reading then increase the exposure by half or a full stop to prevent error especially when large areas of brightness are included in the shot.

In countries south of the equator the light is also very intense, especially around the middle hours of the day when the sun is overhead. This creates very high contrast with a brightness range that's too high for your film to record fully. To prevent disappointment you must therefore decide which is the most important part of the scene and expose accordingly. With slide film, exposing for the highlights is recommended, but with negative film you're better off choosing an exposure that will record some detail in the shadows, as the highlights can be burned in at the printing stage.

To prevent the large expanse of whiteness in this shot from causing underexposure, the photographer took a general meter reading then increased it by half a stop. Olympus OM4Ti, 24mm lens, polarizer, 1/60sec at f/8-11, Fuji Velvia.

Should I buy my film in my home country, or once I arrive at my holiday destination?

A

To a certain extent that depends upon where you're going. Most major cities around the world carry stocks of all types of film, but it's a

wise precaution to take the bulk of what you'll need with you. If not, you may find your favourite stock unavailable, and in touristy areas film tends to cost much more.

As for the amount, that will be determined by how serious your intentions are.

Sunrise is an ideal time to be out shooting – not only is the light beautiful, but the vast majority of tourists will still be tucked up in bed, leaving the whole place to you!

Olympus OM4Ti, 200mm lens, 1/30sec at f/8, Fuji Velvia. In photogenic areas it's easy to use between five and ten rolls per day, and even for sightseeing snaps you'll probably need at least one roll per day. Your best bet is to work out how much you think you'll need then double it.

Do I need to take proof of purchase of my equipment on holiday with me? Also, is it worth taking out insurance on my gear?

If you're taking a lot of expensive equipment with you it's always a good idea to carry proof of purchase, if only to prevent problems with customs when you arrive at your destination and when you return home.

As for insurance, it's a must. Check your home insurance policy to see if the gear is covered in foreign countries, and if not, take out a 'new for old' policy to cover it for the duration of your trip.

When's the best time to take pictures during the summer months?

As a general rule you should avoid taking important pictures from about 10am to 4pm as the light's far too harsh, and with the sun

overhead everything looks rather flat and uninspiring. This is particularly important in hot parts of the world as the light is incredibly strong.

Any time outside this period is ideal, although the most attractive conditions occur during the first couple of hours after sunrise, and during the last hour before sunset, when the sun is low in the sky and the light has a beautiful warmth.

CANDID ANSWERS

Candid photography offers a great release from the confines of formal portraiture. Instead of having to worry about lighting, posing and putting your subject at ease, your aim is simply to wander around, looking for opportunities to capture ordinary people going about their daily lives.

To do this successfully you need quick reflexes and a certain amount of self-confidence. Turning your camera on a complete stranger can be a very unnerving experience, mainly because of the embarrassment you feel if your subject catches you in the act. But as your experience grows this will fade, and you'll find it's possible to photograph people unawares in the most intimate situations.

Which lenses are best for candid photography?

It's tempting to use the longest lens in your gadget bag so you can keep your distance. However, for general use a 70–210mm tele-

general use a 70-210 mm terezoom or 200mm telephoto is ideal because it will allow you to take frame-filling pictures from several metres away. Also, by setting a wide aperture of f/4 or f/5.6, any distracting background details will be thrown out of focus so your subject becomes the centre of attention.

Longer lenses tend to be more suitable in situations where potential subjects are a long way off. At a football match, for example, you could use a 300mm or 400mm telephoto to pick out people from the crowd and capture the emotion on their faces when a goal is scored.

Wide-angle lenses are also perfect for candid photography at close quarters. Because the angle-of-view is so great you can actually photograph people in a crowd or demonstration without pointing the camera directly at them, so they don't realize what's going on.

ABOVE LEFT A 200mm telephoto is usually long enough for successful candid photography, and when set to a wide aperture will render the background a fuzzy blur so your subject stands out.

LEFT The simple, graphic nature of black & white film makes it perfect for candid photography, so don't limit yourself solely to colour.

FROM THE HIP

A great way to take candids in a crowd, or places where your subjects might not be too happy about being photographed, is by shooting with the camera at waist level.

This technique is rather hit and miss, because you can't see exactly what's going to appear on the final shot, but the low angle of the camera can produce eye-catching results and there's no risk of being spotted.

All you have to do is preset the focusing to a distance of, say, 2m, then simply stand opposite your subject and press the shutter release gently. Wide-angle lenses are ideal for the job, because as well as including a lot in the frame they also give great depth-of-field so your focusing needn't be totally accurate.

Which film should I use for candid photography?

For general use ISO 100 film is ideal. In bright conditions it will give you an exposure of 1/500sec at f/5.6, which is fast enough to

prevent camera shake when handholding a telezoom or telephoto lens. The image quality is also excellent.

In duller weather, the extra speed of ISO 400 film will come in handy for keeping the shutter speed up, while indoors you'll need to load up with film of ISO 1000 or above to cope with the lower light levels.

Where should I go to find candid subjects?

Wherever people gather there will be interesting candid subjects. In your local town centre, for example, you'll see the whole gamut of human emotions on display: frustrated mothers carrying heavy bags of shopping, old folk chatting on a bench, young lovers in fond embrace, traffic wardens arguing with angry motorists... Markets, funfairs and sporting events are also worth checking out.

Don't forget about your own family and friends either. If you take a camera along to parties, or on walks and holidays you'll have lots of opportunities to shoot

ABOVE Being able to use your camera quickly makes it possible to take successful candids from very close range – here the subject was only a few feet away.

candids, and because the people know you, they won't pay too much attention if the camera is spotted.

By making sure they have nothing to be suspicious about. If you wander into the middle of a market square with a huge gadget bag and three SLRs swinging from your neck you'll stand out like a sore thumb. But walk around with just one camera and lens in your hand and hardly anyone will notice

you. Even better, take a compact rather than an SLR. Not only will it be smaller and harder to see, but people tend not to associate them with serious photography, so you'll be ignored.

I always seem to spend ages fumbling around with my camera when trying to take candids, and the opportunity is missed. How can I avoid this?

A

Get to know your camera gear inside out so you can operate it instinctively.

Once you've spotted someone who might make a good candid subject.

preset the focus either by guessing or focusing on something a similar distance away. The exposure should also be set, or you could switch to aperture priority, set a wide aperture, and the camera will set the required shutter speed automatically.

All you have to do then is raise the camera to your eye, quickly check the focusing is accurate, trip the shutter, and you'll have the picture before anyone has a clue what's going on.

.....

Am I breaking the law by photographing people without their permission?

No one has copyright on their face, and providing you take the pictures from a public place you're perfectly within the law. So if

someone sees you taking their picture and protests, legally there's nothing they can do, although you're advised to be polite.

The only time you need to be careful is if a candid picture is published and the caption is defamatory to the subject. Calling an old man a tramp just because he looks a little untidy, for example, could have you facing a lawsuit.

BELOW Wherever you go it pays to keep an eye out for interesting candid opportunities. Here a child enjoying a lazy summer's afternoon makes a perfect subject.

LANDSCAPE ANSWERS

Landscape photography is the second most popular subject for photographers after people, and understandably so. There is nothing more enjoyable than heading off into the countryside and spending the day capturing beautiful scenery with a camera. Unfortunately, few landscape pictures do justice to the original scene. Faced by such beauty, most photographers just fire away carelessly, and all too often end up with a pile of snapshots that fail miserably in their attempt to capture the character of a place.

Successful landscape photography is all about watching, waiting and walking. You need to get to know the landscape, understand its rhythms, and let yourself be influenced by what you see. You need to wait until the light is just right before tripping your camera's shutter. But perhaps most important of all, you need to walk, and walk, and walk some more. Rarely are the best landscapes captured from the side of the road, or a footpath that is frequented by everyone else, and it is only by getting off the beaten track that you will discover those magical scenes no one else sees.

This beautiful detail would have been lost in a wider shot, but by fitting a telephoto lens the photographer was able to make it the sole element in the picture. Olympus OM4Ti, 135mm lens, 1/2sec at f/16, Fuji

Velvia.

Which lenses would you recommend for a keen landscape photographer?

The vast majority of landscape photographers use wide-angle lenses almost exclusively because they offer several distinct advantages. For a start, you can include a much

greater area in the viewfinder than is visible with the naked eye. The wide angle-of-view also makes it possible to create powerful compositions, by emphasizing foreground interest to add a strong sense of distance and scale to your pictures. Also, wide-angle lenses give extensive depth-of-field at small apertures, so you can keep everything in the scene

sharp, from the immediate foreground to the distant background.

For general use, a 24mm or 28mm wide-angle lens is ideal, although even wider optics such as a 17mm or 20mm lens can produce staggering results when used carefully.

Telephoto lenses come into their own when you want to isolate a small part of a scene – an old farm at the base of enormous cliffs, or reflections in a lake, perhaps. Because telephotos compress perspective they can also be used to make the elements in a scene appear crowded together. This works particularly well on shots of mountain ranges or distant hills and adds dramatic tension to a picture. In terms of focal length, you will find telephotos from 85-300mm the most useful. Anything longer tends to be too heavy to carry around if you are walking long distances.

Wide-angle lenses are perfect for general landscape use, allowing you to emphasize foreground interest and include large areas of a scene in the frame. Creating a sense of depth and scale is vital to the success of a picture. Olympus OM4Ti, 28mm lens, 1/30sec at f/16, Fuji RFP50.

Late afternoon sunlight creates beautiful conditions for landscape photography. Here the photographer kept the sun on one side of the camera, so the low-angle side-lighting revealed texture in this rather flat moorland scene. Pentax 67, 55mm lens, 1/15sec at f/16, Fuji Velvia.

What is the best time of day to photograph the landscape?

An appreciation of light is an essential aspect of landscape photography. As the sun arcs across the sky each day the colour. harshness and intensity of the light

changes, and each permutation transforms both the physical appearance and mood of the landscape.

Generally you will obtain the best results during early morning or late afternoon. Not only is the light lovely and warm but, with the sun low in the sky, raking shadows are cast across the landscape to reveal texture and form in even the flatest scenes.

You can also take superb pictures at dawn, when veils of mist hang over rivers and lakes and in valley bottoms, or at dusk, when golden shafts of sunlight make even the dullest scenes look beautiful.

In bright, sunny weather, the worst time to shoot is around midday. With the sun almost overhead the light is far too harsh and shadows are very strong, making the landscape look flat and featureless. The only exception to this is during late autumn and winter, when the sun never climbs to an angle more than about 40° into the sky and the light is attractive from dawn to dusk.

The only way to catch the light at its best is by spending time outdoors, observing the magic spell it casts on the landscape. When you arrive at a location, ask yourself if the light could look better. Sometimes you may only have to wait for a few minutes until a cloud passes over; at others you will have to return a few hours later when the sun's position has changed, or on another day.

This may seem like a rather laborious way of going about your business, but in the end your efforts will be amply rewarded. For more details see Lighting Answers (page 50).

THE LANDSCAPER'S KIT

Portability is an important factor to consider when putting together equipment for landscape photography. You need an outfit that will cope with all

Two manual focus 35mm SLR bodies with a spot or partial metering option

Lenses from 24/28 to 200mm

A hotshoe-mounted spirit level to check your horizon

Tripod and cable release

Cloths to wipe rain off your gear

Slow film: ISO 50 to 100 your picture-taking needs, but be light enough to carry long distances over rough terrain. A serious landscaper's outfit would contain the following:

Notebook and pen to log shot details

Top-quality detailed maps of the area

Gadget bag or photographic holdall

Polarising, warm-up and grey graduated filters

> Energy-giving snacks

Alarm clock!

I live in a boring part of the country. How can I ever hope to take interesting pictures?

Ahhh, this is a common complaint of budding landscape photographers. Unfortunately, it's a poor excuse for producing second-rate

pictures.

Successful landscape photography is all about using light and composition to make the most of a scene, not being surrounded by beautiful scenery. Even the English Lake District can look dull and dismal if it's captured badly, but a relatively boring location will look magical if it's brought to life by the camera of a skilled photographer.

So instead of feeling left out because there's nothing interesting to photograph where you live, rise to the challenge. The more you explore an area the more you'll get to know it, and that's when you'll start discovering the real beauty that's eluded you so far.

This scene was photographed in dull weather using Agfachrome 1000 film to add a grainy, pointillistic feel. A soft-focus and an 81B warmup filter helped to enhance the light and create a very atmospheric effect. *Olympus OM4Ti, 28mm lens, 1/250sec at f/16.* Have you got any tips for creating interesting compositions?

The main thing to consider when photographing the landscape is you're taking a three-dimensional subject and cramming it into two, so to retain that feeling of depth and scale A lichen-covered boulder has been used successfully in this picture to provide foreground interest and pull the whole composition together so the eye instinctively takes in the whole scene.

Pentax 67, 55mm lens, 1/15sec at f/16, Fuji Velvia.

you need to compose your pictures carefully. The final result should also be visually pleasing, with the various elements in the scene linked together so the viewer's eye is naturally carried up through the scene to the background.

When you discover a scene that shows promise, a good way to start is by seeking out some kind of foreground interest such as a wall, stream, hedge or rocks to provide a logical entry point into the picture and add scale. If this feature creates a natural line, so much the better as it will carry the eye through the scene as well.

A wide-angle lens will allow you to emphasize foreground features, and their 'weight' can be controlled by varying shooting distance and camera height. The closer you are and the lower the camera, the more the foreground will dominate the shot. The picture should also be composed so that there are other interesting features in the middle distance and background for the eye to move to – almost as if the scene were on different planes, with one carrying the eye to the

next. If one feature acts as a focal point, such as an isolated farm house or a single tree, position it off-centre (see Rule of Thirds in Composition Answers, page 54).

Finally, the amount of sky you include can make a big difference to the compositional balance of a picture. If the sky is full of interesting cloud patterns you shouldn't be afraid to make a feature of it, but as a rule-of-thumb, placing the horizon twothirds up from the base of the picture, so the sky only occupies the top one-third, tends to give the most pleasing result.

With telephoto landscapes your priorities change somewhat. It becomes more difficult to emphasize depth because perspective is foreshortened by the lens, so you're better off going for a more graphic effect. Try to emphasize repeated patterns or shapes, and planes of colour or tone in the landscape, including perhaps just one element as a focal point so the eye has something to settle on.

What's the best type of film for landscape photography?

For general use most landscape photographers prefer slow film, with a speed of ISO 50 to 100. The main reason for this is it gives optimum image quality, with fine grain, rich colours and superb sharpness.

In terms of specific brands, that's really up to you. Fujichrome slide film is preferred by many landscape photographers because it produces very bright images with deeply saturated colours – particularly greens. However, others swear by films such as Agfachrome and Kodachrome which give a more true-tolife rendition of colours.

If you're looking to create something a little different, then try a roll or two of faster film, with a speed of ISO 1000 or above. The grain is unashamedly coarse and colours are noticeably weaker, but in soft light or stormy weather the results can look beautiful.

Landscape pictures can also look stunning when shot in black & white, because the medium gives you the chance to make use of tone, texture and form rather than colour. And if you want to create something totally different, nothing beats Kodak High Speed Mono Infrared film. See Film Answers on page 26 for details.

PHOTOGRAPHING WATER

Water is a natural, common feature of the landscape. Rivers and streams wind through the countryside like a network of veins and arteries, bringing life to the land, while lakes and ponds punctuate the scenery like enormous full stops. Except for total desert landscapes, wherever you go it's impossible not to find water in one form or another, and the photographic opportunities it presents are endless.

The reflections in calm water can be used to add interest to a picture – if you stand by the edge of a lake or pond in calm weather you'll be able to capture a perfect mirror image. When photographing reflections in this way, use a polarizing filter to remove any unwanted glare from the water's surface. Rivers or streams winding away into the distance can also be used to lead the eye through a scene, thus improving the composition immensely.

For shots of waterfalls and fastflowing rivers, mount your camera on a tripod and use a slow shutter speed of ½ sec or slower, so the water records as a graceful blur while static elements in the scene come out sharp. Stopping your lens down to a small aperture will help to ensure you can use a slow enough shutter speed, but if that fails you can reduce light levels by fitting a neutral density or polarizing filter to your lens (see Filter Answers, page 20).

Capturing moving water as a graceful blur may be something of a cliché, but it works beautifully – as this picture shows.

Pentax 67, 55mm lens, 2secs at f/16, Fuji Velvia.

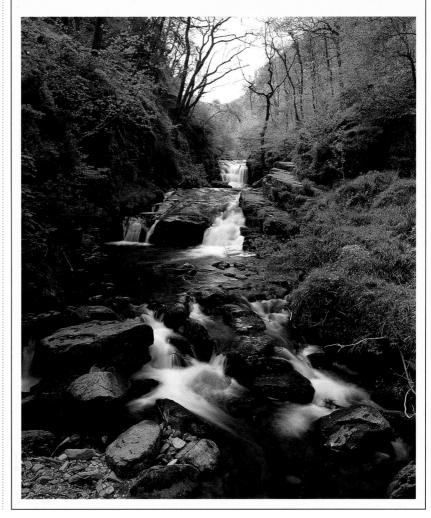

Are there any filters that can help improve my landscape pictures?

The best filters for landscape photography are generally those that enhance the good work mother nature has already done, rather than changing it and adding tacky effects.

A polarizer will come in handy for deepening blue sky, removing unwanted glare from foliage, reducing surface reflections from water and generally increasing colour saturation. The 81-series of warmups are also indispensable for balancing the slight coolness in the light on dull, cloudy days, or for enhancing warm sunlight.

But perhaps the most useful filter of all is the good old grey grad, which allows you to reduce the difference in brightness between the sky and ground so when you expose for the landscape, the sky comes out as you remembered it with the clouds intact. Other types of graduated filter can also be used – a pink or mauve grad works well at dawn and dusk to add warmth to the sky, or in dull weather – but grey is best for general use as it doesn't alter the natural colour of the sky.

For more about these filters, see Filter Answers (page 20).

It isn't essential, but you'll find that your pictures improve if you do make the effort.

The main advantage of using a tripod is that you can set slow shutter speeds without fear of camera shake spoiling the results. In turn, this frees you to use slow film for optimum image quality, and small lens apertures to maximize depth-of-field.

In bright weather conditions you may find you don't need one, but early or late in the day, when light levels are much lower, it will be indispensable.

......

Is landscape photography just about capturing sweeping views?

.

Not at all. The key to landscape photography is to capture the character of a place, and often you can do that just as effectively by concentrating on small details.

A telephoto lens can be used to home in on interesting sections of a scene, for example. Or you can capture the many intricate patterns and textures that appear

CONSULTING MAPS

The more you know about an area before visiting it, the greater your chances of taking successful pictures, so any background work you can do will be worthwhile.

Ordnance Survey maps are particularly valuable to UK landscape photographers because they provide a great deal of information about the topography of the land. Contour lines tell you how high a particular location is in relation to surrounding scenery, while their closeness indicates how steep or gentle the gradients are. The maps also show many other useful features, such as rivers, streams, footpaths, roads, sites of ancient settlements and so on. You can even roughly calculate the best time of day to visit a particular spot once you know which direction it faces. All this information will help you build up a mental picture of the area you intend exploring, so you have some idea of what to expect before you arrive.

in the landscape, such as lichens on a drystone wall, the rough texture of tree bark, or autumn leaves carpeting the ground.

All you have to do is ask yourself what it is about a scene or area that you like, then answer that question with your camera in whatever way you feel is suitable.

Is it worth photographing the landscape in bad weather, or should I wait for the sun to come out?

Yes, bad weather is definitely worth it. The mood of the landscape changes completely in bad weather, and if you brave the

elements you could be rewarded with stunning results.

Two filters were used to capture this English Cornwall seascape: a grey grad to help retain colour and detail in the beautiful dawn sky, plus an 81B warm-up to enhance the light. Spend time analysing a scene before photographing it, so you can decide which filters, are required. *Pentax 67, 55mm lens, 1/2sec at f/16, Fuji RFP50.*

SUBJECT: LANDSCAPE ANSWERS

LEFT For this shot the photographer used a telephoto lens to isolate a small hill farm nestling at the foot of rugged fells. Positioning the farm at the bottom corner of the frame helps to emphasize the scale of the scene. Olympus OM4Ti, 135mm lens, 1/60sec at f/11, Fuji Velvia.

BELOW Shafts of sunlight make the lush green trees in this scene stand out brilliantly against the stormy sky. Such conditions tend to come without warning and often only last for just a few seconds, so you must be ready to make the most of them and risk being soaked to the skin if a downpour starts.

Pentax 67, 200mm lens, 1/30sec at f/16, Fuji Velvia.

The most dramatic conditions occur when sunlight breaks through during a storm and illuminates the landscape against a backdrop of black clouds. This may only last a few seconds, with the light levels constantly changing, so you need to be ready to capture it. Use a graduated grey filter to make the sky even darker, and meter for a part of the scene that's lit by the sun. Should it start to rain while the sun is out you may also have the chance to photograph a rainbow arching across the landscape. Position the bow against a dark background if you can, so its colours stand out.

Mist and fog shroud the landscape in a mysterious veil, reducing colours to soft pastel shades, and making hills and trees look like cardboard cut-outs.

The ideal time to catch mist is at dawn during autumn and winter, when it floats

serenely above water and hangs in valleys like a ghostly shroud with church spire and trees breaking through. You need to act quickly though, because once the sun comes up it quickly burns away. When photographing fog, try to include one or two bold features to act as a focal point, otherwise you'll end up with a murky sea of grey and nothing else. A church spire, hills or tall trees are ideal.

99

SPORT AND ACTION ANSWERS

The essence of sport and action photography lies in capturing the drama and excitement of moving subjects on film. To do this successfully you must be totally familiar with your equipment, so you can use it instinctively, and have knowledge of the subject you're photographing. It's no surprise that the best action pictures are taken by sports enthusiasts, simply because the more you know about a subject or event, the more you're able to anticipate what's going to happen next.

Allied to sound knowledge is the ability to react quickly. The most rewarding photo opportunities rarely give any prior warning before happening, so you must be ready at all times, able to focus quickly and accurately, and able to trip the shutter at precisely the right moment. A split second either way and the shot will be lost forever.

For someone used to static subjects such as landscapes and buildings, this can come as something of a shock. Even relatively slow subjects appear to be travelling at breakneck speed when viewed through a telephoto lens, and capturing them on film seems like an impossibility. But don't worry, we've all been there and made the mistakes. We've also discovered that with practice, the seemingly impossible suddenly becomes relatively easy. Just like driving a car. And remember how frightening that was the first time you tried it!

Are long telephoto lenses essential for sports photography?

Again, it depends what your subject is. For sporting events which occur some distance from the camera a powerful tele will be

essential to fill the frame. Photographers covering athletics, motorsport and field events such as football and rugby rarely use lenses shorter than 400mm, and often resort to 500mm or even 600mm optics. Cricket is even worse, requiring lenses up to 800mm for wicket shots.

But these are extremes, and you'll find that if you go along to local venues, or cover more accessible sports, the top end of a 70–210mm or 75–300mm zoom will be fine. If not, you can always increase its power with a 1.4x or 2x teleconverter.

A 200mm lens fitted with a 1.4x teleconverter was powerful enough to produce this framefilling shot of whitewater canoeists negotiating a slalom gate.

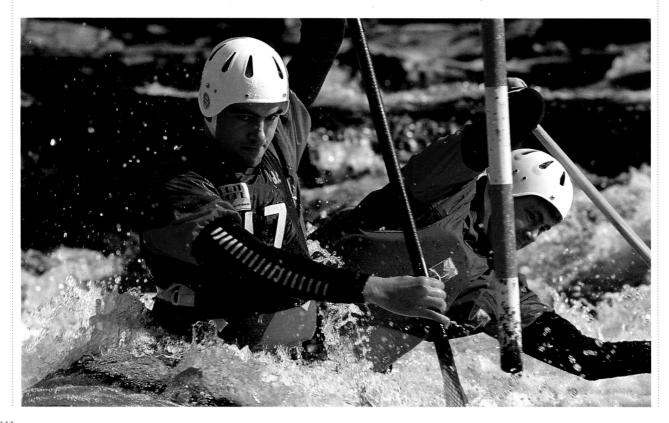

SUBJECT: SPORT AND ACTION ANSWERS

CHOOSING THE RIGHT SHUTTER SPEED

There are three factors to consider when choosing a shutter speed to freeze subject movement: the speed your subject's travelling, the direction it's moving in relation to the camera, and how big it is in the frame.

If your subject is travelling across your path, or filling most of the frame, you'll need to use a faster shutter speed than if it's heading straight towards the camera, is small in the frame, or moving at an angle. The table gives the recommended shutter speeds to freeze a variety of popular subjects.

BELOW Slow shutter speeds are ideal for emphasizing movement – here $\frac{1}{15}$ sec has reduced the runners at the start of a race to an impressionistic blur.

Subject	Across path Full frame (sec)	Across path Half frame (sec)	Head-on (sec)	
Jogger	1/250	1/125	1/60	
Sprinter	1/500	1/250	1/125	
Cyclist	1/500	1/250	1/125	
Trotting horse	1/250	1/125	1/60	
Galloping horse	1/1,000	1/500	1/250	
Diver	1/1,000	1/500	1/250	
Tennis serve	1/1,000	1/500	1/250	
Car at 40mph (64km/h)	1/500	1/250	1/125	
Car at 70mph (112km/h)	1/1,000	1/500	1/250	
Formula I car	1/2,000	1/1,000	1/500	
Train	1/2,000	1/1,000	1/500	

RIGHT When you need to freeze a moving subject, make sure the shutter speed you set is fast enough – here 1/500sec proved suitable. *Minolta* XD7, 200mm lens, Fuji RDP100.

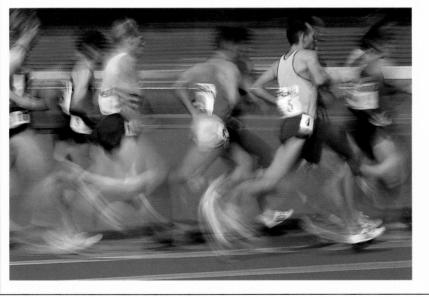

You shouldn't ignore the versatility of shorter lenses either. Action pictures are at their best when they capture the drama and excitement of an event, and that can be done just as well by shooting from close range with a 35mm or 28mm wideangle lens.

Finally, if you're buying lenses specifically for action, choose the fastest you can afford. A 70–210mm zoom with a maximum aperture of f/2.8 is at least double the price of a 70–210mm f/4–5.6 model, for example, but the extra one or two stops will allow faster shutter speeds and slower film to be used in the same conditions. That can make all the difference between a good or great picture – especially when you're working in low light.

••••••

If you refer back to Accessory Answers (page 36) you'll see there are various forms of camera/lens support available. But the favourite among sport and action photographers is undoubtedly the monopod.

Monopods are ideal for use with long, heavy telephoto lenses because they take the weight and strain off your arms and provide loads of support. This makes it far easier to focus the lens and hold it steady for long periods of time to prevent camera shake. Being compact and light, they also give you the freedom to move around so you can change position quickly and easily, and provide a nice fluid action that enables you to keep track of moving subjects.

SUBJECT: SPORT AND ACTION ANSWERS

When shooting indoor action, faster film is required to cope with the lower light levels. For this shot Fuji RHP400 was uprated to ISO 1600 then push-processed by two stops. The final image exhibits noticeable grain, but such treatment was necessary to provide action-stopping shutter speeds.

> Do I need to use fast film when photographing sport and action subjects?

That depends what you're photographing and where, but you should always use the slowest film you can get away with.

In bright weather outdoors, most sport and action photographers use ISO 100 film. This may seem rather slow, but it will allow shutter speeds of 1/500 or 1/1,000sec with your lens set to a wide aperture such as f/4 or f/5.6, and that's more than enough to freeze most subjects.

Faster film is only used when absolutely necessary, to ensure suitably high shutter speeds can be set. In dull weather, for instance, you may find it necessary to load up with ISO 200 or ISO 400 film. Indoors, ISO 400 tends to be the starting point, but it isn't uncommon for ISO 1000 or ISO 1600 film.

The ability to work quickly and instinctively is vital, otherwise many great pictures will be lost

while you spend time twiddling knobs and pressing buttons. Your camera should therefore be easy to use, and present important information in the viewfinder, such as the aperture and shutter speed set, so you don't have to take the camera from your eye.

A motordrive is also handy for saving time and allowing you to capture Here the photographer prefocused on a point along the moto-cross rider's path, then tripped the camera's shutter just before his subject reached that point.

Nikon F4, 400mm lens, 1/500sec at f/4, Fuji RDP100.

sequences of pictures in rapid succession, while shutter speeds up to at least 1/2,000sec will allow you to freeze any subject.

Other than that, any type of 35mm SLR is suitable for sport and action photography – it's your skills that are the most important factor.

SUBJECT: SPORT AND ACTION ANSWERS

I never seem to get my subject perfectly in focus when photographing sport or action. Are there any easy solutions to this problem?

No easy solutions are available, unfortunately, but there are a couple of techniques you can use.

If your subject follows a set course, such as in athletics, motor racing, track cycling and show jumping, your best bet is to prefocus on a point it will pass, such as the corner of a race track, a jump, or the finish line. All you have to do then is keep your eye on that point, then just before your subject reaches it, trip the shutter. Don't wait until your subject snaps into focus, otherwise by the time you trip the shutter it will be too late.

When your subject is moving around in an irregular way, such as footballers, rugby players, and other field sports, you'll have to use a technique known as 'follow-focusing', which involves continually adjusting focus to keep your subject sharp until you're ready to take a picture. This is much more difficult than prefocusing, so practise on moving subjects without taking any pictures - joggers or cars driving down the road are ideal.

Is it necessary to go to major sporting venues to take exciting action pictures?

Not at all. At most large sporting venues, in the UK at least, you need a press pass to take pictures anyway, and they're only issued to

professionals with accreditation from magazines or newspapers.

A far better approach is to visit local sporting venues - most towns and cities have one - where you can get closer to your subjects without the need for a press pass, and where you don't have to jostle for position with crowds of other photographers.

Some sporting events are also better than others in terms of access. Car rallying, motocross, cyclocross, marathon running, canoeing, tennis and city-centre cycling are just a few examples of subjects that can be photographed successfully from spectator positions which are close to the action, without the need for powerful telephoto lenses.

EMPHASIZING MOVEMENT

Don't always be tempted to set a high shutter speed and freeze your subject often, using a slower shutter speed deliberately to introduce blur can work far better because it helps to create a feeling of motion, and it heightens the drama.

Again, the shutter speed you use depends upon how fast your subject is moving and how much blur you want. For a person jogging you could use anything from 1/30sec to 1/2sec, whereas a racing car can be blurred at 1/500sec or 1/250sec.

When emphasizing movement, most photographers use a technique known as 'panning'. This involves tripping the shutter while tracking the subject with the camera, so the background blurs but the subject remains relatively sharp.

Alternatively, mount your camera on a tripod and keep it still during the exposure, so anything that's moving blurs while stationary features come out

Panning the camera using a 1/30sec shutter speed produced this powerful result. The horse and rider aren't perfectly sharp, but the effect works well and is aided by the blur of the surrounding foliage. Minolta XD7, 200mm lens, 1/30sec at f/11, Fuji

RDP100.

pin-sharp. This approach can be used to produce eye-catching pictures of commuters rushing off a train, or crowds of shoppers walking down the high street.

In many situations it can, but don't take that as an indication manual focusing is a poor second.

Autofocus SLRs offering Servo or Predictive mode are ideal because they continually shift focus to keep moving subjects sharp. In Predictive mode the

subject's acceleration is also accounted for. and focus is adjusted at the moment of exposure to ensure a sharp result.

However, autofocusing only works well if you keep the central AF envelope over your subject. Even then, if something comes between you and your subject the lens will hunt around and you'll miss the shot. So, by all means use autofocusing, but make sure your manual focusing skills are up to scratch too.

NIGHT & LOW-LIGHT ANSWERS

Night time holds many mysteries and surprises for all who dare venture into its hidden depths. As the curtains of daylight are drawn across the world everything is transformed into a glittering spectacle of colour. Floodlit buildings stand out vividly against the night sky, neon signs flicker outside pubs, clubs and bars, and a warm, welcom-

ing glow radiates from every window. Stepping out after dark is like entering another world. Even the most uninspiring places by day become a photographer's paradise by night, and no matter where you go you cannot fail to take stunning pictures.

Is there any magical formula to getting the exposure correct when taking pictures at night?

A

The main thing you need to remember is that a typical scene contains dazzling highlights against a dark, murky background, so if

you just fire away with your camera on automatic, chances are you will obtain badly exposed results. Bright lights are the worst culprit. They fool your camera into giving too little exposure, and the rest of the scene comes out very dark.

To avoid problems, meter from an important part of the scene while excluding other elements from the frame. If you are photographing a floodlit building against the night sky, for example, you could move up close to it and take a reading, so its dark surroundings do not

BELOW The first hour after sunset is the most productive period, when the colours in the sky fade from fiery reds, oranges and pinks, to a deep, velvety blue. This shot was taken at 9.30pm during midsummer. Pentax 67, 55mm lens, 4mins at f/22, Fuji Velvia (ISO 50).

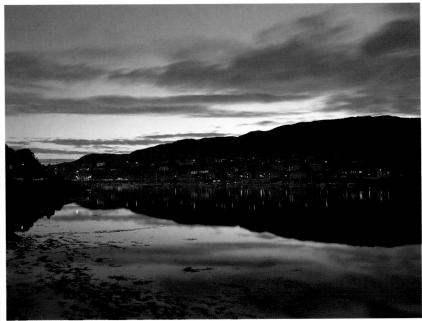

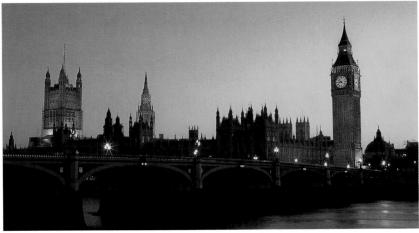

LEFT Neon signs are easy to photograph and create eye-catching images. If you fill all or most of the frame with the neon sign your camera meter can normally be relied upon to give perfect results.

Olympus OM4Ti, 200mm lens, 1/2sec at f/8, Fuji Velvia (ISO 50). ABOVE Care and a little experimentation is required when photographing scenes that contain bright lights. For this shot the photographer bracketed exposures to be sure of getting one of them spot on. *Olympus OM2, 50mm lens, 4secs at f/16, Fuji Velvia (ISO 50).*

SUBJECT: NIGHT AND LOW-LIGHT ANSWERS

confuse your lightmeter. Or if you are photographing a person bathed in firelight, meter from their clothing, so the brightness of the flames does not influence the reading obtained.

To give you an idea of the exposures you should expect when photographing common subjects, use the guide right.

When is the ideal time to take night pictures?

For general night time scenes, such as harbours, floodlit buildings, seascapes and cityscapes, you should ideally start shooting soon

after sunset, when there is still some colour left in the sky. Not only does this provide a more pleasing backdrop to your main subject, but it makes obtaining correct exposure easier.

NIGHT EXPOSURE GUIDE					
	Exposure in seconds for ISO 100 film Aperture				
Subject					
	f/5.6	f/8	f/11	f/16	
Normally lit street	4	8	16	32	
Cityscape at night	4	8	16	32	
Cityscape just after sunset	1/4	1/2	1	2	
Fairground rides (eg big wheel)	3	6	12	24	
Floodlit building (eg church)	2	4	8	16	
Shop window	1/4	1/2	1	2	
Subject under street light	2	4	8	16	
Subject lit up by fire	1	2	4	8	
Subject lit by car headlights (6m)	2	4	8	16	
Brightly lit city street	1/4	1/2	1	2	
Neon signs	1/8	1/4	1/2	1	
Landscape by moonlight	2m	4m	8m	l6m	
Bonfire	1/8	1/4	1/2	1	
Fireworks (aerial)	bulb (B) at f/16				
Traffic trails	bulb (B) at f/16				

CAPTURING TRAFFIC TRAILS

One of the most popular night time subjects is the colourful streaks of light created by moving traffic. To capture traffic trails you first need to find an elevated location which gives a clear view along a road, motorway, or over a roundabout - bridges and high rise buildings are ideal. Late autumn or winter is the best time of year to shoot, as rush hour occurs at nightfall.

After mounting your camera on a tripod and composing the shot, all you have to do is wait for traffic to appear

and trip your camera's shutter. For the best results, set your camera to its bulb setting, so you can hold the shutter open using a cable release for as long as necessary.

For this picture of traffic on a busy road the photographer exposed the scene for 4 minutes at f/16 to ensure colour recorded in the sky. Olympus OM4Ti, 28mm lens, Fuji Velvia

(ISO 50).

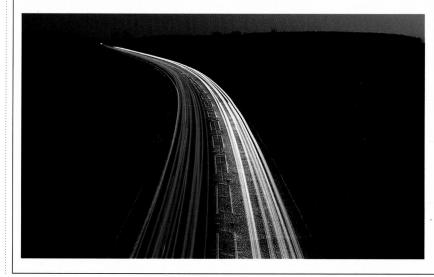

If the traffic runs out, hold a sheet of card in front of the lens while still holding the shutter open, and stop counting.

When the traffic reappears, uncover the lens so more trails can record, and resume counting down the exposure.

Is it okay to photograph normal scenes like landscapes and seascapes at night?

Yes – you can photograph anything you like. Few photographers ever try to

capture the landscape at night, but

the results can look amazing – especially if there's a full moon to bathe the scene in

eerie light, and clouds in the sky to blur during the long exposure.

Take your pictures when you can still just about see what's going on, and set the exposure for the foreground as you would during the day – ideally using a handheld meter – and expect exposure times to run into many minutes. A grey graduated filter can also be used to darken down the sky if it's still quite bright.

PHOTOGRAPHING FUNFAIRS

Funfairs, like firework displays, provide the photographer with endless opportunities to take exciting, colourful pictures. The techniques involved are also very similar.

For shots of fairground rides such as the big wheel and waltzer, simply mount your camera on a tripod, set the lens to f/8 or f/11, and use an exposure of 20 or 30 seconds so the moving lights record as coloured streaks.

To photograph people having fun on the dodgem cars and other rides, combine a slow shutter speed with a burst of electronic flash, so you get both blurred and sharp images on the same picture.

The integral flashgun of your compact or SLR may cut in automatically in low light, or will have a special slow-sync mode that can be set to produce this effect. Alternatively, use a portable flashgun mounted on the camera's hotshoe.

A 30 second exposure at f/16 was used for this shot, so the spinning lights on the big wheel were transformed into brilliant spirals of colour.

Olympus OM4Ti, 85mm lens, Fuji Velvia.

Seascapes can look stunning at night, when a long exposure turns the sea into a beautiful mist floating on the shoreline.

Olympus OM4Ti, 135mm lens, 4mins at f/16, Fuji Velvia.

If I use fast film will I be able to take night pictures without a tripod?

For shots of people gathered around a bonfire, eating toffee apples at a funfair, or peering into shop windows, fast film of ISO

shop windows, fast finit of 150 1000 or ISO 1600 will allow you to take handheld pictures. However, for general night photography it won't. Image quality will also suffer due to the coarse grain and weaker colours, so you're better off mounting your camera on a tripod and using slow film to capture the scenes you encounter in all their glory. Most photographers use ISO 50 or ISO 100 film at night because it gives beautiful colours and pin-sharp results.

What happens if light levels are so low my camera meter won't give a reading?

This should rarely happen as the integral meter of modern SLRs is very sensitive. However, if it does you can overcome it by employing a little trick.

Let's say you're using ISO 50 film and you want to shoot at f/16, but the exposure time required is outside the meter's range. If you set your lens to its widest aperture instead, such as f/2.8 or f/4, a much shorter exposure will be required and it may fall within the meter's range.

All you have to do then is double the exposure every time you close the lens aperture down by a stop, until you arrive back at f/16. If the meter sets two seconds at f/4, for example, the correct exposure would be 4 seconds at f/5.6, 8 seconds at f/8, 16 seconds at f/11 and 32 seconds at f/16.

An alternative method is to set the camera to a much higher film speed. If you can't get a reading at ISO 50, say, you probably will at ISO 1600. The exposure time should then be doubled every time you halve the film speed, until you arrive back at ISO 50.

SUBJECT: NIGHT AND LOW-LIGHT ANSWERS

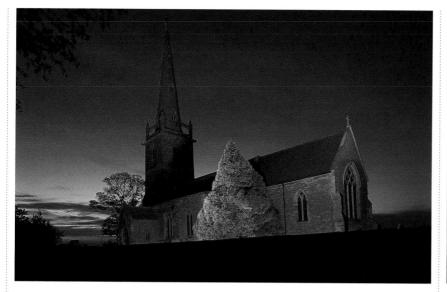

Do I need to use any special filters at night, to control the colour casts caused by artificial lighting?

That depends how realistic you want your pictures to be. If there's just a single light source in the picture, such as tungsten or sodium

vapour, you can balance it using the necessary filter (see Filter Answers, page 20). Unfortunately, general night scenes contain a mixture of several different types of lighting, making it impossible to deal with them all.

Your best bet is just to ignore this problem, as casts produced can actually improve a picture by making it even more colourful than the original scene.

I've heard something called 'reciprocity law failure' occurs at night. What is this exactly?

The film you use in your camera is designed to give optimum results using exposures between 1 to 1/10,000sec. If you use exposures

outside that range the film loses speed, so the exposure suggested by your lightmeter must be increased to prevent the pictures coming out too dark. This can be a problem at night because you'll often be using exposures longer than a second.

The exact amount of increase required varies because each type of film responds differently to reciprocity failure. However, as a rule-of-thumb, if your camera suggests an exposure of 1 second, use $1\frac{1}{2}$, if 10 seconds is suggested use 30, and if 1 minute is suggested use 3 minutes.

I took lots of fireworks pictures last year and the results were a complete disaster. Can you offer me any advice to make sure I have more success the next time?

The first tip is to forget about trying to photograph small domestic fireworks and visit a large communal display where everything is done on a bigger scale. Aerial displays also give better results than ground-based fireworks, because if you're too close smoke will obscure your view.

Once you arrive at the display ask a marshall where the rockets are likely to explode, then select a shooting position that will give you a clear view – move away from the main crowd if necessary.

Next, mount your camera on a tripod and compose the scene you expect to be covering. All you have to do then is set your camera's shutter to B (bulb), trip the shutter with a cable release as the rockets are launched, and hold it open as they explode in mid-air. Once the first rockets die down, keep the shutter locked open, hold a piece of black card in front of the lens, then move it away when the next rockets are launched.

By repeating this two or three times you can capture several firework bursts on the same frame of film, so your pictures are packed with colourful streaks.

ABOVE This is the kind of effect you can produce by selecting a good viewpoint and capturing several rocket bursts on one shot. *Olympus OM2n, 28mm lens, 2mins at f/16, Fuji RFP50.*

ABOVE LEFT The vivid colour casts produced by artificial lights can look striking in their own right, so don't be too eager to get rid of them. Olympus OM4Ti, 24mm lens, 30secs at f/16, Fuji Velvia.

BELOW For pictures of people with sparklers hold your camera's shutter open on the bulb setting for about 20 seconds at f/8 or f/11, then just before releasing it, fire a burst of flash to light your subject. *Olympus OM2n, 50mm lens, Fuji RFP50*.

olympus olivizii, somini iens, ruji Nirso.

NATURE AND CLOSE-UP ANSWERS

Animals and birds can be photographed on several different levels, depending on your experience and interest. Family pets make a good starting point, while zoos give you the chance to photograph exotic species without travelling to the ends of the earth. Bird sanctuaries are another option worth considering, and your own back garden can be the source of many fine pictures.

But for the ultimate experience and reward nothing beats stalking wildlife through the undergrowth or capturing animals and birds from the concealment of a hide. To succeed you must have the same sense of cunning as your quarry, and be willing to play a fascinating game of cat and mouse, but the satisfaction of tracking down an animal and capturing it on film just can't be beaten.

I'm off to visit a zoo soon and would like to photograph the animals there. Got any advice on how do to this?

Zoos and safari parks are great places to try your hand at 'wildlife' photography. Not only are they home to a vast range of species from all four corners of the globe, but the animals and birds are used to having

people around, so you can get relatively close without scaring them away. They're also restricted by the confines of a cage or pen, so they can't vanish into thin air like true wild animals.

All these factors combine to make your life relatively easy. Frame-filling pictures can usually be taken with a 70-210mm zoom lens, and by carefully choosing your shooting position it's often possible to exclude all signs of confinement so the

ABOVE For this picture of a merlin the photographer used a 400mm lens supported by a fence post to prevent camera shake. Critical focusing is essential with such powerful optics.

LEFT Zoos and safari parks are ideal locations to take pictures of animals that you may never be fortunate enough to see in the wild.

pictures look as though they were shot in the wild.

The main problem is caused by wire mesh or iron bars obscuring your view. To overcome this, set your lens to its widest aperture and focus carefully on your subject. If you're using a telephoto lens of 135mm or more the depth-of-field will be so shallow that the bars or mesh won't actually appear on the final shot. Doing this also renders any distracting background detail out of focus so your main subject becomes the centre of attention.

For pictures of animals or reptiles behind glass use electronic flash and press your lens up against the glass panel so the flash doesn't create annoying reflections.

The best pictures tend to be taken at feeding time, when the animals are at their most active. Big cats snoozing under a tree, or a female with her young also provide good photo opportunities.

SUBJECT: NATURE AND CLOSE-UP ANSWERS

USING A HIDE

Working from a hide is a common practice among wildlife photographers because it allows you to get very close to animals and birds and photograph things that would otherwise be impossible.

Hides come in all shapes, sizes and forms. You can buy portable models that pack into a small carrying case and are erected like a tent. Some photographers even use small 'coffin' or 'bivouac' tents which lie close to the ground and can be set up in a small area. Or you could make you own hide using sheets of camouflaged canvas draped over poles. Whichever type you choose, it's a good idea to conceal the hide further using material found at the location, such as fallen branches, leaves, bracken and grass.

Before erecting the hide you must first find a suitable location. Nest sites, watering holes, favourite roosting grounds or feeding places are all ideal, and a few visits to the area beforehand will confirm where most of the activity takes place.

To prevent the animals or birds being frightened off, your best bet is to erect the hide some distance away, leave it for a couple of days so they get used to it, move it closer, leave it again, and so on until you reach the final position. When you go to the hide it's also a good idea to take a friend along as a decoy. He/she can leave once you're inside, and the animals will think the coast is clear.

All you have to do then is watch and wait. Have your camera mounted on a tripod so you're ready to shoot when something appears. It may take hours before you spot anything, so pack plenty of food, drink and warm clothing.

The equipment required will depend

mainly on how close you are to the action. Occasionally it's possible to erect a hide so close that a 70–210mm telezoom or 200mm telephoto lens is adequate, but generally you'll need a 400mm or 500mm lens to do your subject justice.

It's also possible to take successful pictures using your car as a temporary hide. If you park in a picnic spot or woodland clearing you may see squirrels, pheasants, rabbits, foxes and all sorts of other quarry. A telephoto lens can be rested on the windowsill of the door, or supported on a monopod wedged between the door and seat. It's also a good idea to drape a coat over the window opening partially to conceal yourself from view. By concealing yourself with a hide it's possible to observe and photograph timid animals and birds over a period of time from relatively close range.

What kind of lenses will I need to photograph animals and birds in the wild?

Long telephoto lenses are essential for serious wildlife photography, simply because most animals and birds are very timid, making it

impossible for you to get close to them.

As a minimum you may be able to get away with a 300mm for some subjects, but a 400mm, 500mm or 600mm lens is much better because it will allow you to fill the frame from further away.

If you can't afford to buy such a powerful and expensive lens, invest in a 2x teleconverter, which will double to focal length of a shorter telephoto lens – turning a 300mm lens into a 600mm lens, for example.

A monopod or tripod will also come in handy for supporting the lens and preventing camera shake. Alternatively, rest it on natural supports such as a tree stump, rock or fence, and use a beanbag as a cushion so you don't damage the lens.

SUBJECT: NATURE AND CLOSE-UP ANSWERS

What's the easiest way to photograph garden birds without scaring them away?

There are various options, though the one you choose will depend upon the type of birds you want to photograph and the kind of equipment you have.

By far the easiest is to scatter food close to a window, then take your pictures through it while hiding behind the curtains. If you erect a perch from an old branch you can position it in the perfect spot to give you a clear view. All you have to do then is bait it with food for a few days so the birds become accustomed to it. The top end of a 70–210mm telezoom should be powerful enough to give framefilling pictures.

If you don't have a long enough lens for this you could mount your camera on a tripod, position it close to the perch and focus on the area where the birds land. You can then watch from indoors, and when any birds appear, trip the camera's shutter with an electronic or air release. The main problem with this method is that it's rather hit-and-miss because you can't see through the camera's viewfinder. Also, unless your camera is fitted with a motordrive, you'll have to wind on the film manually after each shot, and this will frighten the birds away. For this picture of a starling the photographer hid behind a nearby tree and used a 300mm lens on his SLR to fill the frame with his subject.

Stalking requires great dedication and patience, but the rewards are often well worth the effort – as this excellent picture shows.

Finally, if you've got a big garden there's nothing to stop you erecting a semi-permanent hide close to the feeding site. After a while the birds will get used to it, so you can nip in and out whenever the opportunity arises.

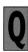

Are there any laws governing the photographing of animals and birds that I need to be aware of?

Certain species of animals and birds are protected by law, and it is an offence to photograph them at or near their nest or breeding site without a licence.

Could you give me some advice on stalking wild animals such as deer and foxes?

A

Stalking is perhaps the most challenging approach to wildlife photography. Like a hunter you follow signs and clues that an

animal is in the area, then carefully get as close to it as possible without being spotted until you can take a successful picture. This can be an incredibly exciting experience because you're working on your basic instincts; looking, listening, creeping through the undergrowth, knowing that one false move, one snapped twig, could spell disaster.

Stalking tends to be used for larger animals, such as deer, but is only viable when you know there's wildlife about. It can also be a very time-consuming business that demands much patience and care.

In terms of equipment, you need to travel light so you can move quietly and quickly. One SLR body fitted with a long telephoto lens – 400mm, 500mm or 600mm is ideal – will take care of the hardware. A monopod or beanbag should be used to support the lens, while film and accessories can be stuffed in your jacket pockets.

To reduce the risk of your quarry seeing you, drab or camouflaged clothing should be worn, along with a hat to disguise your head. You should also avoid wearing aftershave, deodorant or any kind of scent, as its smell will give the game away instantly, and remove any jewellery.

EQUIPMENT FOR CLOSE-UPS

There are various items of equipment that are specially designed for close-up photography. Here's a rundown of the most common.

Zoom lenses If you check your zoom you may find it has a close-up facility. Usually this gives a reproduction ratio up to 1:4 (quarter lifesize), so you can fill the viewfinder of your SLR with subjects around the size of a cigarette packet.

Supplementary close-up lenses screw to the front of your lens like filters, and reduce its minimum focusing distance. The power is measured in dioptres – usually +1, +2, +3 and +4. The bigger the number, the greater the magnification.

For the best results, use them on prime lenses rather than zooms – the 50mm standard lens is ideal.

Reversing rings allow you to mount a lens on your camera the wrong way around so it will focus very close. Unfortunately, by doing so you lose all electronic and mechanical linkage between the camera and lens, so the metering system and automatic aperture stopdown won't function. **Extension tubes** are metal tubes which fit between the lens and camera body, increasing the lens-to-film distance so greater image magnification is possible.

Tubes normally come in sets of three, each a different size so you can obtain various reproduction ratios. When the length of extension matches the focal length of the lens, the reproduction ratio obtained is 1:1 (lifesize). So 50mm of extension with a 50mm standard lens will give lifesize images.

Bellows work in the same way as extension tubes, but they're adjustable so you can obtain intermediate reproduction ratios. They also allow greater extension – often up to 150mm, which gives a reproduction ratio of 3x with a 50mm standard lens. Ideally, bellows should be used on a tripod. It's also worth buying a focusing rail, which allows you to fine-tune the focusing once the tripod is in position.

Macro lens (see Lens Answers, page 14).

Reversing rings and bellows are the perfect choice when reproduction ratios greater than lifesize are required. Both can be used with a macro lens for optimum magnification and image quality.

Also, stay downwind of your quarry.

Finally, disguise the aluminium legs on your tripod or monopod with camouflaged tape, and cover any chrome areas on your camera body with black masking tape to prevent reflections. Once your subject is in view, use tree stumps or foliage as a barrier so it can't see you, and sight it up in the camera's viewfinder. All you have to do then is wait for an opportune moment, and when it arises, fire away.

SUBJECT: NATURE AND CLOSE-UP ANSWERS

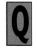

What does 'reproduction ratio' mean in close-up photography?

This term refers to the size of your subject in real life compared to its size on a piece of film. If you work at a reproduction ratio of 1:1, or

'lifesize', a subject measuring 20mm in real life will be 20mm on a 35mm slide or negative. At a ratio of 1:2, or 'half lifesize', it will measure 10mm on a piece of film, at 1:4 it will measure 5mm, and so on.

If you're working at ratios greater than lifesize your subject will be bigger on film than it is in real life. At a ratio of 2:1, for example, a subject measuring 10mm in reality will measure 20mm on a 35mm negative or slide. photographing 'live' subjects though, as they're easily frightened. Always move slowly and carefully, and avoid casting your shadow over the subject.

Nature is also full of many beautiful patterns and textures that can be revealed if you move in close. The veins and cells in backlit leaves, crystals in ice, the delicate colours of flowers and the rough surface of bark or lichen-covered stone are just a few examples.

Sometimes my pictures come out too dark when shooting close-ups. Do I need to increase the exposure? A

That depends upon the equipment you're using. Close-up lenses and reversing rings require no exposure increases, so you can use the expo-

sure your lightmeter suggests. However, close-up attachments such as extension tubes, bellows and macro lenses cause a light loss that must be compensated for.

If your camera has TTL (through-thelens) metering, as the majority of SLRs do, then any exposure increase will be taken into account automatically. If not, the exposure suggested must be increased before the picture is taken.

The table shows the amount of exposure increase required when working at different reproduction ratios.

Reproduction ratio	Exposure factor	Exposure increase (in stops)
1:10	x1.2	И
1:5	x1.4	К
1:2.5	×2	1
1:2	x2.3	11/3
1:1	x4	2
1.4:1	x5.8	2½
1.8:1	x7.8	3
2:1	x9	31⁄3
2.4:1	x11.6	3½
3:1	x16	4

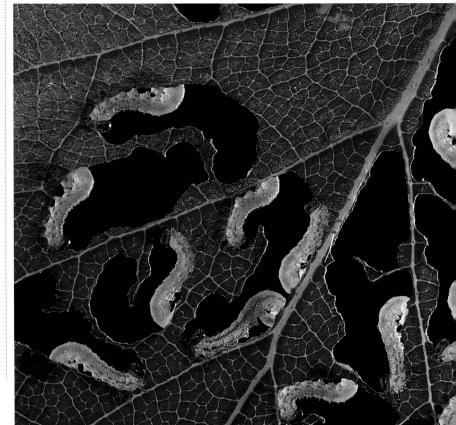

What kind of subjects make good close-up pictures?

More or less anything really. Most nature photographers shoot closeups because there's an infinite

number of subjects waiting to be captured, including butterflies, bees, dragonflies, small mammals and insects. You need to be very quiet and patient when

ABOVE They may not appear particularly exciting when viewed with the naked eye, but in close-up even a simple leaf can be turned into a fascinating image. Here backlighting was used to reveal the intricate network of veins and cells.

Whenever I take close-up pictures hardly anything comes out sharply focused. Why's that?

Because depth-of-field is almost non-existent at close focusing distances. You should therefore use the smallest lens aperture

possible – usually f/16 or f/22 – to maximize what little depth-of-field there is. Careful focusing on the most important part of your subject is also vital, as you may find that only part of it is sharply recorded.

Unfortunately, using small lens apertures leads to slow shutter speeds being required, especially if you're using slow ISO 50 or ISO 100 film. This makes a tripod essential if you're to avoid camera shake. The shutter should also be tripped using a cable release, and if possible your camera's reflex mirror locked up as an extra precaution, to reduce vibrations. Alternatively, use electronic flash (see right).

BELOW For this superb picture of larvae feeding on a birch leaf the photographer used electronic flash to illuminate the leaf from behind, and set it up against a black background to maximize colour saturation. The lens used was stopped down to f/16 to ensure sufficient depth-of-field.

......

USING FLASH FOR CLOSE-UPS

The easiest way to overcome the problems of poor light and long exposures when shooting close-ups is by lighting your subject with a burst of electronic flash. Not only does this allow you to work at small apertures to maximize depth-of-field, but the brief burst of light will freeze any subject movement too.

If you own a dedicated flashgun you may find it will give perfectly exposed results automatically when used at close focusing distances – check the instruction book for details. Special ringflash units are also available for close-up photography, which fit to the front of your lens and have a circular tube surrounding it to provide even, shadowless illumination.

However, most photographers prefer to use one or two manual flashguns filtered to a special bracket and calculate the aperture required to give correct exposure.

This is done using the formula below:

guide number (m/ISO 100)

aperture = flash-to-subject distance (m) x (magnification + 1) So if your flashgun has a guide number of 20, the flash-to-subject distance is 60cm, and the magnification is 0.5x (a reproduction ratio of 1:2, or half life-size), the aperture required is $20/0.6 \times (0.5+1) = 20/0.9 = 22.22$, or when rounded up, f/22.

This aperture is correct for ISO 100 film, so if you're using a different film speed it must be adjusted accordingly to prevent under- or overexposure. For ISO 50 film set automatically to f/16, for ISO 25 film set f/11, and for ISO 200 film set f/32.

By using this formula for a range of common flash-to-subject distances, you can produce an exposure table and tape it to your flashgun.

In terms of flash position, ideally the gun should be taken off your camera's hotshoe and held closer to the lens so your subject will be evenly lit. Special brackets are available for this, and usually allow two guns to be used – one either side of the lens.

Finally, as you'll be using the flash from close range, low-output guns with a guide number around 20 (m/ISO 100) are powerful enough.

Electronic flash is an invaluable ally for the serious close-up photographer, and when used correctly produces superb results.

ARCHITECTURE ANSWERS

Architecture is one of the most accessible subjects available. Everywhere you go you'll find buildings in all sizes, shapes, colours and designs. Periods of history are reflected vividly by the changing architectural styles evident in towns and cities, and they present an endless range of photo opportunities. Even the houses on your street can be the source of excellent pictures.

The aim of the architectural photographer, like the landscape photographer, is to capture the character of the subject through careful composition and use of light. An understanding of architectural style is therefore vitally important, just as knowing something about a portrait subject will help you record their personality.

Technical perfection is also taken for granted. Buildings are static subjects, unable to run away or resist your advances with a camera, so there's no reason why you shouldn't spend hours, even days, searching for the best viewpoint, or waiting for conditions to be right before taking a picture.

When is the best time of day to photograph buildings?

A

The quality of light falling on your subject building has a great influence on both its physical appearance and atmosphere, so the

timing of your shoot must be given plenty of thought.

Professional architectural photographers regularly telephone weather agencies so they know what kind of Modern glass-fronted buildings are best photographed when interesting reflections are formed by the scene opposite. Here the orange glow created by the sunset sky contrasts well with the much darker night sky in the background to produce a highly effective image.

weather to expect. Maps and plans are also studied to establish where the light will be in relation to the building at different times of day – in some cases the light is perfect for only a few days each year. Different types of buildings also suit different forms of light. Old structures tend to look their best during late afternoon, when warm sunlight makes the stonework glow. The beauty of modern architecture, on the other hand, is shown in brighter, crisper light, when blue sky can be used as a backdrop and the strong lines are fully revealed. Reflections can also be captured in glass-fronted buildings when the facade is in shade and the sun is bearing down on buildings opposite.

Dull, overcast weather tends to be unsuitable as the soft light hides texture and reduces depth, while the harsh light of midday is avoided because it causes contrast problems. That's not to say you should always stick to ideal conditions, of course. Harsh sunlight can work well if you are trying to create a bold, abstract image, while misty dawn light is perfect for adding mood to pictures of old buildings.

The appearance of a building is also changed dramatically once daylight fades. Tall buildings look stunning with the last rays of sunlight glancing across their facade, and once artificial illumination takes over at night you can produce excellent pictures of all types of buildings, from the local café to majestic cityscapes.

Whenever I photograph buildings they always appear to be toppling over. How can I avoid this?

The problem you're referring to, known as 'converging verticals', is common in architectural photography. It's caused when you try to

photograph a tall building from close range, and are forced to tilt the camera up to include the whole structure in the shot. By tilting the camera, the vertical sides of the building appear to lean inwards, and in some cases this gives the appearance that the building is about to fall over.

To avoid converging verticals you must keep the back of the camera, and the film plane, parallel to the front of the subject building. This is best done using a shift or perspective control lens, which has an adjustable front element that can be moved up to include the top of the build-

SUBJECT: ARCHITECTURE ANSWERS

ABOVE Converging verticals were avoided in this shot by moving very close to an ornamental pond and using the reflection of the building in it to add foreground interest. Late-afternoon sunlight makes the stonework glow beautifully. *Olympus OM4Ti, 21mm ultra wide-angle, 1/30sec* at f/16, Fuji Velvia.

BELOW Where converging verticals can't be avoided your best bet is to exaggerate them by moving in close and looking up the front of the building with a wide-angle lens, so the vertical sides lean dramatically. ing without tilting the camera (see Lens Answers, page 14).

Other options are:

• Backing off until you can include the whole building without tilting the camera. This usually gives you lots of empty foreground space, which can be filled with a colourful flower bed, path or gateway.

• Shooting from a higher viewpoint so you're looking straight across at the building rather than up at it. Often, standing on a wall or step-ladder will provide enough height. If not, there may be a suitable building opposite.

• Shooting from further away with a telephoto lens, so you don't have to tilt the camera so much and the effect of converging verticals is minimized.

Which lenses are most suited to architectural photography?

Most architectural photographers prefer wide-angle lenses, simply because they allow large buildings to be captured from relatively close

range. They also give you plenty of control over the composition – foreground interest or frames can be included, and slight changes of viewpoint can totally change the feel of the shot. For general use a 28mm or 35mm lens is ideal, while an ultra-wide 17mm or 20mm lens is ideal for creating dramatic perspective.

Don't ignore your telephoto or telezoom lenses though. Focal lengths from 80–200mm are perfect for isolating interesting architectural details, such as the gargoyles on a church, or the pattern of windows in an office block. Telephotos can also be used to take dramatic pictures of distant buildings, or to fill the frame with impressive city skylines and compress perspective.

SUBJECT: ARCHITECTURE ANSWERS

What's the best viewpoint to photograph buildings from?

The best viewpoint is the one which captures a building at its most impressive, and that can only be discovered by spending time looking at your subject from all angles.

Buildings shot square-on look attractive, but the lack of depth tends to produce rather flat results. To avoid this, and give an impression of three dimensions, move towards one corner so the side as well as the facade is revealed. Shooting from a very high or low angle can also work well, as it presents a view we're not used to seeing from eye-level.

When you're wandering around, look for other features that can be included to make the composition more attractive – such as the overhanging branches of a tree, pillars and gate posts, flower beds and ponds or lakes that may include a reflection of the subject buildings.

This shot of St John's College, Cambridge, England, was carefully composed so an archway opposite formed a perfect frame. It's always a good idea to consider various options before committing yourself.

Olympus OM4Ti, 28mm lens, 1/60sec at f/11, Kodak Ektachrome 100 Elite.

Whenever I try to photograph buildings in a city centre, they always seem to be partially obscured by shade. What do you suggest?

> This is a common problem in builtup areas. Usually the shadows of buildings opposite are cast across the one you're trying to photo-

graph for most of the day, causing problems with contrast. It's only when the sun's almost overhead that you get a clear view. The trouble is, by that time – around midday – the light's too harsh.

Your best bet is to photograph the building during early morning or late afternoon, when it's completely in shade and contrast levels are more manageable.

Which filters do you recommend for architectural photography?

A polarizer is invaluable for saturating colour, deepening blue sky and removing unwanted reflection from windows. You'll also find an 81A

or 81B warm-up useful for enhancing warm sunlight to make buildings glow, and grey graduates for reducing contrast between the sky and your subject building. Here a polarizing filter was used to saturate the rich red of the brickwork and deepen the clear blue sky. The building, captured in late afternoon sunlight, is the photographer's local post office.

Olympus OM4Ti, 28mm lens, 1/60sec at f/11, Fuji Velvia.

For interior shots it's worth using 80A and 80B blue filters, to balance the orange cast from tungsten lighting, and an FLD filter to balance the green cast from fluorescent tubes.

Are architectural details worth photographing?

If you look closely at a building you'll see many different architectural details, from the steel and concrete frames of modern archi-

tecture, to the fluted columns and ornate cornices of older structures.

In a wide-angle shot these details tend to get lost against the sheer size of the whole building, but when captured in isolation they come to life and create excellent pictures in their own right. Modern architecture is full of patterns and abstracts due to the repetitious design,

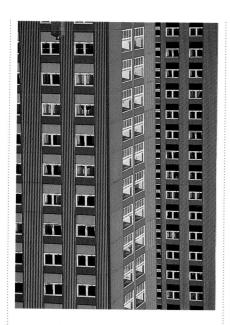

Here the repetition of lines, colours and shapes in a modern tower block has been turned into a striking abstract image.

Minolta XD7, 300mm lens, 1/125sec at f/11, Fuji RDP100.

while older stone buildings reveal wonderful textures, colours and magnificent examples of stone masonry that have withstood centuries of exposure to the elements.

So in answer to the question, yes, architectural details are worth photographing, and make a perfect 'theme' to help improve your eye for a picture.

I'd like to take some pictures of the town I live in. Where's the best place to shoot from?

Town and cityscapes look their best when captured from a high viewpoint, so you can include large areas and lots of detail in the

frame – shooting from ground level is limiting because often you can't see beyond the first row of buildings.

If you look around there's bound to be a high viewpoint somewhere. Try the top floor of the multi-storey carpark, a nearby hillside, the tower of your local church, or a bridge. Failing that, ask permission to shoot from the window of a local office block. If money's no object you could even charter a light aircraft and take some stunning aerial shots.

INTERIORS

Photographing the interior of a building is generally far trickier than photographing the exterior. More often than not you have little space to move around, light levels are low, and artificial illumination is used, which presents problems with colour casts.

The first problem can be overcome by using a wide-angle lens. Usually a 24mm or 28mm lens should do the trick, but in small buildings a 20mm or even 17mm will be better. Make sure you compose the shot carefully to avoid converging verticals – stand on a chair or steps if necessary.

Low light levels dictate that a tripod is almost essential if you want to use slow film for optimum image quality. Unfortunately, few stately homes and castles allow the use of tripods, so you'll have to find some other form of support – some photographers carry a pocket tripod and rest it on a step or banister. Flash isn't a viable solution as your gun won't be powerful enough to cover the whole interior. Flashguns tend to be banned anyway in such places, as they distract other visitors.

In old buildings the lighting is also uneven. Small windows and artificial sources are only effective over limited areas, so you end up with bright highlights and deep shadows, and the contrast is too high for your film to record fully. The only way to overcome this is by taking a meter reading from the extremes of brightness, then using the average of the two as a compromise. Alternatively, light the darkest areas with flash if possible. Where a building is lit by daylight only it's a good idea to shoot on an overcast day, when contrast is lower.

Modern buildings don't suffer from this problem as the interior lighting is much better. The problem is artificial sources tend to be used, so you must filter the light to prevent colour casts on daylight film (for details see Filter Answers, page 20).

When there's a mixture of light sources, such as tungsten and fluorescent, shoot on colour negative film so the colour balance of the pictures can be controlled at the printing stage.

In modern interiors a variety of light sources are used, making it impossible to balance them all. As this example shows, however, it's possible to take perfectly acceptable results using normal daylight film and no filters. *Minolta 7000i, 16mm fish-eye lens, 1/8sec at f/11, Fuji RD 100.*

STILL-LIFE ANSWERS

It may not offer the excitement of action, the cunning of candids or the scale of landscapes, but still-life photography is a challenging and highly rewarding subject that really tests your creativity, imagination and technical skills to the limit.

What makes still life different from other disciplines is that you can't just point a camera and fire away. Before a picture can be taken you must first find suitable objects, turn them into a pleasing composition and carefully light the set to bring out its aesthetic

appeal. Actually firing your camera's shutter is the last step in a process that can take anything from a few minutes to several days.

To many photographers this seems like a waste of valuable time, but the satisfaction to be gained from producing a successful still life is immense, simply because you have total control over every stage of the process, from start to finish.

For this simple still life the photographer began with a couple of pears then added the other fruit piece by piece until he was satisfied with the overall balance of shapes, colours and textures. Windowlight from the side provided the illumination.

Olympus OM4Ti, 50mm lens, 1/8sec at f/11, Kodak Ektachrome 100 Elite.

Imagination goes a long way in still-life photography, as this superb image shows. The paperclips were simply arranged on a sheet of blue perspex, sprayed with water, then lit using electronic flash.

Pentax LX, 50mm macro lens, 1/60sec at f/16, Fuji RF50.

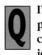

I'd love to have a go at still-life photography, but I can never come up with any interesting ideas. Got any suggestions?

For many photographers, finding suitable props is a major stumbling block, but a quick search around your home will reveal a broad range of interesting subjects.

Something as ordinary as a bowl of fruit or a pile of fresh vegetables can be turned into stunning pictures with a little thought. Then there are ornaments, cutlery, clocks and watches, old bottles, rusty tools, gardening implements and so on. Collections are also ideal, whether they're stamps, seashells, coins, postcards, war medals, candlesticks, or model planes.

Alternatively you could devise a theme. such as Christmas, the swinging sixties, your favourite colour or a specific shape, then look around for suitable objects.

The key is to try and look at simple objects in terms of their colours, textures and shapes, rather than what they really are. By doing this you'll find it's possible to turn almost anything into a successful still life.

> Is there a limit to the number of props that can be used in a stilllife shot?

No, but you must be able to justify the presence of each item, otherwise they shouldn't be included. It's easy to overcomplicate a composition by adding more and more

props, but this usually creates a confusing clutter rather than a pleasing picture. The solution is to keep things simple and take it slowly. Start off with an empty

table top and one or two key props, then add a couple more and vary their position in relation to one another until you come up with a pleasing, balanced composition.

Don't worry if the composition looks a little gappy - the space between the props is as important as the props themselves in terms of the overall visual balance of the shot, so avoid trying to fill every vacant space with something else. Often one or two objects in plenty of space can produce superb results.

Finally, try to make your compositions look natural and lifelike, rather than being too ordered and tidy. There's nothing wrong with continuing the still life outside the picture area, for example, so some props are cut off at the frame edges. This tends to produce better results than a still life that fits perfectly into the camera's viewfinder, because it adds intrigue.

What equipment will I need to photograph still lifes?

A great advantage of still-life photography is you can create superb results with the minimum of equipment - a simple, manual

35mm SLR and 50mm standard lens is all you need to get started. A short telephoto lens of 85mm or 100mm will come in handy for some shots, plus a macro lens or close-up attachment for taking pictures of small objects, but they can be added later.

The only other major items required are a sturdy tripod to keep your camera steady and in position, plus a cable release to trip the shutter and prevent camera shake when using long exposures. Reflectors are invaluable for bouncing the light around to fill in shadows or create highlights on certain props. Make them in different sizes from sheets of white card and polystyrene, silver foil stuck to card, or small mirrors that can be precisely angled to bounce light around or direct on to specific areas to create highlights.

In terms of film, most still-life photographers stick to slow materials of ISO 25-100 for optimum image quality and resolution of fine detail.

Having said that, don't be afraid to experiment with faster film of ISO 1000 or above - the coarse grain and softer colours can produce beautiful images when used on suitable subjects. Still life also lends itself to black & white, so why not try your hand at mono photography if you haven't already?

For this shot the photographer filled a selection of bottles with dye then arranged them on a lightbox so the backlighting emphasized the colours and created a pleasing effect. Pentax LX, 50mm lens, 1/15sec at f/16, Fuii RF50.

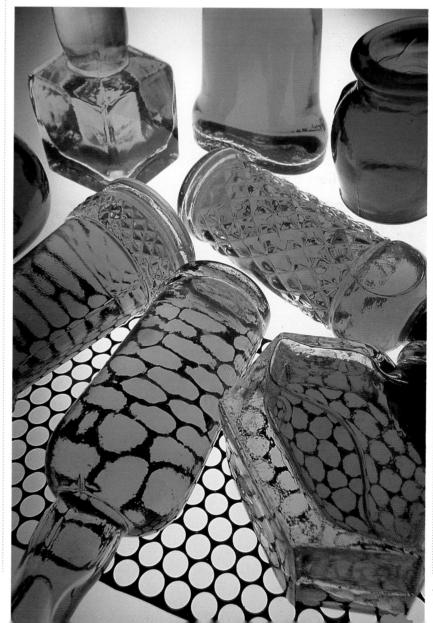

An old door covered in peeling paint provided a textured backdrop for this beautiful study of withering flowers. Still-life photographers are notorious for scouring rubbish heaps and rummaging through skips to find unusual backgrounds for their work.

Mamiya RB67, 90mm lens, 1/4sec at f/22, Fuji Velvia.

What kind of things make suitable backgrounds for still lifes?

That depends on what you're photographing more than anything else.

If you want to keep things as simple as possible a sheet of black card or velvet will provide an uncluttered backdrop that emphasizes the shape of sleek, shiny objects. White backgrounds are also ideal when you want a very clean, crisp feel.

For a more rustic, textured feel try using an old tarpaulin or canvas sheet. Alternatively, make your own textured background by painting canvas or an old

bedsheet with pots of old emulsion applied liberally.

For still-life shots of small objects all kinds of materials can be used. Black perspex is ideal if you want to produce clean reflections, while oiled slate works well with jewellery or shiny ornaments because its texture emphasizes the smoothness of the props. A pile of bricks, an old door covered in peeling paint, the back of a leather jacket or rusting corrugated metal sheet are other materials worth considering.

I'm unsure about the best lighting to use for still-lifes. Could you advise me?

The type of lighting used for a still life must be given plenty of thought because it not only determines the overall mood of the

shot, but also how well the shapes of the objects are revealed, how strong the colours look, and if texture is visible.

As a starting point, the daylight flood-

ing in through the windows of your home is ideal. All you have to do is 'position a table next to a large window, then erect a background sweep from card or canvas and arrange your still life on it.

Shoot during late afternoon and warm, low-angle sidelighting will cast long shadows that reveal texture and form in the props. The soft light of an overcast day is also ideal if you want a more delicate effect, and can be controlled using reflectors to bounce the light around.

Or you could stand translucent objects on a windowsill and use the window as a background. This works particularly well with things like bottles photographed at sunset because the colours in the sky outside will be picked up by the glass.

An alternative source of light is your portable flashgun. If you connect the gun to your camera with a sync cable it can be used in any position around the props. You need to soften and spread the light to produce attractive results though. This can be done either by firing it through a diffusion screen made from tracing paper, or bouncing it off a reflector.

FOUND STILL LIFES

If you don't fancy the idea of taking a selection of objects and turning them into an interesting composition, another approach is to photograph things as you find them in situ.

Found still lifes can consist of virtually anything: pebbles and seashells on the beach, autumn leaves and fir cones beneath a tree, a pair of old boots on the garage floor, crushed tin cans by the side of the road, an old car overgrown by weeds, fishing tackle laid out on the riverbank, piles of plant pots behind the greenhouse... If you keep your eyes peeled while you're wandering around you'll come across all kinds of things.

These onions were discovered in a garden shed and photographed as they appeared. Fast film was used to create a pastelly, grainy image and a nearby window provided the diffuse lighting. *Olympus OM4Ti, 50mm lens, 1/250sec at f/11, Agfachrome 1000RS.*

Frontal light is ideal for revealing the colour of an object, but because shadows fall behind it the results can easily look flat, so it's best avoided for anything other than straight 'pack' shots. When you want to reveal texture and modelling, move the light to the side more, so that shadows become an integral part of the shot – with the light coming from 90°, a dramatic half-light/half-shade effect will be produced that looks highly effective.

Top lighting is another popular technique used by still-life photographers. The light is diffused using a large softbox known as a 'fish fryer' or 'swimming pool', which is suspended above the set – you could make one by stapling several sheets of tracing paper to a wooden frame. To

Late afternoon sunlight flooding in through a leaded window provided the illumination for this sumptuous still-life. Noticing the shadow pattern being cast on his dining room door, the photographer created the picture around it simply by draping muslin in the background and placing a vase of dried flowers in the path of the light.

Pentax 67, 105mm lens, 1/15sec at f/11, Fuji Velvia. Usually found still lifes are photographed using natural daylight. However, it's worth carrying a reflector in your gadget bag to bounce light into the shadows and produce more attractive results. Fill-in flash can also be used for the same purpose. When composing the picture, don't worry about whether or not the subject is actually identifiable, and don't be afraid to move objects around if it will produce a better picture.

avoid shadows, stand the props on white card so the light is reflected upwards.

Finally, your flashgun can be used to paint the still life with light. All you do is fit a paper cone to your gun so just a narrow beam of light is produced, then selectively light different parts of the still- life by firing the gun several times using the test button. This must be done in a dark room with your camera set to B (bulb).

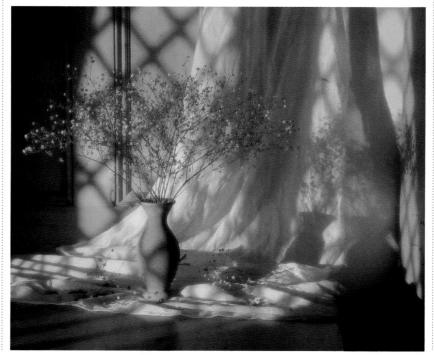

SPECIAL EFFECTS ANSWERS

Photography, like painting, is a medium that's open to infinite experimentation. Most of the time you'll use traditional techniques to produce successful images, but when the creative bug bites there are also many alternative methods waiting to be explored. You can create unusual images in-camera, in the darkroom, or using existing pictures. You can add subtle effects to enhance a picture, combine images to produce unusual multiple exposures, or completely defy reality and bring your wildest fantasies to life.

Whichever route you take, special-effects photography is a fascinating subject that will provide endless hours of fun and inspiration.

How can I create bas-relief images using colour slides?

Bas-relief is a technique which allows you to create images that appear like low-relief sculptures or etchings.

To begin with, you'll need a colour slide that contains large areas of flat tone, and strong, well-defined subjects. The next stage is to make a lifesize (1:1) duplicate of the original slide (see slide copying panel, page 125).

Lith film works best as it gives a highcontrast black & white negative, but conventional negative film will do as an alternative. Bracket your exposures when making the dupe, and choose the negative that has a similar density to the slide. Finally, sandwich the slide and negative together so they're slightly out of register and the etching effect is created. The sandwich can then be copied onto colour slide film if you like.

For this bas-relief image the original slide was copied onto Agfa Ortho high-contrast black & white negative film, then the two images were combined slightly out of register.

What happens if you process a roll of film in the wrong chemicals?

Normally the consequences of this act can be disastrous if you do it accidentally, but over the past few years it has become common prac-

tice among portrait and fashion photographers as a means of creating bizarre effects.

The two most common methods are to process colour slide film as colour negative film in C-41 chemicals, so you actually obtain colour negatives, or to process colour negative film as slide film in E-6 chemicals so you obtain colour slides.

These are no ordinary slides or negatives though. Strange colour casts are produced and image contrast goes crazy, so the final pictures are often completely different to what you'd expect. Even better, it's almost impossible to predict

Rating Fuji Super G 400 colour negative film at ISO 100, then push-processing it two stops in E-6 chemistry produced this strange effect.

what the effect will be as it differs widely from one film type to another.

When treating slide film as negative film, you'll usually obtain acceptable results by rating it at the manufacturer's recommended ISO, as any exposure error can be corrected at the printing stage. However, cross-processing colour negative film tends to cause a loss of speed, so you usually need to underrate it to compensate. As a starting point, try rating ISO 100 slide film at ISO 25, and bracket the exposures to make sure some of the shots are

SUBJECT: SPECIAL EFFECTS ANSWERS

perfect. Push-processing the film by one or two stops can also make a difference to the final results.

Finally, you must give the lab clear instructions so they know how to process the film. To avoid confusion, stick a label on the film cassette saying 'C-41 process', or 'E-6 process', and explain what you've done. Some high street labs will refuse to cross-process film in this way as it can ruin the chemicals, but most professional labs will accept your request.

Could you give me some advice

on using lith film?

Lith film is a high-contrast material that produces negatives comprising just black and white, with no intermediate grey tones. It's intended mainly for document copying, but can also

be used to create eye-catching images. Being an orthochromatic material (not sensitive to the red end of the spectrum), lith film can be handled and processed under a red safelight without fogging, so most photographers use it to make highcontrast copies of existing negatives in the darkroom. Here's how it's done:

1 Under safelight conditions, cut a sheet of 5x4 in lith film in half, place one half on the enlarger baseboard and the other back in the box. Now place your black & white negative on top and contact the two together with a sheet of clean glass.

2 Make a test strip (see Printing Answers, page 68) to determine the best exposure for the lith image, then process the lith film in print trays using a lith developer such as Kodak Kodalith RT. Fix and wash the test strip then examine to determine the best exposure.

3 Repeat step 1 with the other half of the lith film sheet, expose it for the required length of time, then process, fix, wash and dry it. This gives you a lith positive.

4 Place the lith positive on another sheet of unexposed lith film, cover with a sheet of glass, and repeat step 2 to make another exposure test strip.

5 Finally, contact-print the lith positive with another sheet of lith film, then expose for the required time and develop it to produce a lith negative. You can now make enlargements from this negative by enlarging it onto grade four or five paper.

SLIDE SANDWICHING

Sandwiching is a popular method of creating double-exposure effects by combining two existing slides. By working with images that have already been processed you can immediately see how they will work together, so you needn't commit yourself until the final result looks good.

The key to successful sandwiching lies in choosing your images carefully so they complement each other and work well together. For this reason it's a good idea to avoid using two well-saturated or detailed slides, otherwise you'll end up with a confusing mess. Instead, combine a strong image that will stand out in the final sandwich with one or more weaker ones, such as a silhouette with a colourful filter effect.

Most photographers put together a collection of images for use in sandwiches, like skies, filter effects, bright splashes of colour, patterns and textures, so they can pick and choose which ones to combine. But you needn't limit yourself to colour slides alone - interesting effects can also be achieved by sandwiching a colour slide with a black & white or colour negative.

Once the final combination has been chosen, the images are taped together at the edges to keep them secure and placed in a plastic slide mount. You then have the option to copy them so the original slides/negatives can be used in other sandwiches (see slide copying panel, page 125).

A close-up of a doll's face was sandwiched with a wide-angle shot of a forest canopy to produce this bizarre image. The two slides were then copied using a slide duplicator.

To create this highly graphic image the photographer copied a normal continuous tone image (below) onto Kodak Kodalith Ortho film from the original 35mm image, then printed it on grade 4 paper (right).

SUBJECT: SPECIAL EFFECTS ANSWERS

Is it possible to add special effects to black & white prints without a darkroom?

The easiest way to transform your black & white prints is by toning them to add an overall colour. A variety of toners is available,

including sepia (warm/brown), blue, green and copper, plus selenium, which creates a range of different colours depending upon the type of paper used.

ABOVE Toners can completely transform the mood of a black & white print. Here sepia toner has added an attractive warmth to this stormy seascape.

BELOW With a Jessop Colorvir Kit all sorts of exciting effects are possible. A yellow solarization bath followed by blue toner was used to produce this eye-catching result.

ABOVE The same statue was photographed several times on the same frame of film using different filters and zoom settings to achieve this overlapping effect. Such images are easy to produce using cameras that have a multipleexposure facility.

To tone a print all you need is a toning kit, which can be purchased from your local photo shop, a set of developing dishes, and some print tongs. Toning can also be carried out in daylight using existing prints, and the whole process only takes a few minutes. Instructions are enclosed with the kits so you know

exactly what to do. Sepia toner is a two-stage process which involves first bleaching the print to fade the image, then immersing it in a tray of toner so the image reappears with a delicate brown colour. Most toners, however, involve just one bath.

The other popular method of manipulating black & white prints is by using a process known as Colorvir. This comprises a series of chemicals which have been devised so you can create a range of colour effects including multiple toning, solarization and contour-line derivations.

Colorvir kits are distributed in the UK by Jessops, and a starter kit is available which contains small quantities of all the chemicals and simple instructions so you can experiment with the full range of effects.

Q

I'd like to have a go at creating multiple exposures. Could you give me some advice on how it's done?

Multiple exposures are created by re-exposing the same frame of film several times to different subjects or scenes. At its simplest this may

involve superimposing the moon on a night shot, or capturing the same person twice in the same picture, but once you've mastered the basics you'll be able to produce seemingly impossible visual illusions.

To make sure your plans are successful, however, you need to bear in mind a few important factors.

Firstly, complicated ideas require thorough planning, so you know exactly what you want to include. With medium- or large-format cameras you can mark the position of important elements on the ground glass focusing screen to prevent overlap, but a 35mm screen is too small so a sketch should be drawn instead.

Next, if you're going to expose the whole of the frame each time so each image overlaps, you need to choose your background carefully. If it's detailed or coloured you'll be able to see it through subjects that are captured after the first exposure. Indoors, this can be avoided by using a black velvet background. Outdoors, shoot at night when the sky is black, or make sure important features fall

SUBJECT: SPECIAL EFFECTS ANSWERS

COPYING SLIDES

The final stage in several special-effects techniques involves duplicating colour slides to produce identical copies. Duplicating is also advisable if you want to enter slides into competitions or send them away for publication, but would rather hang on to valuable originals. The easiest way to make 35mm dupes from 35mm originals is by using a simple slide duplicator. This is basically a metal tube with an internal lens and a slide holder and diffuser on the end, which you fit to your camera body using a T2 mount. The cheapest models allow 1:1 (lifesize) dupes only, while more expensive units have a zooming capability so you can crop the original.

Electronic flash is the best form of illumination to use for duping. If you

A typical set-up for copying slides using a simple slide duplicator attached to an SLR, and a dedicated flashgun to provide the illumination.

have a dedicated flashgun and a dedicated sync cable, all you have to do is place the gun a couple of feet behind the duplicator and your camera will work out the correct exposure automatically. Daylight can be used, but its colour balance varies so you may have problems with colour casts. Tungsten lighting is also an option, but it gets very hot .

In terms of film, dupes can be made using conventional slide film, but for top-quality results you should use a special slide duplicating film such as Kodak Ektachrome Type K or Fuji CDU and colour balancing filters.

in plain, dark areas.

Finally, if the images in a multiple exposure overlap across the whole frame, the exposure used for each one must be reduced proportionally, so when they all combine the end result will be correctly exposed. As a rule-of-thumb, with two images you should underexpose them both by a stop; with three, underexpose each by 1½ stops; with four images, underexpose each by two stops, and so on. The only exception to this is if important subject matter falls against a black area, you're using a black background, or part of the picture area is masked off during each exposure. Then you can expose as normal; otherwise, overexposure will occur and ruin the effect.

My camera has no multipleexposure facility. How can I re-expose the same frame of film?

You need to recock the camera's shutter without moving the film. To do this, press the rewind release button on the camera to disengage

the film sprockets, and hold it down. Now hold down the film rewind crank at the same time, so it can't move, then operate the film advance lever to cock the shutter with the film disengaged.

The film shouldn't move, but just in case it does, waste the next frame when you've completed the multiple exposure by taking a picture with the lens cap on. This prevents any image overlap.

An alternative method is to rewind and reload the film after making each exposure, so you can keep exposing the same frame. If you do this, mark the film edge when it's loaded into your camera so that you can align that mark against a suitable reference point when you reload it the second time. This ensures that all the exposures align perfectly.

Instead of throwing rejected slides into the dustbin, experiment with them and see if you can come up with something unusual. This striking blue image was produced by placing the original slide in a dish of diluted bleach, which caused the film's emulsion to fall apart and produced a strong colour cast.

126

I come across a lot of photographic terms that I don't really understand. Could you explain the meaning of them?

There are literally hundreds of technical phrases and buzzwords used by photographers – enough to fill a whole book on their own.

Here's a list of the most common.

Ambient light Available light, such as daylight, tungsten room lighting or windowlight.
Aperture Hole in the lens through which light passes en route to the film. Each aperture is given an f/number to denote its size. Large apertures have a small f/number, such as f/2.8; small apertures have a large f/number, such as f/16.
ASA Old method of measuring film speed (American Standards Association).

Backlighting Term used to describe shooting towards a light source, so your subject is lit from behind.

Beam splitter Mirror or prism which reflects and transmits light, used in cameras with autofocusing or spot metering.

Brightness range The difference in brightness, often measured in stops, between the highlights and shadows in a scene.

B setting A shutter setting which allows you to hold your camera's shutter open while the shutter release is depressed. Handy for night photography, when the exposure time required runs outside the shutter speed range on your camera.

Burning in Darkroom technique where more exposure is given to certain areas of the print, to darken them down or reveal detail.

C-41 process Chemical process used to develop colour negative/print film.

Catadioptic lens Another name for a mirror lens.

Catchlight The reflections created by highlights or bright objects which appear in your subject's eyes and make them look more lively. **Cds cell** Stands for cadmium sulphide cell, a type of light-sensitive cell found in many light meters. **Chromogenic film** Colour film that forms dyes during processing. Ilford XP2 is the only mono type available.

Cibachrome Now called Ilfochrome Classic. Ilford printing paper which allows colour prints to be made directly from colour slides. **Co-axial socket** Socket on the camera into which you plug a flashgun or sync cable. **Colour contrast** Use of colours which clash when in close proximity to each other, such as red and blue. **Colour harmony** Use of colours which look attractive together and produce a soothing result, such as green and blue.

Colour sensitivity How well film responds to light of different wavelengths – some films are more sensitive to certain wavelengths, particularly red and blue.

Colour temperature Scale used to quantify the colour of light. Measured in Kelvin (k).

Compound lens Lens made up of different elements.

Contrast The difference in brightness between the highlights and shadows in a scene. When that difference is great, contrast is high; when it's small, contrast is low.

Contre-jour French term which means shooting into the light, or 'against the day'.

Converging verticals Problem common in architectural photography which makes buildings appear to be toppling over. It's caused when the camera back is tilted to include the top of a building.

Cut-off Darkening of the picture edges, caused when a lens hood or filter holder is too narrow for the lens, or too many screw-in filters are used together. Also called vignetting.

Data back Camera back that allows you to print the time and date on your pictures. Daylight-balanced film Film for normal use which is designed to give correct colour rendition in light with a colour temperature of 5,500k. Depth-of-field The area extending in front of and behind the point you focus on that also comes out acceptably sharp.

Depth-of-field preview Device which stops the lens down to the taking aperture so you can judge depth-of-field.

Depth-of-focus The distance the film plane can be moved from the lens without losing sharp focus.

Diaphragm Name given to the series of blades that form the lens aperture.

DIN German method of expressing film speed, still used today along with the ISO scale. **Double exposure** Technique used to

combine two images on the same piece of film.

E-4 Old colour slide film process replaced by E-6. Now only used to process Kodak Ektachrome colour infrared film.

E-6 Process used to develop just about all colour slide film except Kodachrome.Emulsion The light-sensitive layer on film and printing paper.

Enprint Standard size of print used by processing labs, usually measuring 6x4 inches. **Exposure latitude** Amount of over- and underexposure a film can receive and still yield

acceptable results. Colour print film has a latitude of up to three stops over and under.

Field camera Type of large-format camera which folds down for easy carrying.

Film speed Scale used to indicate the sensitivity of film to light. An ISO rating is used. The higher the ISO number, the more sensitive the film is and the less exposure it requires.

Filter factors Number indicating the amount of exposure compensation required when using certain filters.

Flare Non image-forming light which reduces image quality by lowering contrast and washing out colours.

Flash sync speed Fastest shutter speed you can use with electronic flash to ensure an evenly lit picture. Varies depending upon camera type – can be anything from 1/30 to 1/250sec with most SLRs.

Focal length Distance between the near nodal point of the lens and the film plane when the lens is focused on infinity. Also used to express a lens's optical power.

Focal plane shutter Type of shutter found on all SLRs and many medium-format cameras. Focal point Point where light rays meet after passing through the lens to give a sharp image. Also used to describe the most important element in a picture.

Fogging Accidental exposure of film or printing paper to light.

F/stop Number used to denote the size of the lens aperture.

Grey card A sheet of card equivalent to the 18 per cent grey reflectance for which photographic lightmeters are calibrated.

Ground glass screen Type of focusing screen found in many cameras.

Guide number Indicates the power output of an electronic flashgun and is expressed in metres for ISO 100 film.

High key Type of picture where all the tones are light.

Highlights The brightest part of a subject or scene.

Hyperfocal distance Point of focus at which you can obtain optimum depth-of-field for the aperture set on your lens.

Incident light reading Method of measuring the light falling onto your subject rather than the light being reflected back. Incident readings are taken using a handheld light meter. Compare with 'reflected metering'.

Infrared filter Opaque filter that only transmits infrared light. Used with infrared film.

Iris Another name for the lens aperture. **ISO** Abbreviation for International Standards Organization, the internationally recognized system for measuring film speed.

Kelvin Unit used to measure the colour temperature of light.

Key light The main light in a multi-light set-up which provides the illumination on which the exposure reading is based.

Leaf shutter Type of shutter found in many medium-format and all large format cameras. The shutter is in the lens rather than the camera itself and operates like a lens iris, allowing flash sync at all shutter speeds.

Lifesize Term used in close-up photography when the subject is the same size on film as it is in reality.

Line film High-contrast black & white film which eliminates almost all intermediate grey tones. Lith film High-contrast black & white film which eliminates grey tones to produce stark black & white images.

Low key Picture which has mostly dark tones to give a dramatic, moody effect.

Magnification ratio Also known as reproduction ratio. Refers to the size of a subject on a frame of film compared to its size in real life. Masking frame Also called an enlarging easel. Used to hold printing paper flat during exposure and allows you to create borders around the print.

Medium-format Type of camera using 120 roll film. Images sizes available are 6x4.5cm, 6x6cm, 6x7cm, 6x8cm and 6x9cm.

Mirror lock Device found in some cameras which allows you to lock up the reflex mirror prior to taking a picture, to reduce vibrations and the risk of camera shake.

Monochromatic Means 'one colour' and is often used to describe black & white photography or colour photography when a scene comprises different shades of the same colour. Monopod Camera support with one leg. Multi-coating The delicate coating applied to most lenses and some filters to prevent flare. Multiple exposure Technique where the same frame of film is exposed several times to create unusual effects.

Neutral density filter Filter which reduces the amount of light entering the lens without changing the colour of the original scene. Newton's rings Patterns caused when two transparent surfaces come into contact – such as a negative in a glass negative carrier. One-shot developer A type of film developer which has to be discarded after one use only. **One-touch zoom lens** Zoom design which allows you both to focus and zoom the lens using a single barrel.

Open flash Technique where the camera's shutter is locked open, usually on the B setting, and the flash is fired at the required moment. **Orthochromatic film** Film which is insensitive to red light so it can be processed under a safelight. Lith film is an example.

Oxidation Process by which photographic chemicals become exhausted due to exposure to oxygen – one reason why they should be stored in full and tightly capped bottles.

Panchromatic film Type of film or printing paper sensitive to all colours in the spectrum. Normal colour film is panchromatic.

Parallax error Problem encountered when using rangefinder and twin-lens reflex cameras. Because the viewing and taking systems are separate what you see through the viewfinder isn't exactly the same as what the lens sees. It's most noticeable at close focusing distances, but modern compacts are corrected for it.

PC socket Socket on camera body which accepts a flash sync cable.

Photoflood Tungsten studio light with colour temperature of 3,400k.

Photopearl Tungsten studio light with colour temperature of 3,200k.

Pinhole camera Simple camera which uses a tiny pinhole to admit light to the film inside instead of a lens.

Predictive autofocusing Autofocus mode found on some SLRs which predicts how fast the subject is moving and automatically adjusts focus so when the exposure is made your subject is sharp.

Primary colours Colours which form white when combined. Red, green and blue are the three primary colours of light.

Prime lens Any lens with a fixed focal length, such as 28mm, 50mm or 300mm.

Push-processing Technique where film is rated at a higher ISO, then processed for longer to compensate.

Reciprocity law failure (see Film Answers, page 26).

Red-eye Problem caused by light from a flashgun reflecting back off the retinas in your subject's eyes so they record as red spots. Reflected metering System of light reading used by a camera's integral meter; which measures the light reflecting back off your subject. Compare with 'incident light reading'. Ring flash Flashgun with a circular tube surrounding the lens to provide even illumination of close-up subjects.

Rule of Thirds Compositional formula which is used to place the focal point of a shot onethird into the frame for visual balance.

Selenium cell Type of cell found in light meters which is sensitive to light and doesn't need a battery to work.

Selenium toner A toner which makes black & white prints archivally safe by converting remaining silver salts into a stable compound. Can also add a subtle colour depending upon the paper type used.

Snoot Conical attachment which fits to a studio light so you can direct the beam of light to where it's needed.

Softbox Attachment which fits over a studio flash unit to soften and spread the light.

Stop Term used to describe one f/stop. If you 'close down' a stop you select the next smallest aperture. If you 'open up' a stop you select the next largest aperture.

Thyristor Energy-saving circuit in many automatic and dedicated flashguns which stores unused power to reduce recycling time. Transparency Another name for a slide. Tungsten-balanced film Film designed to give natural results under tungsten lighting.

Universal developer Type of developer that can be used to process both black & white film and printing paper.

Uprating Rating film at a higher ISO, then 'push-processing' it to compensate.

Vanishing point Point where converging lines in a picture appear to meet in the distance, such as furrows in a ploughed field.

Variable contrast paper Black & white printing paper that can produce contrast grades from 0 to 5 with the aid of filters. Vignetting See 'cut-off'.

Waist-level finder Type of viewfinder used on many medium-format cameras which you look down on with the camera held at waist level. Wratten Kodak brand of gelatin filters. Favoured by professionals for their high quality, but expensive and easily damaged.

Zone system A system devised by the late Ansel Adams which involves previsualizing how you want the final black & white print to look at the time of taking the picture, so you can choose the exposure carefully. The scene is divided into zones – black is zone I and pure white zone 9, with various densities of grey tones falling in between the two extremes.

INDEX

Action photography 100–105 AF modes 11 Animals 108–113 Aperture 15, 40, 42, 81 Architecture 55, 114–117 Autofocusing 11, 12, 75, 103

Babies 84 Backlighting 43, 46 Backgrounds 16, 46, 81, 120 Bad weather 51, 98–99 Bags and cases 38 Bellows unit 111 Birds 110 Black & white photography 25, 96 Black & white printing 66–73 Black & white processing 62–65 Bounced flash 30, 33 Bracketing 48 Bulb setting (B) 105, 107 Burning–in 73 Bas relief 122

Cable release 38, 105 Camera handling 12, 74 Camera shake 12, 17, 36, 38, 59, 74 Candid photography 85, 92–93 Centre-weighted metering 45 Close-up photography 111-113 Colorvir 124 Colour 60-61 Colour balancing filters 24, 53, 117 Colour casts 53, 107, 117 Colour slides 27, 45, 61 Colour temperature 24, 53 Compact cameras 10, 43 Composition 54-59, 96 Contact sheet 68-69 Contrast 46, 47, 80, 116 Converging verticals 18, 114 Cropping 72 Cross processing 122

Darkroom 67 Depth-of-field 16, 40-41, 94 Direct flash 33 Dodging 73 Double exposures 74 Duplicating 125

Evaluative metering 44 Exposure 42–49, 90, 104, 106 Exposure compesation 4, 46–48 Extension tubes 111

Fibre-based paper 70 Fill-in flash 11.81 Film care 28 Film choice 26-29, 82, 84, 91, 92, 97.102 Film processing 62-65 Film speed 9, 27, 42 Fill-in flash 11, 32 Filters 20-25, 38, 96, 106 Filter factor 20 Fireworks 107 Fisheye lens 15 Flashguns 31-35, 86, 113 Flare 37 Flash sync 11, 31 Floodlit buildings 104 Focal length 14-15 Focusing 11, 103 Fog 51, 99 Fogging 76 Foregrounds 56, 94, 96 Graduated filters 21, 53, 98, 106, 116 Grain 27-28, 82, 84, 97, 102, 106 Guide Numbers 31 Handheld meter 48

Hides 109 High contrast 46–47 Holiday and travel photography 88–91 Horizon 37, 59

Incident light 48 Infrared film 29 Interiors 117

Kelvin scale 53

Landscapes 55, 94–99, 106 Large format 13, 26 Leaf shutter 11 Lens hoods 37 Lenses 14–19 Lighting (daylight) 50–55, 80, 87, 91, 95, 114 Lighting (studio) 82 Lith film 122 Low light photography 59, 104–107

Macro lenses 18, 84, 111 Masking frame 66, 69, 70 Medium-format 13, 26 Metering 43-49 Mirror lenses 17 Mist 51, 99 Monopod 37, 101, 109 Motordrives 102 Multiple exposures 124–125 Multigrade paper 70–71

Night photography 104-107

One-shot developers 63 Overexposure 46-47

Panning 103 Panoramic cameras 13 Paper grades 70–71 Patterns and textures 58, 98, 115–116 Perspective 16, 17, 56, 57, 94 Perspective control lenses 18, 114 Polarising filters 20, 51, 61, 96, 98, 116 Portraiture 33, 78–83 Posing 79, 81 Pre–focusing 103 Program modes 44 Push processing 28

Rangefinder camera 13 Reciprocity law failure 107 Redeye 34 Reflectors 33, 81 Resin-coated paper 70 Retouching 72-73 Reversing rings 111 Rule-of-thirds 55

Saturation 61 Selenium toning 124 Sepia toning 124 Servo focusing 12 Shift lens 18, 114 Shutter speeds 9, 42, 74, 107 Shutter priority mode 44 Silhouettes 46, 52 Slide copying 125 Slide sandwiching 122 Slow-sync flash 34 SLR 8, 9 Softbox 35, 82 Soft focus filters 21, 25, 82, 84 Sports photography 11, 100-103 Spot metering 45 Spotting prints 73 Still-life 118-121 Studio lighting 82, 121

Sunrise/Sunset 53 Supplementary lenses 111

Teleconverters 18, 109 Telephoto lenses 12, 16, 56, 57, 78, 84, 92, 94, 100, 109, 115 Test strip 69 Top lighting 121 Travel photography 88–91 Tripods 36, 59, 74, 98 TTL metering 43, 112 Tungsten film 29, 117 Tungsten lighting 29, 117 Twin lens compact 10 Twin lens reflex 12

Umbrella, flash 35, 82 Under-development 65 Underexposure 46-47 UV filters 21

Viewpoint 55, 116 Vignetting 37, 72, 75

Warm-up filters 24, 51, 53, 81, 82, 98, 117 Wide-angle lenses 16, 56, 84, 92, 94, 115 Windowlight 79, 86, 120

Zooming 18 Zoom compacts 10 Zoom lenses 15, 18, 84, 92, 94, 115 Zoos 108